IND COOPE &
SAMUEL ALLSOPP
BREWERIES
The History of the Hand

Ian Webster

AMBERLEY

First published 2015

Amberley Publishing
The Hill, Stroud
Gloucestershire, GL5 4EP

www.amberley-books.com

British Library Cataloguing in Publication Data.
A catalogue record for this book is available from the British Library.

ISBN 978 1 4456 3898 0 (print)
ISBN 978 1 4456 3910 9 (ebook)

Typesetting and Origination by Amberley Publishing.
Printed in Great Britain.

CONTENTS

PREFACE

In December 1997, the unthinkable happened: Bass bought the premises of Ind Coope. The new owners then set about removing all traces of their once great rivals: anything gold and green was taken down, painted over or disposed of. Offices, cupboards, desks and filing cabinets were cleared, and important historical items were thrown into skips. Much was lost, but thankfully not everything. People such as John Webster, my Dad, witnessed this and intervened. He managed to save a near-complete collection of the company magazines *The Red Hand* and *Burton Herald* and was given permission by his supervisor to take them home – after all nobody else wanted them, least of all Bass! It was these magazines that first inspired this project in 2010, and therefore, I dedicate this book to my Dad.

What follows is an incomplete account of Ind Coope and Samuel Allsopp's breweries in Burton upon Trent from 1742 to 1997. Writing any history is fraught with problems, not least how to squeeze over 250 years into one book! Although carefully researched from the company archives held at the National Brewery Centre in Burton upon Trent, it is inevitable that this book contains some omissions and mistakes, for which I apologise; however, there will be a second edition at some point. If you are able to help with photographs, company documents, stories, beer mats, labels and other items of breweriana ... in fact anything related to Ind Coope and Samuel Allsopp, please get in touch at thehistoryofthehand@gmail.com or via the publisher, thank you.

Please note that although cursory mentions are made to Ind Coope at Romford and the other sites in Allied Breweries, this book predominantly concerns itself with the happenings in Burton-upon-Trent. The histories of these other breweries are outside of the scope of this book.

During the last five years, I have spoken to many people who worked at the brewery; their recollections have been crucial in telling the story and I have tried to include as many as possible. Interviews were often very funny and candid, I have compiled these tales in a chapter called simply 'Mischief', which I hope gives a unique insight into brewery life. I would like to thank everyone for their kindness and belief in this project.

This book would not exist without Vanessa Winstone at the National Brewery Centre, who arranged the access to the company archives and the reproduction of many images herein.

I would also like to express my gratitude to the following: Stephen Sinfield at the Burton Mail for additional research, proofing and support; Ray Anderson and Mike Brown at the Brewery History Society for saving the archive material from certain destruction; Roger Protz and Emma Porrett at CAMRA, Keith Osbourne for access to his collection of beer labels; Ronald Pattinson, Malcolm James, Terry Garner, Thomas Otho-Briggs, Arthur Roe, Kevin Slater and Chris Bowen for research materials, photographs and postcards; Joe Stamper for the brewery tour; Stuart Hunt for Photoshop duties; and my incidental models John, Maureen, Beth, Alex, Lew, James, Charlotte, Mark and Tim.

Finally, I would like to thank my family and friends for their support and especially my wife Netty for being behind me all the way.

Ian Webster, November 2015
thehistoryofthehand@gmail.com

CHAPTER 1

BENJAMIN WILSON (SNR)

In the Beginning ...

In January 1742, following the death of Mary Walker, the *Blue Stoops*, an inn on High Street, Burton upon Trent, was sold by her son to his brother-in-law, Benjamin Wilson (designated senior or Snr to distinguish him from his son, also Benjamin Wilson would take over the business).[1] The small brewery was positioned on the east side of the High Street with the River Trent and the Hay at the rear. Using current geography, it would have stood where Molson Coors UK Headquarters are.[2] Details about the early life of Wilson (Snr) are sparse; it is likely that he was born in the Derby area in either 1712 or 1713 and was a ropemaker. He married Hannah Walker, probably in 1736, the daughter of the late John Walker and Mary Walker. John had

Where it all began, the site of the Blue Stoops and latterly Allsopp's Old Brewery on the High Street, now home to Molson Coors offices (Annette Webster).

been the landlord of the *Blue Stoops*. As was common in those days, the inn had a small brewery attached and it was here that he learnt to brew, presumably from his unnamed brother-in-law.[1]

Two written accounts exist of Wilson (Snr) both in the 1853 book *Burton and Its Bitter Beer* by J. S. Bushnan. The first comes directly from the author himself:

> A man more competent than Benjamin Wilson cannot easily be imagined. With a mind form and disciplined, comprehensive in his views of business, and at the same time minutely careful in details, he was of a truly large spirit, yet a shrewd financier; the very soul of honour, and thorough man of business; a theorist, yet a practical man; a speculator, yet of caution bordering on closeness. True in friendships, exact in his engagements, simple in manners, hearty in feelings, amiable in demeanour, courteous in all communications, he never lost a friend or made an enemy; he extended his transactions without creating jealousy, and rendered every customer a warm partisan.[3]

From such a glowing and personal reference, you could be fooled into believing that the two were close friends. However, Bushnan wasn't born until 1807, seven years after Wilson (Snr) died, so they never actually met!

The second account comes from a man simply known as Dyche, described as a seventy-four-year-old[4] 'bright-eyed and brisk old fellow' whose father worked for Wilson (Snr). Dyche remembered him as 'a kind, hearty, portly, well-favoured old gentleman, somewhat peppery withal, but never angry without a cause, and always ready to reason with men'.[5] Unlike Bushnan, Dyche would have known Wilson (Snr) from an early age as he used to take his father's dinner to the brewery.[4] When asked about the formation of the business, Dyche said that 'the brewery was so old that no one ever heard of its having a beginning. The very land it stood upon was freehold; and that made it out to be older than the abbey'.[5]

There is confusion as to the date of the founding of the business; the date 1708 was quoted in various historical articles that appeared in the Ind Coope & Allsopp Ltd. (IC & A Ltd) company magazine *The Red Hand*[6,7,8] and had been incorrectly copied from there. The error crept in from the misinterpretation of a phrase in the 1798 book *History and Antiquities of Staffordshire* in *Burton and its Bitter Beer*.[9] The statement 'The first origin of this business here was about ninety years ago, and simply commenced with a few public-houses; and one Benjamin Prilson was the first who began ...'[10] was taken by Bushnan who wrongly concluded that 'Prilson' was a misspelling of 'Wilson'. It was a misspelling but of Benjamin Printon, who opened a brewery in 1708 in Horninglow Street.[11]

The actual date was 12 January 1742 when Wilson (Snr) paid his brother-in-law £164 for the *Blue Stoops* 'together with outhouses, brewhouses, barns and stables', which was detailed in deeds later held by Samuel Allsopp.[12]

Dyche's father worked for Wilson (Snr) as a sawyer for forty years, sawing up the timber that had been imported from the Baltic, into staves for casks.[5] He himself had been apprenticed under cooper John Hill.[4] Although Wilson (Snr) allowed his men to have ale, he did not permit drunkenness, so strong beer was not supplied. Wilson's men were described as 'wholesome fellows ... not bloated, big and "rotten," like London porter-brewers'.[4] Sawyers however had the reputation for being big drinkers, Dyche's father being no exception and was regularly fetched from the public house during busy times. Dyche himself was taken on as an apprentice by Wilson (Snr) at the age of fourteen, and he could earn up to £4 a week. Dyche's brothers also worked in the brewhouse, leaving in 1806 after the Napoleonic blockade meant there was no work.[4]

Following the opening of the Trent Navigation in 1712, Burton upon Trent found itself directly linked with the ports at Hull and Gainsborough and thereby with the ships that sailed to other English ports and more foreign climes. Wilson (Snr) built his business up between 1742 and 1750 with most of his beer going for export, and it seems likely that contacts made with Hull merchants during his former career as a ropemaker proved useful. By 1750, he was producing 1,000 barrels per annum and employed thirty men.[13] The business continued to grow

during the 1750s, enabling him not only to pay off his original mortgage on the *Blue Stoops* but also to expand with land and property in High Street, Horninglow Street and Winshill.[14]

During Wilson (Snr)'s time, the market in London was small. Brewers from Burton had to deal directly with wagoners, who would take the orders, transport the ale and guarantee the return of the barrels. The cost of doing this, along with the risks, meant that brewers sent 'only what they could spare'.[4] Burton Ale was only available in one house in London – *The Peacock* at Gray's Inn Lane. Bushnan neatly summarised the situation: 'nay, that even the Tsar Peter and his boorish nobility delighted in them long before either of our royal Georges had imbibed their fragrance at St James'.[15]

The Early Exports

An eyewitness account of an imperial banquet thrown by Tsar Peter and Empress Catherine shows the reverence in which English beer, which was in fact Wilson-brewed Burton Ale, was held in: 'As soon as one sits down, one is obliged to drink a cup of brandy, after which they ply you with great glasses of adulterated tokay and other vitiated wines, and between whiles a bumper of the strongest English beer!'[16]

Burton Ale had reached the height of Russian society by good fortune and trade. The need for hemp, flax and timber in the Burton area, all of which were being imported by Baltic captains, coupled with a lack of capital locally meant that Burton 'could only offer good ale in exchange, which being strong and sweet, as it was then the custom to brew it'. This ale 'greatly pleased the northern strangers. They soon came back for more', and so over time the market developed.[17]

An interesting snapshot of Wilson (Snr)'s business in the mid-1760s was quoted by Alfred Barnard in his *Noted Breweries of Great Britain and Ireland* (the name William Mornby is likely to be a misspelling of William Horner). It should be noted that Wilson seemed to be dealing not with the merchants at the Baltic ports, but rather the intermediaries at Hull and Gainsborough.

> ...in 1756 the account of Messrs. Blayden of Hull, from October to March was £373 9s 10d; and that of Messrs John and William Mornby of Gainsborough, for the same period, was £288 5s 10½d. In 1766 the account of Messrs Samuel Watson & Sons of Hull was settled by £655 0s 4d. Messrs George Storey & Co. £359 13s 3d; and Mr Robert Wilberforce, £428 13s 2d; which he paid in flax.[18]

Wilson (Snr) and his wife Hannah had eight children. Tragically, five of them died in childhood. Benjamin Wilson (Jnr), born on 10 May 1751, would take on the family business was his third son to bear that name.[19]

CHAPTER 2
BENJAMIN WILSON (JNR)

From Father to Son

In February 1773, Benjamin Wilson (Snr) had reached the grand age of sixty, and the running of the business passed to his three sons, John Walker, William and Benjamin Wilson (Jnr).[1] In 1774, John Walker sold his share to his brothers for £1,300 [2,3] due to a disagreement with Benjamin Wilson (Jnr) wanting to concentrate on the foreign trade and John Walker wanting to concentrate on the home market.[4] He founded a separate business as a brewer/timber merchant against his father's wishes. He set up a brewhouse, but 'he made no hand of it' and his brewery failed – the premises were purchased by Mr Evans and latterly by Mr Worthington. John Walker retired from brewing and founded the Burton Bank with Mr Dalrymple.[4] Four years later in April 1778, William also sold his share to Benjamin Wilson (Jnr) for £650.[5]

By all accounts, Wilson (Jnr) was an excellent businessman. The £1,000 mortgage on the brewery was paid off by 1778,[5] and when he sold the business to his nephew Samuel Allsopp in 1807, he was worth over £10,000.[6]

Wilson (Jnr) was cautious in business. Soon after buying out John Walker, he opened a third brewhouse at the *Blue Stoops*, as was shown in a letter from 12 January 1774:

> We have already two large brewhouses employ'd and about to use a third, the whole of which will take all the money I can raise with convenience to myself, beyond which I do not choose to go.[7,8]

It has particular historical interest as it details the importance of the Russian trade: 'With respect to the quantities of Ale likely to go to St Petersburg ... our orders for that place exceed 600 Hogsheads'.[9]

Another letter from 23 October 1773 to Mr John Daniel Newman and Co., St Petersburg, shows the manner in which the trade was carried out with Russia, both directly from the brewery and via intermediaries:

> ... that tho' many merchants in St Petersburg are supplied with Burton Ale from our House, yet there are many that we are not immediately connected with, their orders being principally transmitted thro' ye Houses of Hull and London, which may be called their representatives, and from who we receive the greatest share of our orders; but, as a foreign Connexion would. be equally acceptable when satisfactorily established, we should. consider it with equal attention and respect.[9]

In a bid to further his business, Wilson (Jnr) travelled to Danzig in 1776, the meeting of merchants face-to-face cementing business relationships and enabling him to gain further orders

in Poland and other provinces bordering the Baltic States. It was also around this time that the brewery began operating under the name Benjamin Wilson & Sons.[10] Other trading names such as Benjamin Wilson and Co. and Wilson Bros were used.[11]

The First Expansion

Until 1790, brewing took place exclusively at the *Blue Stoops*; then in January of that year, he purchased Samuel Sketchley's brewery on the north side of Horninglow Street (this is still standing, and it now called 'The Malthouse'). This comprised of a dwelling house, a brewhouse, store rooms, Coopers' Shops, stables and maltings. This raised his capacity to 4,500 barrels a year, a figure that he reached in the 1791/92 season and was managed by William Wilson. Even with this increase, the success of his business meant that he found himself unable to fulfil all of his orders at particularly busy times. He had a capacity of around 500 barrels per month of the brewing season, which usually stretched from October to April.[6]

One year St Petersburg alone ordered in excess of 600 Hogsheads (1,200 barrels). He resorted to leasing Malthouses, even going as far as buying ale from other brewers to fulfil orders in 1785 and 1791.[12]

Brewing in the Late 1700s

Modern brewing is an exact science, but back in the late 1700s, even an experienced brewer such as Wilson (Jnr), using the highest quality materials, struggled to create a consistent product from one season to another. Brewing was very much at the mercy of the weather, especially in the autumn and spring, and a particularly mild spell during the winter could lead to the suspension of brewing due to concerns of temperature control during malting and fermentation.[12]

The key to producing excellent ale was using excellent raw materials. Wilson (Jnr) kept a tight rein on the malting process, buying the best-quality barley grown on light sandy, loamy or chalky soils, with a 'mealy' character that was high in starch content and low in nitrogen. Most came from farms in Lincolnshire, Nottinghamshire and East Anglia and closer to home Ibstock, Smisby and Ticknall. Unsurprisingly, as his business grew, he looked further afield for his supplies. The price of barley fluctuated from year to year depending on the quality of the harvest, and this had a direct effect on the price of his ale. He also had to contend with Malt Tax that rose fourfold from 1s 4½d per bushel in 1780 to 4s 5¾d in 1803. Wilson (Jnr) was a canny business man and would buy malt when the prices were low and keep it in storage.[13]

Another raw material that fluctuated in price was hops. In 1800, the weather was very wet with high winds, leading to a poor harvest and prices that were raised threefold. He bought his Kent hops from merchants in Southwark such as Sir William Shakespeare and Sir James Sanderson and North Clay hops from Nottinghamshire Flower, Ellis & Co.[14]

Polish and Russian timber was in constant demand for casks. He would store timber at Gainsborough. Other materials such as iron hoops came from local suppliers; coal camel from Swadlincote, Newhall, Stanton and Ripley; and coke from north Derbyshire.[15]

A note from his brewing book dated 31 August 1791 showed how forward-thinking Wilson (Jnr) was. He lamented that 'every part of the business is done with hand pail, from drawing off the mash to filling the casks for exportation', and he yearned for 'the aid of machinery to save great expense'.[16]

From Burton to the Baltic

Wilson (Jnr) was the most successful Burton brewer of his time. In 1795, he made £506 15s 4d. This increased to £2,762 3s 0d the following year and £3,075 3s 7¾d in 1799.[17]

The ale made the 150-mile trip from Burton to Hull by canal and river, with delays due to frosts and floods meaning the ale could miss the boat. Henshall & Co. and John Smith of Gainsborough were used to transport his goods. When in Hull, Wilson (Jnr) used any number of shipping agents, the largest boasting offices and warehouses on the High Street. He owned a one-third share in two ships: *Humber* and *Porter* and also used other ships. Exports from eighteenth-century England were of less importance than imports, which meant that the imports paid the majority of the shipping costs. Beer was seen almost as ballast, meaning that exporting beer was cheap and a highly profitable business.[18]

The political climate had a great bearing on costs. Before 1775, most exports went to St Petersburg, and contacts in Danzig were established soon after – one Frederick William von Ankum remained a customer for twenty years. Russian aggression in Poland and the Crimea leads to deterioration in Anglo-Russian relations, so the amount of ale sent to merchants in Danzig and Elbing slowly increased. Tariffs rose by as much as 300 per cent for English ale imported via St Petersburg, and by 1787, orders had all but dried up.[19] Despite her great fondness for Burton Ale, Empress Catherine could not prevent the tariff that was to 'protect the agriculture of the Russian empire, and to protect the native brewing of very bad black beer'.[20] Trade between the two countries ceased completely in 1800 when an embargo was placed on all English ships and merchandise.[21]

Orders were won at home, mainly in London and Liverpool, but generally, the brewery was running well below capacity and large amounts of capital were tied up in casks. The year ending April 1795 was particularly hard, although trade picked up again via Danzig and Elbing later that year.[22]

The threat of war with France between 1793 and 1806 made shipping more dangerous: travelling by convoy, with an associated increase in costs, became the norm. Trade, and indeed an important chapter in the history of the Burton brewing industry, ended abruptly following the Berlin and Milan Decrees of 1806/07 and the Orders of Council, which was passed in reprisal. A mere 200 barrels was sent via Hull in 1806–07, and this was bound for London.[22]

Due to the highly profitable nature of the export market to the Baltic, sales to other areas were small: some ale was exported to Portugal, Italy and Ireland and via London and Liverpool merchants to West Indies and Southern Europe. Locally, ale was supplied in Burton and the surrounding area and to Bristol, Oxford, Norwich and even Edinburgh, but in comparison with the Baltic export market, it was laborious and far less profitable. Wilson (jr.) was a merchant brewer who also traded in other commodities such as timber; he'd save the best Stettin staves for himself and sell on the lower-quality Danzig Crown Pipe and brack staves. He also dabbled in tallow, wheat, hemp and flax. He was a partner in the Alrewas Cotton Mill and became chief buyer of raw cotton. In 1801, he made almost as much profit from this as he did brewing. He was also involved in short-term share transactions and long-term loans, looking to maximise on his excess capital.[23]

Introducing Samuel

Wilson (Jnr) was a wealthy bachelor and therefore had no heir. His sister Ann had married a Derby gentleman, James Allsopp, in 1778. Samuel Allsopp was their eldest son, born on 12 August 1780 in Burton upon Trent. He married Frances Fowler, and they had four children: Charles James (1805–44), Frances (1807–48), William (1809–15) and Henry (1811–87).[24]

Samuel was taken into the family business in 1800, and when Wilson retired in 1807 at the age of fifty-six, he sold the business now situated in High Street and Horninglow Street to Samuel for £7,000; however, he left £4,250 in the business on the understanding that he receive 5 per cent interest per year.[25]

CHAPTER 3

SAMUEL ALLSOPP

'A hard time he had of it ...'

Despite Wilson (Jnr) only having a financial interest in the business, the brewery was renamed Wilson-Allsopp, indicating the clout of his name.[1] So well known was he that letters addressed simply 'Herr Benjamin Wilson, England' would make their way correctly from Russian and Baltic merchants.[2] When Samuel Allsopp bought the family business off his uncle in 1807, economic conditions were far from promising or, as Bushnan put it, 'a hard time he had of it'.[3] The Berlin and Milan decrees of Napoleon that removed the lucrative Baltic market had been so abrupt that Samuel's brother Thomas, who was in Hamburg on business, was urged by the local merchants to flee. He exited the city through one gate as the French Army entered through another, escaping by a matter of minutes.[4]

The blockade forced twenty-seven-year-old Allsopp to search for fresh markets to sell his ale. He made an attempt to export in 1807; some reached their destination, but many cargos were seized, leaving problems with compensation claims from underwriters.[5] Another account states that in 1807 'he had scarcely an order for a cask of ale!'[4]

The years between 1806 and 1814 saw the brewery 'rested on its oars'.[4] At no point between 1807 and 1811 did he sell more than 2,000 barrels per year.[6] Attempts were made to develop the home markets:[5] the three most obvious were London, where Burton Ale was a sought after

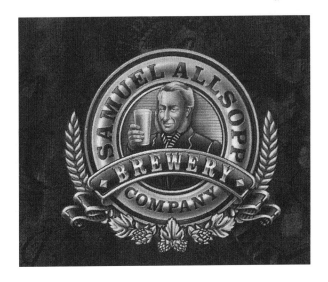

The logo of Samuel Allsopp Brewery Co. (1994–98) showing the likeness of Samuel Allsopp (National Brewery Centre).

commodity, South Lancashire and Birmingham.[5] Due to the increased transport costs, Burton Ale attracted a higher price than the local ale, so merchants pressured Allsopp to absorb the freight costs, he refused and cleverly entered into a price-fixing agreement with other Burton brewers.[7]

Tied houses, a fairly common practice in London, was a rarity in Burton, so Allsopp found himself having to sell to merchants and publicans over whom he had little power. He employed agents in London, Manchester, Liverpool, Hull and West Bromwich to look after his interests, and he began to diversify his beers to suit local tastes by changing the colour and flavour, leading him to brew Porter for the first time. The West Bromwich agency lasted only until 1808, abandoned due to poor sales and high rates of theft on the canal.[7]

The reorganisation of the business was a large undertaking: more customers meant more clerical work, and pilferage en route increased to the extent that Mr Cartmeal was employed to look after the large shipments to Manchester. It also became harder to plan the brewing program. His Baltic customers gave several months' notice of their orders, and English merchants and publicans gave little. Barley increased drastically in price. Wilson (Jne=r) had complained at paying 38s per quarter in the 1790s. Allsopp found himself paying up to 70s in 1813. Staves were also in short supply.[6]

A Brief Respite

When Wilson (Jnr) died in March 1812, the business passed solely into the hands of the Allsopp family.[1] By 1814, the political situation had changed for the better. Samuel's brother Thomas was dispatched to Danzig in an attempt to secure orders from former customers. At the end of the war in 1815, the blockade was lifted and the Baltic trade was revived. There was even a brief resumption of trade with Russia between 1820 and 1822, but harsh tariffs on English imports and the development of the Baltic's own brewing industry meant that by 1825 it was all but over.[8] In the years of the blockade, tastes had changed and the once lucrative markets had all but dried up. Even the Polish nobility, once great Burton Ale drinkers, had either been destroyed or scattered by the war. In 1820, an order from Thomson, Bonor and Co. of St Petersburg for 500 barrels was received. This was duly dispatched, and Samuel Allsopp travelled expectantly to St Petersburg, Moscow and all the Russian ports. He returned with orders and promptly set about brewing. The name of Wilson-Allsopp still stood for quality, and Russian merchants would not buy beer from anyone else. In a cruel twist of fate, a high import duty was slapped on all English ale in 1822 (except for porter, which could not be made in Russia). Allsopp found himself in possession of stock and no one to buy it. Futile attempts were made to lobby Parliament to act; Lord Liverpool was particularly apathetic to Allsopp's plight. Thomas Allsopp was duly dispatched on a tour of the United Kingdom and was very successful in his attempts.[9]

Between 1822 and 1826, Allsopp sent ale to 346 London customers – 234 in Liverpool and 128 in Manchester. Advertisements such as the following were used to drum up interest, presumably to sell the unwanted Russian beer.[8]

> In consequence of the sudden prohibitory measures adopted by the Russian Government, affecting various exports from Great Britain, Wilson and Allsopp of Burton-upon-Trent will directly offer to the public a quantity of rich pale and fine-flavoured Ale, of uncommon strength, brewed expressly for that market, at the reduced price of ⅔d. per gallon, at Burton (from whence there is a water conveyance to every part of the kingdom) in casks of about forty gallons each... It is too well known to comment that the ale from this Brewery has stood pre-eminent and unrivalled in the Baltic market for the last forty years.[10]

'Burton Ale Houses' began to appear in London. No longer confined to *The Peacock* in Gray's Lane, places like the *Offley's*, run by Mr Offley, or the house in the court opposite Bow Street in Cheapside could deliver a 'nip of Burton'. Burton Ale became fashionable, although to many it

was 'too heady, too sweet, and too glutinous, if not too strong'. The ale 'was so rich and luscious, that if a little were spilled on a table the glass would stick to it', leading to the rumour that Burton Ale contained honey.[11] It was a drink to be savoured but not for everyday consumption.

'Is this the Indian beer? I can brew it.'

1822 was a significant year in the history of the brewery as it was when Samuel Allsopp dined with Mr Marjoribanks (pronounced Marchbanks), an East Indian Director. The events of that night were recorded in precise detail by Bushnan; however, as this was some thirty-one years after the event, and at best a second-hand account (the likely teller appears to be Allsopp's Head Maltster Job Goodhead), the fine detail of the tale may well have been embellished. But no account of the history of Samuel Allsopp would be complete without it, so it is quoted here in full:

> Mr. Allsopp, though a man of high courage, and with a spirit as stanch as ever warmed the breast of a true English gentleman, felt, nevertheless, somewhat daunted by the sudden obstacles that had risen in his path. While in this frame of mind he went to London early in the year 1822, intent, as we have before mentioned, on the advancement of his trade in the metropolitan districts, and with the object of introducing the new ale which he was then contemplating, first in the northern districts, and afterwards generally throughout England.
>
> It happened at this time, that dining with an East Indian Director, Mr Marjoribanks, in the course of conversation he happened to make some remark on the late occurrences in Russia, the neglect of his remonstrances by the government, and the gloomy prospects of his house from the loss of their European trade.
>
> 'But why not, Allsopp,' observed Mr Marjoribanks, 'leave the cold climates, and try the warmer regions of the earth? Why do you not make an attempt on the Indian market?'
>
> 'I never heard of it.'

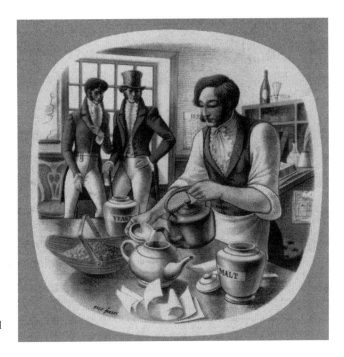

Job Goodhead brewing the first Allsopp IPA in a teapot (National Brewery Centre).

'There are 5,000 hogsheads of English beer sent to Madras and Bengal every year; and, what is more to your purpose, it is a trade that can never be lost; for the climate is too hot for brewing, unless at a distance so great that the carriage must eat up all the profits; and no tariff can ever affect you. We are all now dependent upon Hodgson, who has given offence to most of our merchants in India. But your Burton ale, so strong and sweet, will not suit our market.'

Here Mr Marjoribanks rang the bell, and directed his butler to bring in a bottle of Hodgson's ale, that had been to India and back. The butler poured out a glass for Mr Allsopp, who held it up to the light, and then, tasting it, exclaimed, 'Is this the Indian Beer? I can brew it.'

'If you can, it will be a fortune to you,' was Mr Marjoribank's reply.

On Mr Allsopp's return to Burton-on-Trent, sitting one morning in his counting-house, one of the men came to tell him, 'There's a hamper for you, sir, just come down by the mail from London.' On opening this it was found to contain a dozen of ale; and with some joke about 'coals to Newcastle' — 'a present of ale to Samuel Allsopp at Burton!' — he took up a bottle on which was written 'Hodgson's Indian beer.' Little did Mr Allsopp imagine that he had at that moment in his hand the key to a colossal business, and the foundation of the future great prosperity of Burton-upon-Trent.

Mr Marjoribanks recommendation, and the evident importance which that gentleman attached to it, by forwarding this sample, forcibly impressed the mind of the great brewer; so, setting aside the sample of malt which he was then carefully examining, he directed 'Job Goodhead' to be summoned.

Now this Job Goodhead was the maltster of the house; and though apprenticed to Mr Benjamin Wilson, in 1803, is still alive, as if to laugh to scorn what some have endeavoured to make out—the fatal consequences of drinking much Burton ale. Job Goodhead, too, is as hearty a fellow as any in Messrs Allsopp's employ, where he still fills his old post; and as he delights to tell the story:

'Job,' said Mr Allsopp, holding out to him a glass of the Indian beer, 'can you dry your malt that colour?'

'Yes, sir,' answered Job, at the same time tasting the beer, and sputtering it out fast, for Job was of the old school, and preferred his ale strong and sweet. 'But, sir,'—

'Never mind the taste, Job. Can you dry your malt to this colour?—are you sure?'

'Quite sure, sir.'

'Then do so.'

The great brewer and his hereditary maltster set to work at once; and the first specimen of the great pale ale and bitter beer trade of Burton, now extending to so many thousand hogsheads, was brewed in a teapot.[12]

Records indicate that Allsopp had already tried his hand at Pale Ale as early as 1808 while trying to break into the London and Liverpool markets. Allsopp wrote to his customers asking 'Whether Pale Ale or that of a darker colour is most liked with you?', and a letter from 21 January 1809 states, 'What regards the Quality of the Ale, I am confident no one can surpass it; the bitter I added with more Hops, expecting that it should be liked the better as it is in Liverpool, but I had rather give it less.'[13]

It seems highly unlikely that a brewer of such standing would not have heard of the Indian market and the teapot seems fanciful, but it's a great story – overstated or not!

The fall of Hodgson ...

British ale had been exported to India from the earliest years after colonisation, but it wasn't until the late eighteenth century that the amount became significant. In 1775, it was a mere 1,680 barrels, which increased to just over 9,000 in 1800 and 41,000 by 1817,[14] but none of this ale came from Burton. It was Hodgson who first had produced sparkling ale made from pale

malt, which not only survived the journey but also came into top condition during the trip, so it was Hodgson who invented what was to become known as India Pale Ale (IPA).

Hodgson appears to have fallen out of favour by attempting to fix the price of his ale and cornering the market. His misdemeanours are detailed in the 1822 *Circular on the Beer Trade in India*: Hodgson's ale was very much in demand, and by purposely ensuring an irregular supply, it was possible to guarantee a very high price. When other brewers attempted to export ale, Hodgson would purposely flood the market, driving down the price and causing his competitors to think twice about making additional shipments. With the market now his, he was able to command prices of 180 rupees per Hogshead, sometimes up to 200! The name Hodgson became of such high repute that retailers were reticent to buy anyone else's ale, as they would struggle to sell it.[15]

... And the rise of Allsopp

The first batch of IPA was produced in the October 1822 brewing season. It was a 'more bitter and less sickly ale' and reputedly first saw sale in Liverpool where there was a problem – it was undrinkable. Rather than the ale being returned to the brewery as bad, Allsopp himself travelled to Merseyside where he persuaded his customers to 'give it time to mend itself', with a promise to take back any that was damaged or unsellable. With the Wilson and Allsopp reputation on the line, the customers did as asked and the beer was allowed 'to ripen and improve' and became fit for consumption.[15]

Before Allsopp could begin his new export business, there were problems to overcome: the cost of freight from Burton to London was 60s per ton, three times that charged for the London to Calcutta journey. The inland journey was fraught with perils – theft was commonplace, particularly at locks. The casks were not of a size currently made by the brewery, so time and money was invested in producing strong 54-gallon casks. After arrival in London, the ale was loaded onto ships and sent to India, but even after all of this arduous journey, the fate of the ale resided with the 'tasters' who worked in the Indian ports. They had the power to accept or reject all beer arriving from England.[15]

In late 1822, the first consignment, totalling forty-five barrels, made its way to Calcutta. This was easily sold by local merchants and was proof enough that here was a new and highly profitable market. Production began in earnest in 1823, and by 1824, he exported almost 2,000 barrels via London and Liverpool, most of which was to end up in India and some in the West Indies.[16] This marked the end of fifteen frustrating years. Allsopp had managed to weather the storm, unlike many smaller Burton brewers. By the time of Allsopp's meeting with Marjoribanks, only five remained in Burton: Allsopp, Bass & Ratcliff, Thomas Salt & Co., William Worthington and John Sherratt.[17]

In 1824, Hodgson not only raised his prices but also started refusing credit, demanding cash even from his most trusted customers. He even started his own agency in India, hoping to become brewer, shipper, merchant and retailer. This leads to a backlash, and his customers started to look elsewhere. By the end of 1824, Allsopp was receiving letters from Calcutta praising the quality of his ale and requesting that more be sent. He responded by steadily increasing his exports. The year 1824 saw 109 Hogsheads leave from London and Liverpool, and 1825 saw 588 Hogsheads, twelve butts and ten-and-a-half casks to ports in both Calcutta and Bombay. A letter dated 12 October 1825 from Capt. Probyn stated that 'many who have long been in India, declared it to be preferable to any they had ever tasted in the East', and in his opinion, it surpassed the quality of Hodgson's.[18]

Allsopp's reputation for a reliable quality of ale and supply was beginning to be cemented, as can be seen in an 1825 letter from the heads of the Calcutta houses: 'We think we need not urge you to be cautious in sending us your very best ale, for we are sure you will do your best, for your own as well as our sakes, if you are desirous, as we believe you are, of fully introducing your ale, not only at this Presidency, but throughout the East Indies'.[19]

The manner in which Allsopp ale had, in four short seasons, established itself in East India against Hodgson is best shown by a rather short but telling entry from *The Calcutta Weekly Price Current* from 4 November 1826. This is especially notable because no other ales are mentioned:

Rupees
ALE – Hodgson,per hogshead 170
Allsopp's Burton, " 170[19]

Henry Allsopp in India

Just as Wilson (Snr) had taken Wilson (Jnr) into the company, who had in turn had taken in Samuel, in 1830 it was the turn of Henry Allsopp. Henry would later succeed his father and take the company to unimaginable heights, but at the tender age of nineteen or twenty, having received a commercial education in the house of Messrs. Gladstone & Co. of Liverpool, he found himself in India, where he opened Agencies and established the family business even further. His reward when he returned home was a partnership in the firm.[20]

A letter dated 12 November 1828 to Henry from Mr Lyon in Calcutta advised that beer be shipped from England in late October or November, so that it would arrive in thirsty India in March or April: 'it is our hottest season, and the quantity of Beer then consumed is tremendous,' Lyon explained. 'Your Beer is certainly a most delightful beverage during this hot season; it is

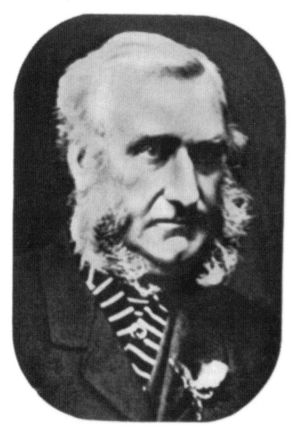

Sir Henry Allsopp (1st Lord Hindlip, National Brewery Centre).

always cooled with saltpetre before it is frank; we can make it by this article as cold as ice'. Lyon's brother was a partner of Messrs Bass & Co., and he went on to explain that he had bought some of Bass's ale thinking it to be Allsopp's and then had problems selling it.[21]

IPA and other Burton brewers

Other Burton brewers were quick to exploit the IPA trade. Bass and Salt began production in 1823, and by the 1830s, Bass and Allsopp were sending approximately 6,000 barrels per year to Calcutta. Additional beer may also have been sent to other Indian ports. As the fortunes of the Burton brewers rose, Hodgson's fell. In 1832, Bass and Allsopp exported twice as much as Hodgson, and by 1840, between them they controlled the market. Despite the name of Samuel Allsopp being synonymous with IPA, Bass regularly exported more, but it is likely that his figures also included beer brewed by Worthington, Salt and other local brewers.[14]

But what was it that made Burton IPA more popular than the London brew? The answer lies in the local water supply, which proved excellent and unparalleled for the production of sparkling pale ale. It was this quality that would make Burton into the brewing capital of the world and draw other brewers to the town, including of course the Romford concern of Ind Coope & Co.

CHAPTER 4

SAMUEL ALLSOPP & SONS

Further Expansion

When exactly the brewery adopted the name Samuel Allsopp & Sons (SA&S) is unknown, but it seems likely that Charles James Allsopp (b. 1805) and Henry Allsopp (b. 1811) would have been taken into partnership at the age of twenty-one as Wilson (Jnr) had done with Samuel. This would date it to *c*. 1832 when Henry came of age. Bushnan claimed this happened in 1822, but this seems a little early.[1]

Between the years 1822 and 1839, the Burton brewing industry as a whole, and SA&S and Bass in particular, gained strength. Profits were reinvested, premises extended, new steam-powered equipment bought, and the first attempts at introducing science into brewing were made. The brewery was extended, and among the work two massive chimneys were built, which were to stand for ninety-seven years. At the base of one was buried an engraved sheet of glass and a bottle, the text read 'At fifty minutes past 7 o'clock in the morning of the 23 June 1843 the first brick of this chimney was laid … by Samuel Charles Allsopp, Esquire aged fifteen months. The adjoining bottle of ale was brewed at the time of his birth, 24 March 1842.'[2] The infant Samuel Charles was the son of Henry Allsopp.[3]

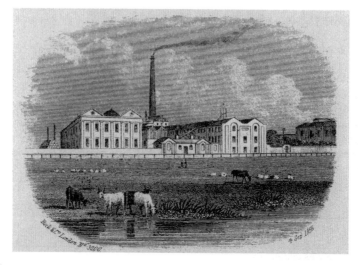

Allsopp's Old Brewery, 4 September 1856. (National Brewery Centre)

The Death of Samuel Allsopp

Samuel Allsopp would not live to enjoy this success. He died on 26 February 1838 aged fifty-seven.[4] Shortly before his passing, he, along with William Worthington, Thomas Webb and Michael Bass[5] were involved in bringing the railway to Burton upon Trent and therefore bringing the beer of Burton upon Trent to the entire world. The Birmingham & Derby Junction Railway opened in 1839 linking Burton to the ports at London and Liverpool. Beer that once travelled by canal at 60s per ton with a week's transit time now took twelve hours to get to London at a mere 15s.[4] (See Chapter Six – Delivering the Goods.)

Henry Takes Control

Samuel Allsopp left the company to his two sons Henry and Charles James, who carried on the Indian trade and further developed the home trade, empowered by the new railway system. Charles James died in 1845, aged around forty years old, and the ownership of the company passed solely to Henry. By 1844, Allsopp's had the lion's share of the Indian trade and they were unable to meet the demand for the home market, which led to the brewery being extended on High Street.[6] Henry took on partners, most likely Henry Townshend and Henry Blundell Leigh in the mid-1840s, along with a large injection of capital.[6,7] Two further partners Thomas Poyser and James Finlay were in place by 1854.[8]

Two fascinating documents have survived: a single volume from 1 October 1846 and another stretching to two volumes from 1 July 1854. Beautifully presented, they are inventories of the brewery and associated premises, most probably they date from when the new partners bought into the company.

In 1846, the High Street brewery comprised of two counting houses, strong room, a large private counting house with brewer's room on the upper floor, with cellars in the basement, and engine and boiler House with malt chamber over and mill room on the upper floor. There was a brewhouse with a large beer store, No. 1 tun room, No. 2 tun room, union cleansing room, middle tun room, pump tun room, principal tun room and a large running store with a cleansing room and a hop room. The spacious yard featured capital spring wells and was enclosed by folding carriage gates, with a side gate to High Street. There was a cask inspector's office, carpenters' shop, allowance room, blacksmiths' shop and a three-bedroom family residence for brewer and manager.[7]

On Horninglow Street (later known as the Middle Yard) there was a family residence for Henry Allsopp with servants' quarters and gardens, a newly erected malting house, the middle floor for malt and barley, a barley steep on the ground floor, a drying kiln, counting house, malting house, three malting houses used for storing ale, a boiler and a cask steaming shed. There was also stabling for eight horses, a counting house with a paint shop above, a cooperage for thirty-four coopers, a saw pit, a Wheelwrights' shop and a spacious yard for casks. Another house, Trinity Court, was occupied by Mr Phillips.[7]

Eight years later the process was repeated in greater detail. At Horninglow Street little seemed to have changed. Ten malt houses in Brook Street, Park Street, Green Street, Anderstaff Lane and Horninglow Street were recorded. Office space for Henry Townshend and Thomas Poyser was listed, the latter living in a very large twenty-eight-room house on Horninglow Street owned by firm. The firm's agencies were listed as London, Liverpool, Manchester, Birmingham, Dudley and Derby. There were forty-seven horses, seven wagons, five carriages, eleven carts and thirty-one floats. The names of the horses were also given – ten were known as Gilbert! Ninety-four thousand casks ranging from butts to kils, with another 6,000 being built or repaired in the cooperage, these were designated as either export or stout casks (as in strong and not the drink, at the time Allsopp was dealing exclusively with IPA and Strong Ale).[8]

In 1851, the Allsopp family influence was still central to the running of the company. The Directors of SA&S were Henry Allsopp, Henry Townshend, Henry Blundell Leigh, James Finlay

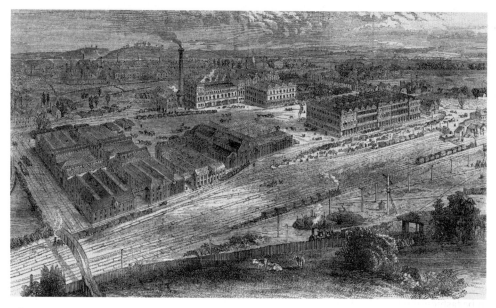

Allsopp's New Brewery from *The Illustrated London News*, 1 November 1862.

and Thomas Poyser. Although Henry was chairman at the monthly meetings until the 1870s, as time went on the hold exerted by the Allsopp family gradually waned. Now in his sixties, the company passed from Henry to Samuel Charles.[9]

Great advances in brewing occurred under Henry Allsopp, chemist. Dr Henry Böttinger, who had studied at the University of Giessen, was appointed as a scientific advisor in 1845. Allsopp's became the first brewery in Burton, and probably the world, to make such a move. Until this point brewing was not so much a science as an art form. Little was understood about the basic principles of fermentation and spoilage of beer, for example in 1835–36 nearly 10 per cent of exports to Calcutta were deemed damaged. The appointment was to prove a masterstroke, and to enable further experiments a model brewery was built and Böttinger was appointed Head Brewer in 1860 – a position he held until 1865. His successor was Dr Peter Griess who was known for his discovery of diazo-compounds. Henry offered him excellent facilities and allowed him to develop the Model Brewery. By the 1880s he had established quality control of raw materials and improved the efficiency of the brewery. One of the major advances was all-year brewing, which was established at Allsopp's and the other large Burton breweries by the mid-1880s. This was brought about by advances in cooling techniques and allowed the brewing of lighter ales.[9]

Henry, like many of the other Burton brewers, was also involved in politics: he was MP for Worcestershire from 1874 to 1880 and was created a Baronet in 1882. He was raised to peerage (or 'Beerage' to coin popular 1880s slang) in 1886 as Lord Hindlip of Hindlip and Alsop-en-le-Dale, he held this title until his death the following year, after which it passed to his son Samuel Charles (2nd Lord Hindlip).[9]

Allsopp's New Brewery

As the business grew, the current premises on High Street became unable to meet demand. Seven maltings were built at the Moor Mill Dam,[10] this was soon followed by one of the finest buildings in the history of the town: Allsopp's New Brewery. Constructed between 1859 and 1860, with

additional work in 1867 and was designed by architects Hunt and Stephenson of Westminster with Robert Davison[11], it had 'a greater capacity than those of any single brewery in England'.[12] The Offices were situated at the front, directly onto Station Street, with the Brewery behind.[11] Early drawings show an elevated section over the main doorway of the offices, a second storey was added c. 1895 by T. Lowe & Sons.[13] Part of the building was demolished in 1962 and the Offices and Fermentation Block were Grade II listed in 1979.[11] Please see pages 22 to 23 for a more detailed description.

In May 1860 another branch line was constructed from the Midland Railway to the new brewery. The site was developed hand in hand with the railway, the new sidings extended alongside the Ale Loading Dock, with lifts that could raise eight casks a minute. One line went to Brook Street via the New Cooperage. When the casks had been cleaned/repaired they either went to the Racking Rooms at the new brewery or were transported to the old brewery. Between four and five miles of private railway were laid between 1864 and 1867.[14]

After the opening of the New Cooperage, the Old Cooperage became the area where new casks would be manufactured. It became the hub for many different tradesmen, from coopers to painters, blacksmiths, wheelwrights and bricklayers. Coal was also stored here in great amounts. Directly opposite stood the New Trinity Church, built with money from Henry Allsopp. Just behind this is an area of land called Church Croft, purchased in 1857. In the 1860s, this was developed into a timber yard: great stacks of Memel oak from the Baltic stood seasoning, waiting to be fashioned into casks. The railway crossed High Street and into the old brewery, where it was traversed by a metal footbridge that joined the brewhouse with the union rooms/racking rooms.[14]

Arctic Ale

In 1852, Admiral Sir Edward Belcher commanded what was to be the final and largest Admiralty expedition, to rescue Sir John Franklin who set out in 1845 to complete the charting of the Northwest Passage. Franklin had had two ships, HMS *Erebus* and HMS *Terror*. They sailed from Greenhithe, England, on 19 May 1845, wintering in 1845–46 on Beechey Island and then becoming trapped in the ice off King William Island in September 1846. Later reports show that Franklin died there on 11 June 1847, although the whereabouts of his grave remain unknown.[15] The wreck of HMS *Erebus* was to remain hidden until September 2014.[16]

Among the supplies for Belcher's 1852 expedition was 540 gallons of Burton Ale, brewed by SA&S – a brew that would become synonymous with the journey and be known as 'Arctic Ale'. The birth of Arctic Ale appeared as a footnote in *Burton and its Bitter Beer* thus: 'In the spring of last year, 1852, the Lords of the Admiralty invited all the great brewers to send in samples of their ale for their Lordships to select that which should be provided for the Arctic Expedition. The invitation was generally responded to and the ales of Messrs Allsopp were chosen.'[17] The date of 1852 must have been a typographic as the ale was brewed towards the end of 1851. Arctic Ale would also feature in Sir Leopold McLintock's expedition in 1857 and again in 1875 when Sir George Nares asked for a similar beer to be supplied.[15] Director Mr Maxwell Todd described the original brewing process in an 1895 article:

> The special qualities which rendered this beer so valuable for the purposes of the expedition were its strength and nutritive qualities. It is one of the strongest ales ever brewed by Allsopp's, and it may be mentioned in passing that the consistency of the wort was such that it would not run from the copper through the tap in the ordinary way, but had to be lifted out in buckets.[18]

The 1875 brew was sampled by Alfred Barnard in 1888 while visiting the laboratory of head chemist Dr Griess. Alas there were no remaining stocks of the 1852. Capt. Sir Edward Belcher described the ale as 'A most important and valuable aid' while commenting it could withstand temperatures of –42F before freezing!' Barnard recorded the ale as 'a nice brown colour, and of

a vinous, and at the same time, nutty flavour, and as sound as the day it was brewed'. He noted that although brewed at a high gravity, there was a lot of unfermented extract, which meant it was around 9 per cent alcohol by volume, meaning it was a 'valuable and nourishing food'.[19]

Two further accounts exist describing the ale, one from the 1895 Maxwell Todd article:

> Allsopp's have only at the present time eleven bottles of this beer left. It has been re-corked, as if it were Waterloo port. It is almost 'still' and, indeed, has never been very effervescent, although not at all flat. Its colour is a rich brown, and its flavour is suggestive of old Madeira. It is to-day as sound as on the day of its birth twenty years ago.[18]

A much later analysis was published in the *Journal of the Institute of Brewing* in 1961. Among the figures obtained were the following: present gravity 1053.4°, original gravity 1126.4°, alcohol (v/v) 9.55% and colour (EBC) 156°.[20] A sample of the ale was analysed in 2010, at the request of Chris Bowen, which confirmed the durability of this unique brew (*see pages 109 to 111 for a more detailed description*).

As befitted an ale famed for its keeping qualities, it would continue being produced into the 1970s. A letter from December 1896 sent to Allsopp's customers sought pre-orders for the 1897 brewing, described as a 'Strong Ale (similar to that brewed by Allsopps for the English Arctic Expedition of 1875)' that 'improves year by year, and therefore quick consumption is unnecessary'. The ale was available in barrel at £5 (not including the cask) and in bottle at 7s per dozen pints and 4s per dozen half pints.[21] Records exist of a 1937 brew, and it was certainly produced in the 1950s,[22] where it was advertised with the strapline 'Keeps out the cold.'[23]

'Arctic Ale used to be stored in barrels for a year,' explains Head Brewer David Platt. 'We'd brew one winter and bottle the next winter.'

The name changed in 1956 to Arctic Barley Wine[22] and finally in 1970 to Triple 'A'.[24] 'Triple A stood for Allsopp's Arctic Ale,' reveals Platt. 'It had been reformulated and it wasn't the product it used to be. I think it was 1079 whereas Arctic Ale was 1082 or 1084.'

The Red Hand

SA&S registered a series of trademarks on 29 February 1876,[25] all depicting an open right Red Hand. The mark had been in use since 1862.[26] Three of these, Nos 2,945, 2,949 and 2,950, were maintained by Carlsberg UK until 2002 and are now covered by a newer trademark. The open hand was a very common sign at inns, indicating that their ale was in good condition.[25] The hand went through a number of modifications over the years and was adopted as the trademark of the joint company IC&A Ltd in 1934.

The Visit of Alfred Barnard

In 1888, Mr Alfred Barnard toured the brewery (he would also visit Ind Coope & Co. too) while researching his four-volume epic *The Noted Breweries of Great Britain and Ireland*. In historical terms Barnard ranks as the most important visitor to the breweries. Although both the breweries would entertain royalty, for the meticulous detail (machinery, room dimensions, etc.) in his accounts and the beautiful engravings, Barnard trumps them all. Like many brewery histories, this book is heavily indebted to this gentleman, but rather than quote him at length the reader is encouraged to seek out these books for further reading.

Barnard followed the brewing process from beginning to end. He was met by director Mr Poyser and superintendent Mr Grinling at the new brewery and given a brief history of the place, then with a letter of introduction in and he set off for the Shobnall Maltings, of which there were four buildings in two pairs, with a barley floor spanning each and three malting

floors. There was also a well house, water tower and engine house on site. The maltings were serviced by a loop line from the L&NW Railways to enable the malt to be transported to the brewery. The area covered seventy acres, which dwarfed the twenty-three acres of the Ind Coope site, and had a park and a well that supplied brewing water. This was transported to the brewery by means of a large pipe. There were three additional malting blocks on the new brewery site.[19]

Barnard followed the journey of the malt to the new brewery on Station Street, where it was lifted to the mill room on the top floor, after which it fed the mash tuns below. Two massive water tanks, one for brewing and the other for washing, were at the north end. The floor below contained eight mash tuns made of English oak and able to process 4,000 qu of malt per week. The coppers had a capacity of half a million gallons per week and were built so the hops could easily be added. Two Blackman's air propellers kept the place 'cool and entirely free from steam' and it was noted that the workers wore white flannels that were supplied and washed by the company. The wort then flowed into either Morton's or Helical circular refrigerators and when cooled it was pumped into the rounds room and the yeast pitched. After partial fermentation it was transferred to the unions, which were capable of processing 263,088 gallons at any one time. A second union room was accessed by an iron bridge; the racking room below measured nearly 400-feet long and over 100-feet wide. A second racking room was in the new brewery. Up to 20,000 casks were examined, smelled, filled, hopped and corked each week. The model brewery was also housed in the new brewery and was a completely separate operation except for water and power.[19]

The old brewery covered three acres and despite the name it had been constantly modernised, the last time being 1887. Barnard entered by the iron gates on High Street and into the brewhouse on the left where he met Head Brewer Mr Martin. The layout was very similar to the new brewery; the top floor housed the malt receiving room, the mill room and the coppers. Below the mash tuns and Hop-back and on the ground floor were the fermenters. There were four union rooms with a racking room below. After racking, the casks were taken to the new brewery for storage in the ale stores. A sample from each cask was stored in case of a customer complaint, this coming under the jurisdiction of Head Chemist Dr Griess. In the laboratory samples of water, malt and yeast were also tested. It was while in the company of Dr Griess that Barnard sampled the 1875 brewing of Arctic Ale.[19]

The new brewery cooperage extended from Station Street to Brook Street, covering six acres, and was home to massive stacks of casks – up to 100,000. Barnard then went to the old cooperage in Middle Yard and also saw the saw mill, turnery and stables. The offices were inspected as well as the strong rooms, which housed old ledgers and letters from the earliest days of the company. Barnard also visited the hop stores and clock tower and was particularly interested in the machinery.[19]

Money!

By 1886 the decision was made to float the company on the stock market; the asking price was £3.3 million (remember this is the 1886 price, the approximate current value would be £330 million). A document entitled Memorandum as to Division of Purchase Money dated 31 December 1886 shows how the money from the formation of the limited company was to be distributed. Firstly £1.39 million in cash was split between the nine partners, then other payments were made: Henry Allsopp £289,430; and compensation was paid to Mr Grinling and various other monies went to relatives of deceased partners, bringing the total to £2.2 million. The goodwill was also distributed meaning that that the shareholders were paid the following totals in cash and shares (all figures to the nearest thousand):

Henry Townshend £653,000, Samuel Charles Allsopp £481,000, R. C. Leigh £278,000, John Blundell Leigh £276,000, George Higginson Allsopp £259,000, Josiah Poyser £220,000, Alfred Percy Allsopp £180,000, James Young Stephen £145,000 and Alexander Finlay £169,000.[27]

The floatation of the company marked the end of an era and with it a change of fortunes.

CHAPTER 5

SAMUEL ALLSOPP & SONS LTD

'Give Back the Money'

In February 1890 a scathing article about the fortunes of Samuel Allsopp & Sons Ltd appeared in London newspaper *The Standard*.[1] The chairman Samuel Charles Allsopp (2nd Lord Hindlip) responded in two ways: he threatened to sue for libel[2] and he arranged a special meeting of Ordinary and Preference shareholders. It was a lively affair; the meeting room was packed and the directors were hissed at, which was a departure from the optimism felt only three years before.

In February 1887, probably buoyed on by the recent success of Guinness's Brewery Co., SA&S Ltd had been offered for sale at £3.3 million and the public response was incredible. Rumours were that between 35,000 and 38,000[3,4] applicants had offered over £100,000,000, with pledges from Dundee alone being enough to float the company. Although many prospectuses had already been sent by mail,[5] the temporary offices at No. 5 Angel Court, Throgmorton

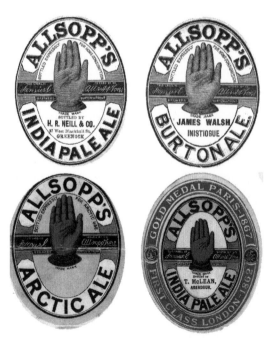

Allsopp's beer labels. Top row, *c.* 1884, bottom row post-1887 (Keith Osbourne).

Street were besieged and thirty to forty constables had to keep order while 25,000 prospectuses were given out. The document was written to show that the company was progressive, with average annual profits (of an impressive £229,826) for 1884–86. The estimated value of the company comprised of tangible assets (premises, machinery, fixed plant, raw materials, ale, casks, staves, drays, recoverable debts, etc.) and goodwill.[6] The goodwill figure of £1.1 million would later be brought into question and lead to accusations that the company was sold for more than it was worth.[7]

In the early days, Ordinary Shares rose by 80 per cent, but by March 1887 they began to slide. The first half-year profits in August 1887 were a disappointing – £97,337 – although this was in part blamed on the extremely bad weather conditions seen that year; Henry Townsend remarked that he'd never experienced such a trying season in forty years.[8]

In 1888 the profit was £176,000 (£53,000 less than the three years before flotation) and sales had dropped by 7½ per cent. This was blamed on increased competition and 'the evil system of tied houses' – SA&S Ltd like many, Burton brewers did not own any tied premises[9] and the company was reluctant to enter the market, envisaging that the high prices currently being paid for tied houses would cause the system to collapse. It was also noted that some customers had either been overlooked or not treated well during the share allocation.[10]

July 1889 saw the resignation of three members of the Executive Board: Mr Grinling, Mr Poyser and secretary Mr Ogden. These were replaced by head brewer Mr Joseph Stirk, agency manager Mr Auty and secretary Mr Maxwell Todd.[11] Grinling and Poyser's resignations were explained away due to advanced age and length of service respectively. The profits were similar to the previous year, the reason given that the large Porter breweries were now producing similar products to SA&S Ltd, and that after dismissing the whole tied house system only a year ago, they had started to buy properties at vastly inflated prices.[12]

When Samuel Charles Allsopp stood up to speak on that fateful Friday in February 1890 he had many questions to answer. With the words of *The Standard* article still fresh, he started thus: 'This meeting has been called by me personally, and not by the company, in consequence of certain statements which have appeared in the newspapers ... I can explain the reason for the depreciation in shares, and can answer any questions you may like to put.'[13]

In the face of hissing and booing Hindlip was resolute that he and the directors were 'prepared to stand by every word' of the prospectus.[13] He then revealed that though he, Henry Townsend, George Allsopp and Percy Allsopp still held the bulk of their ordinary shares and approximately £150,000 of their debenture and preference stock had been sold to fund the purchase of tied houses.

A consignment of unsatisfactory foreign barley was partly blamed, as was the new Beer Duty. Hindlip finally agreed to the formation of a Committee of Inquiry.[13] A representative of the accountants then spoke and like Hindlip stood his ground saying he would change 'not a syllable, nor a figure' of the report.

Various shareholders then spoke, It was then pointed out that the Chairman and his family had received £1.1 million in goodwill and then a list was read out of share allotments to staff at the London and Westminster Bank, which were given in preference to Allsopp's customers. No wonder some were declaring that 'they would never sell another drop of "Allsopp"'.[14]

The Committee of Inquiry was elected a month later and given the mandate to inquire if the statements in the prospectus were true and to investigate the management of the company since launch. If the prospectus was true it meant that the company had been 'woefully mismanaged'.[14]

The committee reported back in June and found that the accounts for 30 August 1882 to 31 December 1886 and 1 January 1887 to 31 December 1889 were accurate and the value of the assets of the company also to be true. They noted a decrease of 21 per cent in sales, 17½ per cent in gross profits and 23½ per cent net, the reason being the company had given virtual control of the share allotment to the London and Westminster Bank, thereby committing 'a very grave and serious error in judgement, giving great offense to trade customers, to whom a very disappointing proportion of shares was allocated'.[15] Even the committee itself came under

criticism for not being large enough or as thorough as they might. The position was neatly summed up by *The Standard*:

> The history of Allsopp's Brewery Shares has been that of a thoroughly unstable and treacherous security ... It is plain that an unhappy and disastrous mistake has been made somewhere ... The statements in the Prospectus were, in plain words, not true ... All the facts could not have been disclosed ... Either Messrs Allsopp were themselves deceived about what money they had been making, or they kept part of the truth back ... Had the time not been smartly chosen and the 'profits' deftly set out to catch the eye there would have been no rush. Messrs Allsopp would have been allowed to keep their dwindling business to themselves ... They must give back the money, and cancel the bargain.[16]

Hindlip's Response

By mid-1890 Samuel Charles Allsopp's had sold his ordinary shares[17] and proceeded to resign as chairman in October 1890, thus withdrawing completely from the company. He was replaced by Mr Grenfell.[18] *The Pall Mall Gazette* printed a scathing piece about his actions:

> It cannot be said that Lord Hindlip's resignation... is a very chivalrous step, seeing that the business with which his name is so closely identified is in serious trouble. It is natural, of course, to the man who takes his responsibilities lightly to get out of a position which leaves him open to easy attack: but there are those who would have faced all the disagreeableness in order to pull the thing through. The shareholders, however, have this consolation, that the business may go better under a new head: certainly it cannot go much worse.[19]

At the 1891 AGM, shareholders bitterly accused Hindlip of 'leaving the sinking ship'[20] and there was call for a new board containing 'No Allsopps!'[20] Along with Hindlip, Mr Townshend, Mr Dobree and Mr Stirk had all tended their resignation in the previous twelve months.[21] The problems facing the company stemmed from the amount of capital expended the previous three years buying tied houses. In early 1888, purchases were a mere £8,000. In December it shot up to £74,000, June 1889 £130,000, December 1889 £195,000, June 1890 £325,000 and December 1889 £463,000. Add to this a problem with the brewing process, beer returns were high. As one shareholder succinctly put it, 'they were not producing the proper article'.[20] One of the answers was to sack the head brewer[22] and by July 1892 a new one was instated who managed a remarkable turnaround in quality. If a quote from *The Money Market Review* was to be believed, 'the products of the firm are, without doubt, the best in the market'.[23]

Unfortunately the core problem remained that the shareholders had paid too much for a business that 'had begun to fall off before they had actually for possession of it'. Profits were falling by £30,000 per annum, and out of the original board only Percy Allsopp and George Allsopp remained – one shareholder dubbed it the 'Allsopp Fiasco', but there was worse to come ...[22]

'How A Million was Lost'

Mr Grenfell resigned as chairman in August 1894 on grounds of ill health and passed away the following March. The new chairman, Alfred Percy Allsopp, expressed his gratitude for his service, commenting that 'they had taken the best possible step' when appointing him.[24] Against all odds he had turned the company around, announcing not only a profit of £180,465 but now the shareholders were receiving dividends.[25]

At first the business grew under Percy Allsopp – 1895 and 1896 saw profits in the region of £189,000, 1897 £260,000 – so when a calm AGM was held in 1898 the previous twelve

months were described as the best in the history of the limited company. Beer returns were low, in fact their product was 'as near to perfection as possible'[26] and profits were a record £288,000. The SA&S Ltd executive-minute books showed a dramatic increase in expenditure from September 1896 onwards, for example the Pier Hotel in Eastbourne for £23,000 and the lease of the Royal Hotel in Sheffield for ten years at £6,000 etc.[27] Page after page of purchases and loans to publicans are detailed, but where was this extra money coming from? With no reserve fund, the company desperately needed a further injection of capital, taking them up to £3.3 million, to finance the spending of Percy Allsopp, who after the resignation of Maxwell Todd now had full control of the company. There were a few dissenting voices who accused him of buying houses 'left and right', but this was denied with the claim that 'they had carefully diagnosed each case, had rejected all which were not satisfactory'. Such was the success that the company were even looking at diversifying into a wines and spirits business.[28] Capital was raised, with 110,000 deferred ordinary shares at £10 each, and the public yet again bought them.[29]

In 1899 a delivery of twenty-six large, glass enamelled steel tanks arrived by rail all the way from the Pfaudier Vacuum Fermentation Co. of Rochester in New York, via Liverpool, destined for Allsopp's old brewery, and their purpose was to brew lager. The plant cost around £30,000 and was 'recognised to be the most up-to-date, complete and perfect in the kingdom.'[30]

Unlike the production of ales, the carbon dioxide given off during fermentation was reused to carbonate the lager, the whole fermentation process taking place in closed vessels. Much was made of the purity of lager; it was claimed that once the liquor enters the tanks it was untouched by human hand, with only sterile air entering. The plant was capable of brewing 50,000 to 60,000 barrels per annum.[30]

The venture was opened by Percy Allsopp on 18 October 1899, who gave a grandiose speech to the assembled throng of shareholders. The brewery, designed by a young Swedish Brewer E. M. Lundgren, would turn the fortunes of the company around.[31] However five months after this triumphant opening Percy Allsopp resigned, being temporarily replaced by his brother George.[32]

Percy's resignation on 1 March 1900 was initially reported as being 'on account of ill health',[33] but it wasn't long until the truth began to emerge. Initial reports were worrying but vague, with one statement in April 1900 declaring 'The Directors ... regret to state that some recent purchases and investments have not proved as satisfactory as was anticipated.'[32] This was an understatement. By the time of the August 1900 AGM, the full picture had emerged. The new director Mr C. J. Stewart, who had only been with the company a matter of months, had the unpleasant task of delivering the news that the position 'was a very critical one' and that despite the capital raised in the last two years they were 'urgently in need of funds', the reason being

The opening of Allsopp's Lager Brewery, 18 October 1899. W. B. Darley. (Terry Garner).

that Percy's investments had been unwise: 'Many of them were in channels which he suggested a brewery company should not go into, for example, the wine business, casinos, halls and so on'. Percy had spent £2 million in two years,[34] leaving the company with £1.5 million of debts and liabilities that needed immediate liquidation. Unsurprisingly the directors were criticised for leaving too much responsibility in his hands.[35]

Not only had Percy bought licensed premises at inflated prices with an 'almost feverish desire', his activities had adversely affected the market.[36] The losses for the Wine & Spirit businesses purchases were around 70 per cent and tied houses 25 per cent,[37] which equated to £1.67 million.[38] Comments such as 'insane financing that has wrought such havoc',[37] 'absolutely reckless' and 'no terms of censure are too strong to pass upon him'[38] appeared in the press. The company had no option but to try and write off £1.42 million[39] but were unsuccessful. The year 1902 saw profits fall £4,000 short of covering the interest on stocks and loans;[40] they limped on until the 1904 AGM when 'there was a large attendance of disappointed and disconcerted shareholders, who grumbled long and loudly'. In seventeen years the company had lost £4 million[41] and there had been no dividend paid for four years. To rub salt in the wound, while profits from brewing had declined from £152,966 in 1900 to £49,637 in 1904, directors and audit expenses had risen from £1,121 to £7,320 and pensions from £864 to £7,866. A thorough investigation was demanded by the shareholders.[42]

The report arrived some eighteen months later in August 1906 and appeared in the press as 'How a million was lost'. It read 'the company's misfortunes are due to causes, which, with good and careful management, should have been largely, if not altogether, averted.' It recommended no further reductions in capital but savings in expenditure and increased trade. Reductions needed to be made in pensions, directors' fees and head of departments' salaries. Advertising should also be reduced and systems improved.[43]

Unfounded amalgamation rumours had been appearing the press since 1902 and in April 1906 a 'Big Brewery Combine' of Allsopp's, Ind Coope and Thomas Salt was mooted.[44] However, later that year negotiations started with the Burton Brewery Co. and Thomas Salt[45] was to come under considerable criticism and by March 1907 the process had fallen through.[46]

George Allsopp died in 1907, the last remaining member of the family on the board. Hereafter, the company would continue without an Allsopp connection, ending an ownership of over 100 years.[47]

Turning the Corner?

'To put it mildly a company having such a burden could hardly be regarded as in a satisfactory position,'[48] said Mr Peter Remnant, the newly appointed chairman in 1907. The company had reported a loss of £72,294 and were burdened with £1.4 million in goodwill. His solution was simple: to 'get rid of all unremunerative and unprofitable investments'.[49] Within two years the £72,000 loss had been turned into £72,000 profit and in 1911 Allsopp's began to look seriously again at amalgamating with another brewery. Tentative negotiations took place with a number of firms, but an agreement could only be reached with one – Ind Coope and Co. Ltd.[50] The proposal seemed more beneficial than a scheme of reconstruction[51] and the first steps began in June to what was 'hoped to be a very large brewery combination'.[50] In the meantime Mr W. Gardiner Sinclair was appointed sole interim receiver and manager[52] and the process carried on. Winding up orders for both companies appeared before the court[53] but these were held off to allow the amalgamation to proceed. However a 'serious hitch'[54] was reported in May 1912 and by early June the 'proposed amalgamation ... had been dropped'[55] and rearrangement was opted for. The reasons for the choice were to 'avoid the sale of the company's valuable goodwill and to retain for the benefit of those interested the whole of the business ... a sale could only have been affected on disastrous terms, and amalgamation with any other company was next to impossible.'[56]

The Fall and Fall of Allsopp's Lager Brewery

In 1909, SA&S Ltd ran a competition for the best idea for advertising their lager, the prize was a Napier Landaulette motor car valued at £525[57] which was won by Mr W. Hunt Margetson of Balham.[58]

The rise of the Temperance Movement had become another demon of the brewing industry: Mr Sinclair commented, 'We have made up our minds to damn the Government regarding temperance.'[59] The losses of 1905 were blamed entirely on temperance.[60] Allsopp's Lager had long been advertised as a pure and lighter beverage, it was promoted as almost as a health drink.[61]

Conflicting reports exist about the lager market during the war years; one claimed it was still selling well in 1914[62] while another has it in decline, with the cold storage area given over to keeping food.[63] A major blow was dealt in July 1916 when a fire started in the central block of the Lager Brewery in the cold storage area[64] spreading to the main brewery destroying the upper portion. Damage was estimated at 'many thousands of pounds'.[65] A decision was made not to rebuild and the production was moved to Archibald Arrol & Son Ltd of Alloa, where Allsopp's Lager became Arrol's Lager and Calder's Lager, although the name was preserved for the export market. Arrol had recently become a subsidiary company of Allsopp thanks to the arrival of managing director John Joseph Calder in 1913.[63]

'Where have all the lager drinkers gone?' ran a headline in 1921. Allsopp's had just reported a divisible profit of £72,000 less than the previous year, which was blamed on 'a serious reduction in the consumption of lager beer. One important dealer in London had stated that the lager beer trade was absolutely killed'.[66] Production finally stopped later that year.[67]

In 1923/24 parts of the old brewery were leased out to Bass, their locomotives took hogsheads over High Street using Allsopp's private line. After unloading, they'd make their way back via the Hay Branch but in times of flooding when the Hay was impassable the trains would use Allsopp's line to the Saunders Branch. What a change from the early days of the railway when competition between breweries was fierce! Shoe manufacturers Eatoughs took over the union room in the 1920s, and prospered into the 1970s despite a fire in 1926. There was limited use of the brewhouse by Allsopp up until 1934 but after that the building fell into disuse and was eventually demolished, the two chimneys being felled in 1937.[63] The land was bought by Bass in 1979 who demolished the last remaining traces of the old brewery and built offices on the site.[68]

Rearrangement and Rebuilding

The newly reconstructed board met for the first time on 7 July 1913 comprised of Sir William Barclay Peat, John J. Calder, James Davenport, Peter Remnant and Percy Gates.[69]

'At that time, foolishness of previous directors had plunged that great company into liquidation and I was given the task of restoring its fortunes,' recollected Calder in 1959. 'Next door, only a wall between us, Ind Coope & Co. were also recovering from bankruptcy ...' On his first day in Burton he met with Ind Coope chairman Mr Louis Walker and on his second day he spoke out at a meeting at Bass and was invited to a private audience with Col Gretton who said to him, 'We have been associated with Allsopp's for over one hundred years and have always been on friendly terms and I should like you to come and see me at any time, Mr Calder, and discuss anything; it will always be a pleasure.'[70]

'Well I had a long task in front of me,' understated Calder. 'Because the managing director who had destroyed the business had tried to introduce Lager Beer instead of Burton Pale Ale and spent a fortune trying to restore it trying to make people drink Lager Beer. So there was nothing for it but to build up the business again.'[70]

Building up the business involved buying up struggling breweries for their tied estate, closing the brewery, their pubs then being supplied by excess capacity at Burton. 'The Combination

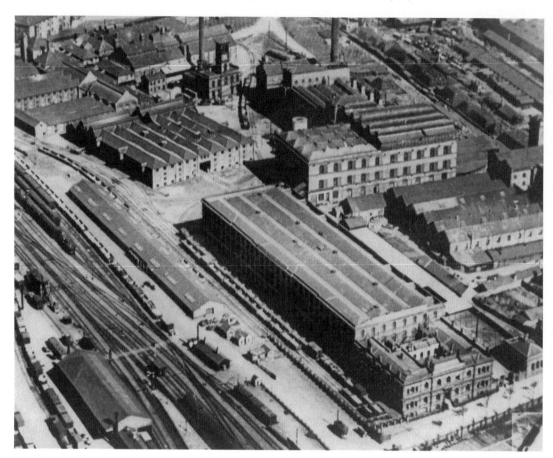

Allsopp's New Brewery, *c.* 1925. (Author's collection).

Principle' was becoming more common in the industry. By streamlining management, administration, buying powers and various departments it was hoped that more business could be secured.[71]

With £1,795,750 written off as 'capital lost or unrepresented by available assets', Allsopp's then made the move to increase the capital by £1,200,000[72] and attempts were made to get the company out of the hands of the receivers.[73]

The first brewery purchased by Allsopp's was Showells in Birmingham. Originally Mitchells and Butlers had been interested but when this fell through in December 1913 the way was clear for Allsopp.[74] Calder recalled, 'After very long negotiations, we added an extra seventy-thousand barrels to our turnover.[70]

The first AGM post-rearrangement was chaired by Sir William who said 'his colleagues were all practical businessmen and they relied very greatly upon their managing director (Mr Calder), who came from a family of brewers and distillers, and whose business experience could not but be spoken of in the highest terms'. He alluded to difficult times ahead but he hoped to 'blot out what had been said in the past – viz., that Allsopp's beers were not equal to those of their competitors'.[74] Progress was slow but steady; a profit of £31,825 was reported in 1915 with 2½ per cent interest paid on some of the stock, this rose in 1916 to £60,791, £127,165[75] in 1917 and £181,602 in 1918,[76] enabling the purchase of their second brewery the New Victoria Brewery in Plymouth in 1920. As the new decade dawned, the effect of high beer tax, which was ten times

the rate prior to the war,[77] had caused a countrywide decrease in barrelage[78] of 15 per cent, add to this the collapse of the lager beer trade in 1921[79] and profits took a downturn.

The years following 1921 were devoted to 'producing a pale ale not only as good as that of their competitors but one which they believed to be the best of its kind in the world'. The beer was first marketed in 1925 and was heavily advertised. Sir William told shareholders 'Demand Allsopp's pale ale in bottles, and see you get it.'[67]

Hall's Oxford Brewery was acquired in 1925 and ceased brewing in 1926,[67] and Stretton's Ales of Derby followed in 1928.[80] By 1930 controlling interests in the Lichfield Brewery Co. and Archibald Arrol & Sons Ltd had also been acquired.[68] In comparison to 1913 SA&S Ltd were in a strong position by 1934 and the business was now ready for the next step, which lay only the width of a brick wall away ...

CHAPTER 6

DELIVERING THE GOODS

The Coming of the Railways

When the Birmingham & Derby Junction Railway opened in 1839, it revolutionised the way that beer was transported. The railway passed Burton to the north-west, running almost parallel to the Moor Mill Dam. In 1847, this section of land had been purchased by Henry Allsopp and would be the site of Allsopp's new brewery. A small station was built at the end of Cat Street, soon renamed Station Street. Initially the traffic was light then in July 1840 the Midland Counties Railway opened. Suddenly there was competition, the route to London was shorter and therefore quicker and costs began to fall. The Birmingham & Derby Junction Railway, Midland Counties Railway and North Midland Railway amalgamated in July 1843 and by 1 July 1844 The Midland Railway began operating.[1]

Generally ale was loaded onto horse-drawn carts and floaters and taken to the station. Congestion became a problem; the streets were crowded from morning until night. Railway Acts were passed allowing the building of the Hay Branch, Guild Street Branch and a new Burton Bridge (locally known as the Trent Bridge), which eased the problem. A further act was passed in 1860 allowing Allsopp to build a private line connecting the new brewery with the old brewery and the Old Cooperage, the idea being that this would avoid using the Guild Street Branch and therefore payment to the Midland Railway, but the 1860 Act had a clause restricting through traffic, forcing Allsopp to use the Guild Street Branch.[1]

The Trent Bridge was opened by the Marquis of Anglesey on 22 June 1864 at a cost of £22,000. This then allowed the completion of the Hay Branch, which until then had stopped at Anderstaff Lane. Traffic on the Guild Street Branch was heavy, especially for SA&S transferring between the old and new brewery and Bass. This often meant that the line was impassable. SA&S therefore took to using their private line which contravened the 1860 Act.[1]

A further Act in 1865 finally enabled Allsopp to use their private railway on the understanding that compensation was paid to Midland Railway. Another line from the new brewery to Horninglow Street was built. In 1867, Allsopp had another private line crossing High Street running alongside Guild Street Branch.[1] Like Bass, SA&S had Maltings at Shobnall, these were built in 1879[2] and were serviced by the LNWR Dallow Line Branch, which opened on 27 October 1880.[3]

Until 1862 all shunting at Allsopp's had been by horse, this changed with the purchase of a *Manning Wardle 60* locomotive, designated fleet No. 1. Over the next fourteen years Allsopp bought another six – one from Thornewill & Warham in 1863 and five more from Hudswell Clarke & Rodgers between 1866 and 1876. In 1875 the Thornewill & Warham loco was given in part exchange for the third Hudswell Clarke & Rodgers engine. By 1887 there were six locos, each capable of handling thirty to forty wagons per day. The livery was green, with an oval plate on the cab, stating 'Allsopp & Sons Ltd' complete with a Red Hand.[1]

Motorised Transport

The first motorised lorries were purchased in 1913 by SA&S Ltd. These were a pair of *Halleys*, built at Yoker near Glasgow. They had solid tyres and an enclosed chain drive.[4] Prior to this photographs exist showing a steam powered lorry. When motorised transport became available, it opened up many new and exciting possibilities: raw material could arrive by road, beer could be moved between breweries and the finished product distributed to customers. The Ind Coope group had between 250 and 300 vehicles by the mid-1950s. Deliveries were by *Morris Commercial* five-tonne platform vehicles and for the heavier loads *ERF* lorries. Rail was still used for consignments to towns when an agency was based. Road Tankers were filled during the night and left the brewery early in the morning taking beer to be bottled and distributed locally. *ERF* rigid eight wheelers with eighty barrel stainless steel tanks were introduced in the 1950s.[5]

Archie Goodchild was a lorry driver in the 1950s. His job entailed getting up at 3 a.m. to drive a tanker that was parked under the Belfast Roof at Burton, filled with bottling DD bound for Romford. Archie stopped at Hall's Brewery in Oxford and exchanged his lorry with George Felton who had driven up from Romford with a load of Nut Brown, Stout or perhaps John Bull. This had been emptied into tanks at Oxford and Archie then drove the empty tanker back up to Burton while George took the bottling DD to Romford.[6]

David Platt remembers the sight of all the tankers parked up under the Belfast Roof: 'They'd line up at two o'clock in the morning. The midnight/one o'clock would be the Romford run; the two o'clock would be Watford. We used to dispatch fifteen tankers a night. We had fixed chassis ninety barrels tankers when I joined. They'd carry DD to Romford for bottling or Torquay where we had a bottling plant. All our depots were at the end of railway lines, so we had Llandudno, Milford Haven, Plymouth, Torquay, Chichester and Cleethropes. We'd send empties to Wrexham, who supplied lager for bottling at Burton, on a dead end run.'

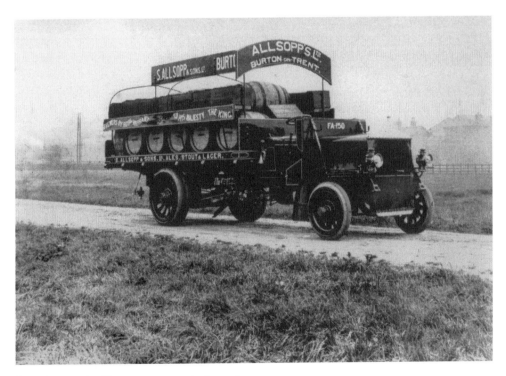

An early example of brewery transport (unknown).

A five-tonner could average 20,000 miles a year and the heavier vehicles, 25,000. By the 1960s lorries painted with the 'Double Diamond Works Wonders' livery could be seen on the roads.[7]

Mick Redyhoff fondly remembers his time on the lorries:

> The garage used to be in Mosley Street. I went for my interview and the boss was Arthur Wood. He said 'You'll work six days a week, six til six.' As they reduced the drivers time they slowly increased the size of the lorries. They used to be five-ton BMC's then they started buying seven ton Fords. They started reducing the driving time, so we'd do four hour spreads with two drivers on the lorry and you'd come back at eight o'clock not six, you'd do that twice a week. It was the best paid job in Burton and I found Ind Coope a very good firm to work for, I thought they were very fair.

Peter Haynes, who worked alongside Mick, left in 1986. 'Redundancy was on offer and I could see changes were coming about, in those days you'd have two men, but now there's one man doing the job. We'd get solo jobs where the driver would deliver up to Sheffield or wherever and bring some empties back.'

In time the group fleet grew to 2,000 lorries, delivery vans, tanks and trailers by 1972, all sporting the brown and orange colours of Allied Breweries (UK) Ltd (ABUK Ltd), with only a Hand, a Squirrel or Huntsman designating, which brewery it belonged to.[8] All of this changed in 1981 with the new green and gold colour scheme[9] By the late 1980s, the fleet comprised of *ERF*'s and seven ton *Fords*.[10] In 1991 ten *Scania* tractors were purchased at a cost of £½m, it was estimated each would cover 85,000 miles a year.[11]

The Flying Director

Not all company vehicles ran on the road, in the late 1940s a *Gemini* aircraft came into service and was stationed at the company's own airfield at Tatenhill. This was then replaced by a *de Havilland Rapide* and then in 1961 two *de Havilland Doves*. With breweries as far apart as Alloa and Romford, a day travelling by rail was cut to a few hours by air.[12] Director Mr David Maxwell gained his pilot's licence in 1927 and became known as 'The Flying Director' covering 20,000 per year. Mr Neville Thompson was also a frequent flyer.[13]

CHAPTER 7

IND COOPE

Introduction

In comparison to the wealth of archive material that has survived for SA&S Ltd including *Executive Minute* books dating back to 1887, very little has survived for Ind Coope & Co. (IC & Co.) prior to 1912. The company must have kept records, however, only one document appears to have endured to the present day, dating from 1859 to 1860. References to the company in the press are also sparse, so it seems that the early history was nowhere near as dramatic as SA&S Ltd!

Romford Days, 1799–1856

The roots of the business that would become IC&Co. in 1845 can be traced back to Romford in Essex and The Star Inn, which stood at the foot of the bridge that crossed the River Rom.

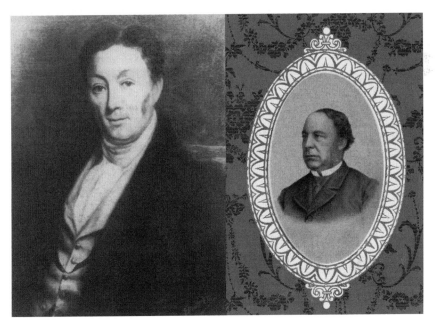

Messrs Edward Ind (Snr) & Octavious Edward Coope (National Brewery Centre).

Romford stood on the only road linking London with Colchester, Harwich and the East Coast and was therefore an important place for travellers.[1]

The Star Inn, run by Mr Cardon, had a small brewhouse attached. By 1750, Mr Cardon had built up a fine reputation for Nut Brown Ale and as his popularity grew he began to deliver to the local area by dray. When Mr Cardon retired in 1799 he sold his business to Mr Edward Ind (Snr) and his partner Mr J. Grosvenor on 23 June and the trade began to flourish. By 1816, Mr Grosvenor had been replaced by Mr John Smith and the company began to trade as Ind & Smith.[1]

Mr Smith sold his share in the business in 1845 to brothers Octavius Edward Coope and George Coope and the name IC&Co. was adopted.[1] Octavius would serve as a Conservative MP for Great Yarmouth, Middlesex, and finally Brentford that he held until his death in 1885.[2] Ind died in 1848 and his place was taken by his two sons Edward Ind (Jnr)[1] and Edmund Vipan Ind.[3]

A local rhyme paid tribute to the popularity of Edward Ind (Snr), 'Where in the town of Romford can we find, a man more genuine than Edward Ind?'[3] The name Ind is pronounced in a number of different ways, rhyming with 'find', sounding like 'Eye-yind', or harsh as in 'India'. The correct pronunciation is unfortunately lost to history.

The company grew, taking Charles Peter Matthews into the partnership, then in the mid-1850s they 'cast an eye in the direction of the Brewing Metropolis, Burton-on-Trent.'[4]

Burton upon Trent Beckons

Prior to their move to Burton, IC&Co. had been brewing an East India Pale Ale, as shown in an advert from 1846 offering 'East India Pale, in Barrels, Kilderkins and Firkins'.[5] The market for this beer was ever increasing, so a move to the future brewing capital of the world, where the water was impeccably suited for this type of ale, made perfect sense.

William Middleton, born in Shoreditch in the East End of London c. 1811, opened a small brewery in Burton on High Street in 1846.[6] In the 1851 Census, Middleton is listed as residing at No. 47 High Street, his occupation being 'Brewer, Cooper and Maltster' employing eighteen men.[7] On 8 June 1853, he took a building lease from the Marquees of Anglesey for land in Station Street. The rent was £21.13.6d for a term of ninety-nine years and on it he agreed to build a dwelling house, brewery and cooperage.[8]

Work was completed by the following year on 2 July 1854. However, by late 1855, Middleton found himself in financial difficulty and sold both sites, Station Street on 17 January 1856 and High Street two months later. The buyer of the High Street brewery remains unknown, but the Station Street brewery was bought for the sum of £7,181.19.0d by IC&Co.[8] The first manager was Mr Martin and later Mr Bird.[4]

IC&Co. was the first London brewer to open a brewery in Burton, the original premises at Romford continued to brew[9] and although both premises shared the same name and board of directors, they operated as separate concerns until 1906.[10] The company grew quickly[9] becoming the third largest behind Bass and Allsopp. By 1888, 400 men and boys were employed producing 200,000 barrels per annum.[11]

Two early maps of the brewery have survived; the first dating from 22 February 1861 and the second from 10 March 1888 that is in much greater detail. The north side of Station Street shows very little difference in 1888 compared to 1861: a new Union Room with a racking cellar underneath and a loading dock having been constructed to the west side of the original Union Rooms, and the General Offices on Station Street are now present.[12,13]

The real difference is on the south side, the 1861 map showed only the Ale Stores,[12] this had originally been a hop yard and by 1863 the cooperage had been erected, and in 1864, the construction of the Mosley Street Branch started, opening on 13 March 1865, the wagons would pull alongside the raised platform of the Ale Loading dock, however, the dock was not quite long enough and certain wagons had to be loaded from ground level. The Mosley Street Branch

Map of Ind Coope & Co. Ltd, 1888 (National Brewery Centre).

ended at Station Street and joined the IC&Co. private sidings that serviced the Union Room and brewhouse. Along with the collection of casks, wagons of spent hops and grains often stood, the yard was a very busy place with farmers collecting grains, etc.[14] By 1888, the Cooper's Shop and associated buildings and the Cask Washing Sheds are visible. What is interesting is the brewer's residence, complete with large garden and greenhouse that stood on land now occupied by the B. Grant & Co. Ltd building erected in 1897.[12,13]

Land to the south west of the station, on the other side of the main line between Curzon Street and Moor Street was purchased, originally to ensure supply brewing water. A borehole was sunk here and the rest of the land was initially used as a sports ground for the staff. The years 1869–70 saw the construction of four maltings.[15] Alongside was a new railway line that opened on 12 January 1870, further extended in 1901 to the area between the Maltings and the yard of Lowe & Sons Builders where IC & Co.'s newly built Bottling Stores stood, this line opened on 1 August 1901. Initially, all shunting on the site was horse-drawn: the movement of the wagons after this was an elaborate arrangement between Midland Railways and the LNWR.[16]

IC&Co. first started using a locomotive in 1867, which remained in service until 1895 when a second designated No. 1 was delivered and named *ESCA*, another had been ordered in 1884 from R. & W. Hawthorn Ltd. IC&Co. only had need for one operating locomotive and one spare kept in the shed. The signal box on Station Street was likely to have been built in 1865 and was Romanesque in design, the windows matching that of the office buildings alongside.[17]

Flotation

In comparison to the spectacle that surrounded the birth and early years of SA&S Ltd, the formation of IC&Co. Ltd on 13 November 1886 was much less dramatic. The capital was £1,500,000 made up of 15,000 shares of £100, with no issue to general public. The first board consisted of Octavious Edward Coope, Mr Thomas Mashier and Mr E. Murray Ind, who had owned the company prior to the flotation, and Edward Ind, C. P. Matthews, E. Jesser Coope,

F. J. N. Ind, C. W. Matthews, E. T. Hulme and E. J. Bird. O. E. Coope was nominated as the permanent chairman,[18] a position he only held for less than a month as he passed away in early December.[19]

Aside from few notable newsworthy events, a maltster's strike in 1889, in which hundreds of men forced their way into the brewery 'handling the manager, his son and the watchman rather severely' in an attempt to persuade others to join the strike[20] and a storekeeper killing himself after a quarrel with his wife[21], the brewery concentrated on brewing 'splendid pale, strong, mild ales and stout' in cask and bottle.[22]

Two more Directors passed away, Matthews in December 1891 and Edward Ind in March 1894. These were rich and powerful men, Ind had been MP for Ipswich and Matthews left a sum of £163,000 in his will.[23]

The company shipped thousands of hogsheads of ale to South Africa during the Boer War. They also held the contract for the Egyptian army, which accounted for 40 per cent of the beer exported by the country.[24]

The Visit of Alfred Barnard

In 1888, Barnard visited the brewery, at that time the company was run by Mr Bird and had expanded to the south side of Station Street and the maltings on the west side of the railway station, covering twenty-three acres, all connected by rail to the Midland mainline.[25] The four maltings at Curzon Street were capable of wetting 120 quarters of malt each, although this was not enough to supply the entire demand, so no doubt malt was purchased from other suppliers.[26]

The main brewery comprised of a large malt store on the first floor, Mill Rooms, with two steel mashers, the ground floor housed the mashing department with sixteen 100 barrel mash tuns and six underbacks. He visited the water tower, which held 85,200 gallons.[27] There were six wort boiling coppers with a total capacity of 900 barrels. After the addition of hops, the boiled

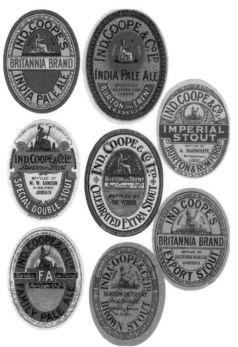

Labels *c.* 1890 showing Britannia trademark (Keith Osbourne).

wort passed through a refrigeration unit[28] before entering the Fermentation Rooms; No. 1 under the Great Malt Receiving Room with twenty-eight squares, while Nos 2 and 3 had sixteen and twenty vessels, respectively. Post-fermentation, the beer entered the cleansing casks or Unions of which there were about 1,424 with a total capacity of 205,000 gallons. Barnard described the five Union Rooms as 'beautiful', noting the iron columns and girders that criss-crossed.[29] A thin stream of cold water could be pumped onto the floor during the summer to keep the place cool. The floor below contained a dozen 150 barrel settling tanks, where the ale was stored prior to racking.[30] The empty casks were steamed, washed, dried and repaired where necessary at the Cooperage, before being moved by railway wagon to the loading stage. He visited the Hop Store, capable of holding 1,500 pockets of hops.[31] Also located on this part of the site was the laboratory and the final buildings of note were the General Offices.[32]

On the south side of Station Street and following the railway line were the Ale Stores capable of holding 45,000 casks, this also housed the Allowance Room, where all men employed by the company could draw their daily allocation of beer.[32] The Cooperage and Washing Shed were a little further away. Casks and timbers were stored in a yard by Mosley Street.[33]

The site was serviced by railway sidings, linked the Midland mainline, with the brewery having its own shunters, these transported the filled casks to the correct sidings for various railway companies; Midland, London, North-Western, Great-Northern or North Staffordshire.[33]

Expansion then Depression

Approximately ten years after the formation of the limited company, it was announced that £500,000 of stock was to be made available to the public. The board consisted of Edward Thomas Helme (Chairman), Edward Jesser Coope, Edward Murray Ind, Charles William Matthews and Archibald Weyland Ruggles Brice. Also associated were Charles Howard Tripp, Algernon Leveson Elwes and George Ittel Blackhall.[34] The money was invested well, sales doubled in three years from £521,835 in 1895 to £1,262,012 in 1898, and in 1899 more shares were made available 'for paying for certain properties purchased and further extension of the business'.[35]

A gruesome death was reported in August 1897 when James Geary slipped and fell into a vat containing boiling beer, 'he was pulled out at once, but he presented a horrible appearance, he lingered in agony for some time, and subsequently expired'.[36]

The centenary celebration in 1899 saw four trains packed with brewery workers leave Burton bound for Crystal Palace, joined by throngs from Romford, 2000 dined on such delights as chicken and tongue, pigeon pie and champagne jelly.[37]

The 1902 Annual General Meeting reported that assets had increased from £3,175,831 to £5,349,634 in the past five years, with sales of £1,575,171 and a profit of £173,466.[38] The first decade of the twentieth century was a hard time for brewers; many would either go out of business or undergo amalgamation. The year 1902 saw rumours of IC&Co. Ltd being linked to the Burton Brewery Co., James Eadie and Thomas Salt. This proved to be unfounded, but it was the first of many.[39] By 1904, the issued capital stood at £3,648,000 and began to weigh heavily on their shoulders.[40]

By 1906, the depression had begun to take hold, the Chairman spoke of 'bad trade'[41], profits were down to £155,821, 'The period under review has been a very difficult one, and the depression in trade existing throughout the country has been severe.'[42] The following week unfounded rumours began to circulate of a Big Brewery Combine with Thomas Salt and for the first time SA&S Ltd.[43] This was soon followed by the reconstruction of the board in June[44] and by August the further rumours had started that Romford was under threat from either partial or full closure,[45] but by October the Burton and Romford businesses had amalgamated under Charles Howard Tripp, who had previously been in charge solely at Burton.[10]

Affairs took a turn for the worse in 1907: Mr Edward Murray Ind said that the Board had not arrived at a scheme for reducing capital, but that losses must fall heavily on the old directors

S 3537 STABLE YARD, IND COOPE & CO., BURTON-ON-TRENT

Stable Yard, *c.* 1900 (Terry Garner).

and their families.[46] Ind stood down as managing director, although he still sat on the board and was granted a retiring allowance of £1,000 p.a. It later emerged that the board had secretly made payments of £4,666 to Ind since 1902. He was accused of 'ruining the company', this was defended by the Chairman Sir Thomas Skewes-Cox, who said there were no accusations of bad faith against Ind and 'the old directors had carried on the business as a limited liability company just as they had carried it on in the days when it was a private firm'.[47] The company went into receivership in January 1909,[48] and a meeting was called in November to discuss whether the company should be closed or reconstructed.[49] The following year, the rumours of amalgamation with SA&S Ltd came up again.[50]

Rebuilding the Business

After the failure of the proposed amalgamation with SA&S Ltd in 1912,[51] IC&Co. Ltd underwent a scheme of reconstruction re-emerging as Ind Coope (1912) Ltd.[52] The newly elected board included Neale Dudley Thompson and Clement Thorley and under their guidance the fortunes of the company began to improve. John J. Calder described the turnaround, 'His [Thompson's] energy and intelligence very soon brought him into the real control of the company. He had as his colleague, Mr Thorley, and under their guidance Ind Coope's financial position improved from year to year'.[53] Thompson and Thorley 'were building up Ind Coope's business, chiefly in Leicester, Leeds, Crewe and the Romford district. They were very successful'.[54]

Early attempts at buying other breweries were unsuccessful, The Burton Brewery Company fell through[55] in 1913, as did Boddington's Brewery in Macclesfield the following year,[56] the first success was Burton brewers Bindley & Co. in 1914,[57] followed by another Burton brewer Robinson's in 1920.[58] Shares were bought in Leeds & Batley Brewery[59] and Woolfs Ltd, Crewe in 1923,[60] with Colchester Brewery Co. in 1925.[61] The Burton Brewery Company was finally purchased in 1927[62] followed by All Saint's Brewery, Leicester in 1929, Budden & Biggs, Stroud in 1931 and Leeds City Brewery also in 1931.[63] The company's name changed to Ind Coope Ltd in 1925,[64] under which it would trade for the next nine years.

CHAPTER 8
AMALGAMATION

Neale D. Thompson, John Joseph Calder and Clement Thorley (National Brewery Centre).

After unfounded rumours in 1906 and an aborted attempt during 1911/12, it is in 1934 that the threads of the story finally intertwine when the two companies amalgamated as Ind Coope & Allsopp Ltd. (IC&A Ltd) on 15 March. Coincidentally, Ansells Brewery Ltd also announced their amalgamation with Holt Brewery Co. on the same day, there was a lot of it about![1]

John J. Calder reminisced about the first steps that led to the merger in a 1947 interview, 'Then one day Mr Eric Thompson came in with an introduction from his father and I gladly helped him, which brought a charming letter of thanks from his father. This gave me the idea and I went to Repton and suggested a merger'.[2]

The exchange between Neale D. Thompson and Calder was recounted by the latter in 1959, 'Well', I said, 'you have had a difficult task of building up Ind Coopes who have 1,600 houses and I have built up Allsopp's with 1,800 houses. There is only a wall between our breweries, do you not think it would be wise for us to join forces and make it a larger and more important company?' He considered the matter and said, 'Yes I think it would be a wise thing, how shall we go about it?' and I arranged then to nominate three directors form Allsopp's; Sir William Peat, Mr Davenport and myself, and they nominated Mr Neale Thompson, Colonel Kingsmill and Mr Courthope MP (afterwards Lord Courthope). 'Well, it took a lot of negotiations and meeting

many lawyers and even more accountants, but finally, in 1934, we merged the two companies and everything was satisfactory.'[3]

As a symbol of the joining of the great rivals, a section of the dividing brick wall was demolished and the two railway systems were connected.[4] Although in legal terms the coming together was described as an amalgamation, the reality of the situation, at least in the internal structure of the company, was that IC&Co. Ltd had taken over SA&S Ltd. Aside from the most obvious clue, the name (at no point do the minute books show any sign of debate, Allsopp & Ind Coope Ltd was never entertained), financially IC Ltd held the upper hand;[5]

	Issued Capital	Debenture Stocks	Assets	Profit 1932	Profit 1933
SA&S Ltd	£1,686,526	£1,528,471	£4,399,630	£130,987	£131,402
IC Ltd	£1,536,757	£1,958,316	£5,749,014	£337,063	£314,526

The first Board of Directors of IC&A Ltd shows a lean towards IC Ltd. Out of the eleven directors pre-amalgamation, two retired, both from SA&S Ltd's side. There were two Managing Directors, one from each, the Chairman was an ex-IC Ltd employee and the Deputy Chairman was from SA&S Ltd.

	Pre-merger	Post-merger
Mr Clement Thorley	Assistant MD IC Ltd	MD IC&A Ltd
Mr John J. Calder	MD SA&S Ltd	MD IC&A Ltd
Col. Sir George L. Courthope	Deputy Chair IC Ltd	Chair IC&A Ltd
Mr Frank Nicholson	Director SA&S Ltd	Vice Chair IC&A Ltd
The Hon. Peter F. Remnant	Director SA&S Ltd	Director IC&A Ltd
Mr Neale D. Thompson	MD IC Ltd	Director IC&A Ltd
Mr Louis E. Walker	Chair IC Ltd	Director IC&A Ltd
Sir Rhys Williams	Director IC Ltd	Director IC&A Ltd
Lt Col A de P. Kingsmill	Director IC Ltd	Director IC&A Ltd.
Sir William Barclay Peat	Chair SA&S Ltd	Retired
Mr James Davenport	Deputy Chair SA&S Ltd	Retired

The bias towards the ex-IC Ltd men was also evident for the Head of Department appointments; there were two Managers of the company at Burton, one from IC Ltd and the other an outside appointment. The Secretary was an ex-IC Ltd employee, as was the Indoor Manager, the Head of Estates, the Head Chemist, there were however two Head Maltsters and Head Coopers one from each.[6] George Preston, who joined the company in 1943, working under Bernard Carfoot in the Transport Office, saw the way the company was being run first hand and is under no illusion,

'Ind Coope took over Allsopp's: you'd got two Transport Managers, two Accountants, two of this and two of that. The better jobs were given to the Ind Coope managers and the Allsopp's chap was his deputy'.

IC&A Ltd acquired the existing share capital and discharged the existing debenture capital of SA&S Ltd, which went into voluntary liquidation, a note appeared in the Executive Minute book 'as from 1st October, 1934, SA&S Ltd shall cease to be a trading concern, and that the properties and the bulk of the assets shall be taken over by Ind Coope & Allsopp'.[7] One very important feature adopted from SA&S Ltd was the Red Hand trademark (the Ind Coope Castle trademark being allowed to lapse[8]), this would survive in one form or another until the Carlsberg–Tetley merger, by which time it had all but lost its link to Allsopp.

CHAPTER 9

THE NEW BOTTLING STORES

Bottling Pre-1948

Following the amalgamation in 1934, the decision was made to close Allsopp's Bottling Stores due to a lack of available space for long-term expansion and to concentrate on using presumably superior IC Ltd Bottling Stores.[1]

Calder had proposed a number of changes to the Allsopp premises in March 1934 that would give maximum improvement for the least possible investment. A 'light building' 90 × 45 feet was considered for housing cold storage tanks, the location of this was given as 'adjoining Ind Coope's wall … immediately above would be the bottling arrangements'. This statement provides the best available evidence for the location of the Allsopp's bottling stores. The dividing wall ran along the whole length of the north east side of the new brewery before taking a right-hand bend and running parallel to the Union Room, presumably the bottling store lay somewhere

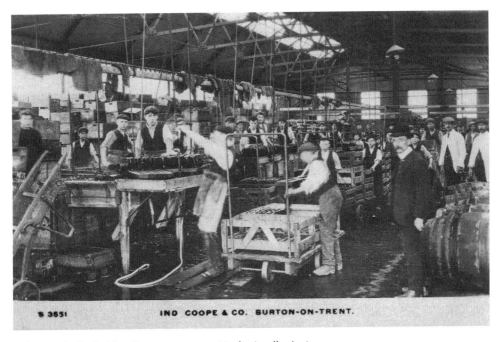

Ind Coope & Co. Ltd, bottling stores, *c.* 1905 (Author's collection).

between the main gate (later known as A Gate) and the Union Room. As for the date when the bottling stores were built, this remains unknown, although a clue can be found in that Alfred Barnard made no mention of bottling premises or equipment when he visited Allsopp's brewery (and IC too) in 1890. It is likely then that all bottling was done by an independent bottling firm.[2] Calder also suggested purchasing a pasteuriser costing approximately £14,000 concluding that 'I think the company will get a first-class bottling plant which it has not at present'. Not surprisingly his recommendations were never acted upon as by July 1934 SA&S Ltd was in voluntary liquidation.[3]

Sited between Curzon Street and the railway line behind malthouse Nos 2, 3, 4 and 5,[4] the original IC&Co. Ltd. Bottling stores had been built in 1901, at a time when all beer was filled directly from the barrel and left unpasteurised. The stores were developed in a piecemeal fashion as the market developed in the early part of the twentieth century, when new developments came along the respective plant was added,[5-7] with the advent of chilled and conditioned beer, a pasteuriser in April 1936,[8] further plant was added by 1940,[9-13] but it was becoming increasingly evident that the bottling stores were no longer able to cope with the changing market for bottled beer. Between 1935 and 1939, production had doubled from 1,678,000 dozen to 3,336,000 dozen, and by January 1940 the directors decided to draw up plans for the new bottling stores with an additional capacity of 50,000 dozen bottles per week.[14] Come February 1941, the company was no longer able to keep up with orders.[15]

To add to the pressure, there was a spate of 'petty pilferage' at the bottling stores in June 1941, the following notice was posted around the brewery:

A number of cases of PILFERAGE have come under the notice of the Management.
This MUST STOP. The object of this NOTICE is to inform all employees that such cases in future will be reported to the Management and the Company's Solicitors will be instructed to take such action as may be considered necessary.[16]

Originally it was proposed to look for a building on a different site, the demolition of malthouse No. 11 and/or No. 12 (behind Allsopp's New Brewery) to make way for a new build was considered.[17] Middle Yard was also a possible location.[18] The cost was to be around £750,000, however, with the country at war it was decided to postpone the scheme, as materials and labour were paramount for the war effort. The plan was to maintain production at 1939 levels until conditions became more favourable, this was managed for the first two years of the war, but then the plant deteriorated further. Although working hours were increased by a third, production dropped by 10 per cent, machine breakdowns became an acute problem and on occasions seven of the nine units were down, leaving fifteen workers per unit standing idle.[19]

Working conditions were dreadful: the floor was continually flooded, 'not unlike a swimming pool, in which it was almost necessary to have on waders'[1] was one observation, the atmosphere thick with steam, the heating inadequate, no wonder there was a high level of absenteeism among staff. Photographs from this period show a dark dingy building with a low corrugated iron roof, broken glass covering the wet floor,[19] stack after stack of wooden crates, it was hard to imagine how poor the Allsopp's bottling store must have been in comparison!

'The old bottling stores was gutted when the new place started up and that's where they used to store the beer before it went out onto the lorries. It was brick built with corrugated on top,' remembered Peter Haynes.

'Britain's Greatest Bottling Stores'

By 1945, bottling was mostly done at Burton, but there were also plants at Romford, Plymouth, Liverpool, London, Cardiff, Llandudno, Leeds and Stoke. All of these were working to full capacity with the machinery old and in need of replacement.[19]

After the end of the hostilities, Mr Neville Thompson was instructed to develop a plan for the new bottling stores, he began work in August 1945 and quickly produced the document Application for Reconstruction of Bottling Stores that outlined the case for what was to be hailed by the company as 'Britain's Greatest Bottling Stores'.[20] In truth, the company had no choice but to invest, but rather than the 1940 plans it was decided to adapt the disused malthouse Nos 2, 3, 4 and 5, which lay adjacent to the current bottling stores on the Curzon Street site.[21]

Engineering plans had already been drawn up in April 1945, showing the ground floor with the unloading dock, empties storage, conveyor system, boiler house, main bottling hall, engine room. etc., the first floor had case storage, case repair shop, tank room, cloak room, offices, hospital, etc.[21] The initial cost was £262,350: £100,000 for building work, steel work and a new chimney stack and an additional £162,350 for new plant including seven bottling units. Wherever possible, old plant was to be reused/reconditioned but considerable investment was required. The four malthouses were to be joined together and a single-storeyed building constructed. The old bottling stores would be converted to a despatch unit, holding about three-days' stock.[19] The company wasted no time, machines were ordered and tenders were received for the building work. An additional railway siding was needed due to the increase in traffic.[22] Mr Neville Thompson had travelled to America and had brought back ideas for 'several novel features ... which should result in the practical elimination of heavy work ... when completed, should be one of the most up-to-date in the country'.[23]

Contracts for the general building work were given to various firms including George Hodges & Sons and Thos Lowe & Sons from Burton upon Trent[24,25] and in August 1945 the Curzon Street Maltings were closed down.[24]

Peter Haynes helped out preparing the site for the new build, 'In 1946 the area had to be cleared, it was all bottles, millions of them, all thick with dust and we had the job. We had to clear all that out before the new building could be started'.

On top of the original estimate, £55,719 was required for extra conveyors, cold room, railway sidings, bulk pasteuriser for lager, beer mains, etc.[26] An initial order was placed for 20,000 metal bottle beer cases, to replace the old wooden items.[27]

A new bottling manager was appointed, a Mr L. W. Bloomfield who was at the time bottling manager at Romford. He was granted the use of the house on the bottling stores premises.[27] The family moved into what was known as 'Nut Brown Manor' in early 1947.[28]

Current staff levels were about 350 people on one shift, with the anticipated increase in demand to twice that of 1939, a two-shift system was envisaged with a very large increase in staff. This came about in 1959, with three-shift working being introduced in 1973.[29]

The new Administration block became occupied in late 1947, as did the new first-aid post run by Sister Kiddoo, boasting a 'well equipped surgery, an attractive waiting room and comfortable rest room'.[28]

The Opening

Thursday 30 September 1948 was a day blessed with sunny weather. IC&A Ltd was understandably very proud of this new venture and invited the entire brewing world to witness the spectacle, representatives from Europe and even as far afield as South Africa and South America attended.[1]

Due to illness Lord Courthope was unable to attend, so the ceremony was performed by the Deputy-Chairman Lieutenant-Colonel A. de P. Kingsmill on a flag draped dais near the main entrance. The dignitaries were given a tour of the stores while all the machinery was idle, this was followed by a buffet lunch at the sports ground on Belvedere Road. In the afternoon, a commemorative plaque was unveiled and then the guests experienced the place in full operation.[1]

During his speech Kingsmill outlined the early history of the company including the 'bad times of 1911 when, owing to the extravagant prices paid for licensed house, the company went

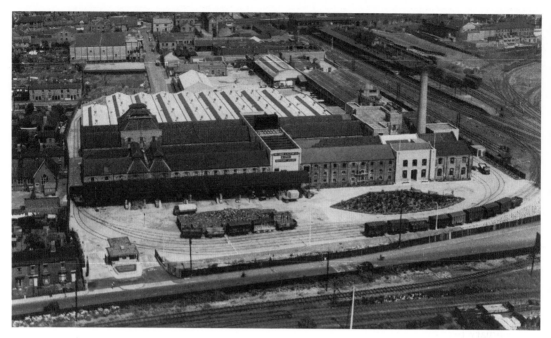

Curzon Street Bottling Stores, *c.* 1947 (author's collection)

into the Receiver's hands'. He then painted a picture of a progressive company who had gone from strength to strength under the leadership of Calder in the previous fourteen years: staff were now experiencing better working conditions and increased pay.[1]

Among the workers that day was Peter Haynes, 'I wasn't there when Mr Kingsmill opened the bottling stores. We were spoken to by one of the Thompsons'.

Mr Neville Thompson also spoke, commending the employees for their contribution to the new bottling stores, which was reckoned to be five to ten years ahead of any other plant in the world. The stores were nearly completely automatic: the only time the bottles were touched by human hands was when being de-crated before the washer. It was planned to eventually have ten bottling units in operation capable of producing more than 1,000,000 bottles per day.[1] In actual fact, eight units were installed by 1949[30] and it took until 1954 for the ninth bottling line to be commissioned[29] by which time the market for take home beer had changed again and plans were in place to start producing canned beer.

It was also hoped to replace the endless convoy of road tankers bringing beer from the main brewery, Thompson envisaged an ambitious solution, 'it will eventually travel in an overhead pipeline over half a mile long – the longest beer pipe in the country'.[1] This was to remain, literally, a pipe dream, although the main site and Curzon Street were eventually joined, as Engineer Mike Jobson recalls,

'A steam main was installed in 1967/68,' it still remains today, unused for decades. 'I was partly involved in installing a multi-purpose pipe line for finished chemicals acetic acid etc. It was about 900 metres long and was the latest technology at the time.

In stark comparison to previous working conditions, the new bottling stores proudly claimed that all steam was contained inside the pasteurisers and that any spilt water drained away immediately, much better than standing nearly clog deep in water! On site was an engine room producing about 1,500 horsepower, a boiler house and a cold room containing enough 120 barrel tanks to hold 500,000 pints of beer and operatives wearing duffel coats and thick clothing, the nearly freezing conditions were proudly described 'It's always winter in this room',[20] this was necessary to prevent the beer from foaming up while filling.

The canteen, which had opened in February 1947,[31] was supervised by Mrs I. Thompson provided breakfasts at 10d each, lunch at 1s 1d. Another form of refreshment was provided at the Bottlers' Arms the on-site pub where all male workers over the age of eighteen could draw their allowance of two pints of mild a day. Fitted out with barrels, jugs and a bar at elbow level,[31] this was run by Mr MacDonald, a gentleman who claimed to know every face in the department therefore ensuing that nobody could get more than their fair share.[20]

Long Life

Nowadays the idea of beer not being available in a can is unthinkable, but back in 1954 it was a new and innovative concept. Informal discussions had taken place at the senior management level between Edward Thompson, Neville Thompson and Mr Joe Thorley in the early part of the year and in June 1954 it was agreed in principle that if a suitable 16oz can could be produced by the Metal Box Co. that the equipment necessary for a fully automated unit with a capacity of 450 cans per minute should be purchased. This comprised of a can rinser, an unscrambler, a filler, a sealer (which would be hired), an X-ray detector and a hydro-extractor for drying cans.[32] The option for a smaller 10oz can was also available.[33]

It was estimated that the outlay would be about £35,000 but there was an air of caution, as it was noted that the most expensive items could be converted back for use in bottling or sold on as standard canning equipment.[32] The planning moved forward throughout the year and in February 1955 the expenditure had been approved.[34]

'We welcomed canning, it made our jobs more secure, we thought it was a good idea,' commented Gordon Carter who worked at Curzon Street. 'In comparison to today it was antiquated, the filling was really slow, but I think we were the only brewery that was canning. It was all about speed and it got faster and faster.'

Canning began in 1956, initially for two beers; Long Life and Allsopp's Lager but the real push was for Long Life. £55,000 was budgeted for advertising the product: 'Introducing Britain's New 5-star National Beer',[35] with adverts in many local newspapers and £29,000 being earmarked for a television advertising campaign starting late July 1957.[36] By summer 1957 the campaign had stepped up a gear 'Everybody … Everywhere … wants Ind Coope's Long Life and Happiness!'[37]

Sales of Long Life took off and by the summer of 1957 the copy on the Long Life can read as follows:

BREWED BY DEEP FERMENTATION

A pale beer of the finest export quality brewed by Deep Fermentation, the special process that gives mellow flavour, subtle aroma and sparkling freshness. 'Long Life' is exclusively brewed for. and sealed in specially lined cans.

'"Long Life" should always be kept cool.'[38]

There was a further investment in 1973, a new bottling line was installed with a capacity of 1,200 bottles per minute, at that time it was the only unit in the UK capable of such speeds. A second canning line was also commissioned.[39] The bottling stores at Curzon Street would remain open until 1987 when the whole department moved to the main site as part of the Greenfield Appraisal Burton Brewery (GABB)/ Greenfield Implementation Burton Brewery (GIBB) project.

CHAPTER 10

BARLEY AND MALTING

The Work of the Head Maltster

In the 1950s, the barley budget of IC&A Ltd was £2.5 million per year, making them the largest buyer in Britain and it was Head Maltster Gerald Otho-Briggs' responsibility to ensure that only the finest barley was purchased.[1]

His son Thomas Otho-Briggs recalls watching his father at work as a child,

> The corn merchants would have specific days when they'd come and see my Father. They'd have suitcases with these long brown envelopes. My father's office was right at the top in Clock Tower and he had a long black table and they'd tip out a selection of barley from different farms in a circle and my Father would use a grain cutter and he'd look inside the grain. He'd buy some and not others. His Secretary would then type out what had been purchased and he'd keep a sample. When the vehicles came in he had a long stainless steel tube with a sharp angle at the end and he'd pierce the sacks to see if the barley in the sack compared with the sample.

Gerald Otho-Briggs inspecting malt samples (Thomas Otho-Briggs).

Gerald Otho-Briggs became Head Maltster in October 1948, a position he would hold until his tragic death in 1968. 'He was about three miles from home in his Lotus Elan S2,' Thomas reveals.

> He was following another vehicle, this bus came up to the junction and just pulled out in front of them. The people in the car in front were killed and my father went under the bus and was killed too. The only damage to him was on his forehead. It was before the days of breathalysers and I think the bus driver had been drinking.

Maltings

Along with being Britain's largest buyer of barley, the company was also the largest maltsters. They had various facilities in the town; seven behind Allsopp's New Brewery[2] and four at Shobnall. The Shobnall maltings were mechanised in 1965 with the installation of Redler power shovels, mechanical kiln stripping, automatic grain handling, kiln pressurisation and Suxe burners.[3] Following the 1962 fire that destroyed malthouse No. 3,[4] a new Saladin Plant was built. There were also the maltings at Mistley in Essex, which were originally run as Free Rodwell, before being acquired in 1961.[1]

Thomas Otho-Briggs recalls some happy childhood memories about the Maltings,

> The floors were vast, about the size of a football pitch, all made of that red aerated brick, they were wonderful to roller skate on when you were ten years old! My Father owned a lovely short haired golden Labrador called Jane, she went everywhere with him, but she refused to go into Shobnall Maltings, As it was just a Maltings there weren't that many people around and that's why they had a lot of cats to look after the grain. They were huge and very scary! As soon as they saw the dog they would jump onto her shoulders, stick there claws in and their teeth and stay there. They were a real problem: they were known to attack strangers also.

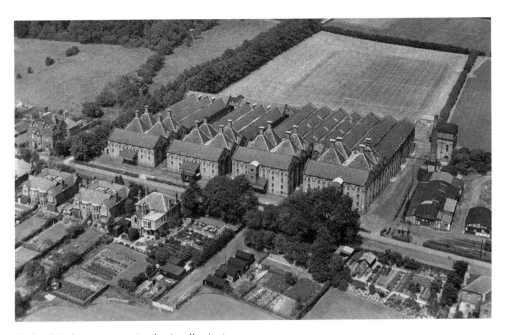

Shobnall Maltings. *c.* 1947 (author's collection).

Peter Brookes was the technical maltster for ABUK Ltd in the 1970s and he took charge of the malting development plan. 'The first phase was the construction of a new malting plant at Mistley in Essex. This plant was commissioned in 1977 and is still operating'.

The maltings at Shobnall were reaching the end of their useful lifespan, Peter Brookes describes the problems. 'It was hard work in floor maltings. It was becoming difficult to recruit people who would do it as the old Maltsters retired. Consequently management became a struggle as there was much sickness and under the Union agreement rest day working was double time. Costs thus became very high.' There were also major problems with the Saladin Plant, 'It was falling apart'.

In June 1981, the inevitable happened and Shobnall maltings closed. Having first supplied malt to SA&S in 1879,[5] the 102-year-old buildings had become severely dilapidated over the years. At one time they were under consideration for listing by East Staffordshire District Council.[6] Demolition began in mid-1981 and by spring 1982 the site was cleared.

The closure meant the loss of twenty jobs, 'Mostly they were at retirement age. Some got work in the brewery,' says Brookes. 'At the time I was not particularly sad to see the old maltings go.'

The second phase of the development plan was the construction of a state of the art facility on the main site began on 5 December 1982. Costing £5.5 million, the Albrew Maltsters Burton Maltings had an annual output of 30,000 tonnes. Albrew Maltsters was a company formed to supply malt to all of ABUK Ltd.[7]

'Planning was started in the early 1980s. It was a model project and was completed within budget,' says Brookes. 'The malting concept of the tower was essentially designed by me. I was backed up by Allied Breweries Engineering Services in the main by Peter Marks as Senior Mechanical Engineer, Roger Holmes as Structural Engineer and Frank Mitchell as Electrical Engineer. Project Manager was Bryan Kilburn (ex-Ansell's Chief Engineer)'.

The first production runs took place a year later on 5 December 1983 and the facility was officially opened on 20 May 1984.

It was opened by Sir Derrick Holden-Brown, there is a rather nice marble plaque commemorating this in the base of the tower building. I hope someone has had the foresight to remove it. We had a good day and several days followed for press, brewers, maltsters, barley suppliers and families. I think this project was a representation of Allied Breweries at its best; a company at the height of its powers.

The tower became a familiar landmark in the town, particularly for the clock and temperature gauge. It was demolished in January 2012 by owners Molson Coors.[8]

CHAPTER 11

FIRE!

The Company Fire Brigade

Due to the high risk of fire in brewery buildings it was common for companies to have their own brigades. IC, SA and Bass did, with photographs existing from the early twentieth century. The Bass brigade was part-time, but IC's was full time.[1] Bryan Chinn joined the service in January 1967, having previously worked as a fire officer for the Ministry of Defence.

'The chief fire officer was J. T. L. Mann when I joined, he was an ex column officer in the NFS and had attended in that capacity at Fauld in 1944. Ind Coope's Fire Service at that time was fully manned both for fire and ambulance duties. Both the fire engine and ambulance were made available for call outs to the local authority and supported the Burton Borough units. Historically, Bass and Samuel Allsopp/Ind Coope had fire engines well before the Burton Borough, and these responded to local fires. The firemen were trained to the same level, and many were ex Borough firemen with wide experience.

In 1967, the fire engine was a Braidwood (open bodied) Dennis built around 1934, registration No. FHA 222, this machine could pump 1000 gallons of water a minute, when the Burton units were only able to pump half that. The ambulance was a Standard Vanguard, c. 1958.

> A shift system with full time staff was operated on a forty-eight hour working week and the fire brigade had other duties which helped to pay for the Brigade. The internal transport was one of these duties, using vans, cars, forklift, and a small lorry. Also firemen used to shunt the artics and eight wheel tankers around the brewery and to the Bottling stores at night. Fire patrols were carried out on evening and night shifts to check fire safety and security, and this included outlying premises.

The Great Hop Store Fire

In the 255 year history of the brewery, one night stands out as the most dramatic. Recorded in depth in a number of publications the events of Wednesday 24 February 1954 go down in history as the night the brewery burned. There had been fires at the brewery before and there would be more fires to come, but nothing to compare to 'The Great Hop Store' fire. This involved hundred firemen from three counties and the firm's own brigade,[2] ten pumps and two turntable ladders,[3] and the smoke was reportedly visible in Repton some four miles away!

Early estimates put the damage at between £500,000 and £750,000,[2] although the fire loss adjusters actually paid out £427,605 (£285,479 for destroyed hops[4] and £142,126 for damage to buildings and plant[5]). Between 7,000[2] and 9,000[3] pockets of hops were destroyed, to put this in perspective, this was enough for 1,500,000 barrels of beer![2]

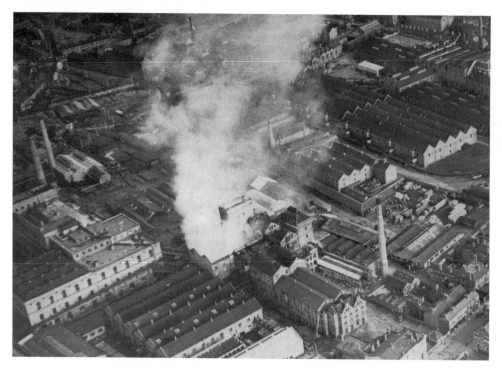

Great Hop Store Fire, 24 February 1954 (Author's collection)

Jill Whetton (née Fern) was fourteen at the time and lived on Mosley Street at her parents' upholstery business Fern's Furnishing. She remembers the night in question, 'It lit everywhere up, me and our Jacqueline we were up all night, as it was an adventure to us. We stood on the corner by the Roebuck, it was dark but it was like daylight. It's a wonder the whole ruddy brewery didn't go up.'

The fire started sometime in the early evening. At 4.30 p.m. a routine two-hourly temperature check of the hop store was made by Shift Engineer Jack Beddows. To maintain the correct conditions a circulation system blew air at about −1°C,[3] and at this check everything was found to be in order,[2–4] however, by 6.30 p.m. billowing smoke and the sound of fire could be heard. Jack raised the alarm. The firm's brigade was the first on the scene, they located the blaze and attempted to fight the fire[6] but it was too intense, the smoke thick, black and choking,[2] so a call was put out to the Burton Brigade. The delay in calling for help was forty minutes, which meant that by the time the Burton Brigade arrived, the fire had become deep-seated. The reasons for not calling for help straightaway can only be speculated upon: perhaps a misjudgement was made on how serious the fire was, or was there a sense of duty or misplaced pride that the fire was on their patch and therefore their responsibility? Whatever the reason, this delay was to have disastrous consequences and would attract criticism in the *Fire Protection Bulletin*, the blaze being used as a prime example of the cost of waiting too long, alongside an aerial photograph showing the Hop Store engulfed in a column of smoke.[6]

After the initial call to Burton, further deployment took place; Derby, Derbyshire, Staffordshire, Leicester and Rutland fire services, with the *Burton Daily Mail* reporting the attendance of Swadlincote and Tutbury brigades too.[7] During the fire the Bass Brigade were on standby with one major pump.[8]

The mobilisation worked very smoothly, although Chief Fire Officer R. C. Elliott commented that 'the only complaints came from Brigades on whom we did not call. They wanted to know why we had not asked for their support'. He was one of nine officers to be overcome by fumes and heat, and he later directed matters from his hospital bed! Despite the large number of fire officers in attendance, some men were on duty for a gruelling nineteen hours.[7]

Initially Mr W. Horobin of the IC&A Ltd Security Police took charge, he saw railway trucks sitting next to the hop store, which needed to be moved urgently. The schoolboy son of Chief Secuirty Officer Mr J. Rose happened to be on site, drawn possibly by the sight of the fire engines, he was duly dispatched by bicycle to Shobnall Street to call Mr Simnett a Shunter.[7]

The hop store was built of brick and was approximately 150 by 75 feet, with wooden floors supported by unprotected cast iron columns, it formed part of a complex of buildings with an area of 400 square feet, with the hop store being surrounded on three sides.[3]

'The ground and two storeys had no windows, being refrigerated. There was only one entrance on the ground floor. This room was insulated and the insulation was covered by tongue and groove boarding which had been varnished many times over the years,' recalled Fireman Ron Geary, who was in attendance. His book gives a very vivid account of the blaze. 'When you were in there you could see the flames running across the ceiling, fed by the varnish.'[1]

The Hop store was full of pockets of hops (hessian bags measuring approximately 1.8 metres long by a just under a metre diameter, weighing roughly sixty-four kg), which were stacked from floor to ceiling, with an almost total lack of gangways.[3] It was later explained to the press that the company had just received most of the 1953 harvest and that it was normal to hold large stocks in case of crop failure.[2]

Directors Mr Joe Thorley and Edward Thompson arrived on site accompanied by their wives. While Thorley supervised the moving of trucks, Mrs Thompson and Mrs Thorley ensured a good supply of tea and refreshments for the brigades.[7] Head Maltster Mr Gerald Otho-Briggs was also present, his son Thomas clearly remembers the fire.

> My father had a telephone call. He didn't tell us what had happened as he didn't involve us in dramas. He was down there most of the night. The place was in a hell of a state: the windows had steel frames and instead of the glass breaking the heat was so intense the glass was sagging from the top of the frame!

One of the biggest problems faced by the fire crews was the nature of the burning hops: dry hops will absorb about eight times their weight in water, so the amount of water being pumped in had to be restricted, otherwise the expanding hops may have brought down the external walls compounding the problem.

Turntable ladders were used to cool the upper levels of brickwork and reduce flying embers. During the night, it was concluded that the contents could not be saved and a decision was taken to contain the fire to the building. Attempts were made to breach the 17.5-inch-thick blue brick walls,[3] first a futile effort with hammer and chisel by Fireman Eddie Smith[1] and then more successfully with pneumatic drills. The team from Charles Griffiths Ltd, led by Foreman Mr Champion was later commended by Mr Thompson, who called them 'good, tough lads',[2] however, this action only confirmed the intensity of the inferno.

'Myself and another chap that I worked with went to the brewery canteen for our dinner,' recalls Reg Docksey then a sixteen-year-old lad working at Briggs & Co. in Moor Street. Reg would later serve on the IC fire brigade. 'We had a grandstand view of what was going on: lots of fire engines, miles of hose snaking all over the place, firemen everywhere!'

'A lot of people wanted to go and see it: some of the streets around were cordoned off,' recollected Peter Haynes. He was living at Winshill at the time and could see the blaze during the night. Even on his way to work the next morning it was visible. 'Coming down Bearwood Hill on my bike you could still see it. What a blaze it was!'

The fire raged through the night, a scene later depicted in the *Burton Daily Mail* as 'like the aftermath of a London blitz'.[7] One fireman described the difficult conditions, 'We just aimed our jets, and if the water slashed back scalding hot we knew it was going on to something burning.'[7]

At 8.45 a.m. on Thursday morning the hop store was vented by breaking the top floor windows using a ceiling hook and thirty minutes later the roof collapsed, causing 100-foot-high flames to shoot into the sky. The order then came and thousands of gallons of water were aimed at the fire.[1] Secondary fires

were contained but unfortunately the wind changed and the Billings Tower caught light. The firemen battled hard and bravely with twenty-one jets and eventually had the fire under control, receiving the stop message at 11.40 a.m., although the firm's firemen would be involved in damping down exercises until the following Monday 1 March.[2]

It wasn't until the early evening of the 25th before the damage could be surveyed; the Hop store was nothing more than a gutted skeleton of brickwork, amazingly no wall had collapsed although one was noted as being very dangerous.[9] Masses of debris and hops lay smouldering, the Billings Tower situated to the top right was burnt out inside and the roof was in danger of crumbling, the Old Mill rooms which, until before the fire were undergoing transformation, were badly damaged in parts and finally the rooms connected to the hop store were charred rubble.[2]

A full investigation followed with Chief Fire Officer Elliott concluding that the most likely cause of the blaze was the heat from an unprotected 100-Watt bulb being in direct contact with a pocket of hops.[3]

In the aftermath of the blaze there was some reorganisation on site; the old IC&A Ale Stores and Architects Department were converted to new General Stores, with the architects moving to top floor of Allsopp's side and a new hop store was built with a capacity of 6,000 pockets and with, not surprisingly, an emphasis on fire safety.[10]

The scars of the fire are still visible today, although now strictly out of bounds hidden behind locked doors. While on a routine fire patrol, many years later this was witnessed by Reg Docksey. 'The evidence of charred wooden lintels above what presumably would have been doorways in one of the walls adjacent to the main hop store building was evident, it didn't take much to realise just what I was looking at.'

There are a few surprising facts about the fire; during the blaze the Bass Brigade were called out to a rubbish fire at COD's Sports Ground off the Trent Bridge and also a chimney fire,[8] but incredibly, despite the raging inferno and the inherent dangers of it spreading to the rest of the brewery, it was business as usual, there was no evacuation of personnel and at no point was beer production interrupted!

Malthouse No. 3

Early one morning in 1962, Maltster Mick Redyhoff was on his way to start work, he clocked in as normal and as he walked across the brewery yard he noticed something wrong,

> I saw all this water lying there and though what the 'ell? Then I realised there was fire engines and the Maltings had gone! I thought me jobs gone! What do I do now? It must have spread from one to the other.

The Maltings were situated next to the train line and the fire was spotted by a train driver on his way to Derby, he raised the alarm at Derby Station.[1]

'Bass Fire Brigade was there before IC,' remembers Mick.

The County Fire Brigade arrived with IC's and they set about fighting the fire, the main problem was a large oil tank that was situated between the buildings, this was kept cool by jets of water, however, the maltings were all interconnected by walkways and the fire spread.[1]

'Heroic Sam saves the day!'

A fire broke out in the Mill Room in February 1971,[11] and this would have spread further without the brave actions of Water Man Sam Hutchins who climbed to a roof above the blaze where there was a tank full of brewing liquor from Shobnall. He pulled the plug and sent gallons and gallons of water down onto the blaze below, this action also reduced the weight on one of the cast iron supporting beams that had been cracked by the fire.[12]

CHAPTER 12
DOUBLE DIAMOND

Introduction

Of all the beers produced by IC and SA, the most famous was Double Diamond (DD). Described by Thomas Otho-Briggs as 'Quite nutty in flavour and malty with a slight aroma of hops, quite dark and not at all bitter, but not sweet like a stout,' the rise and fall of the ale's popularity would track the fortunes of the company. Although many other brands such as Skol, John Bull, Castlemaine XXXX, Löwenbräu would play roles in the story, DD was the leading light, the headline act, the A-list star, it isn't an overstatement to say that the history of DD was also the history of the company.

Earliest known Allsopp's label, *c.* 1840 (National Brewery Centre).

The Roots of Double Diamond

With the strapline 'Works Wonders',[1] this Pale Ale did just that for the company's fortunes from the 1940s, but when was it first brewed and how did the name come about? The evidence is there on labels, in historical articles etc., but the story is far from straight forward.

Information on bottle labels from the 1970s and 1980s (usually those destined for the export market) date the ale to 1876 as these often contained the phrase 'Since 1876' or 'Brewed in England since 1876', although it is doubtful that DD was first brewed in that year. Ind Coope had after all been producing Pale Ale prior to moving to Burton in 1856.[2]

The interlocking horizontal lozenge symbol '◊◊' had been used as a brewing mark on casks of IPA[3] long before IC&Co. had the foresight to register it as a trade mark in 1876 and the earliest surviving IC&Co. Ltd. IPA label from *c.* 1890 features the '◊◊' although the words 'Double Diamond' do not appear. A slightly later but unverified advertisement has the words 'Ask for Ind Coope & Co's Limited Double Diamond' indicating that this was the verbalisation of the '◊◊' symbol and therefore the name of the beer.

From the evidence so far, it appears that DD was an IC&Co. beer that can be dated back to at least 1876, probably earlier, and went on to become the world famous Pale Ale, but, and this is where things get a little complicated, an article in the Summer 1960 issue of *The Red Hand* clearly states that DD 'is a direct descendant of the India Pale Ale first brewed in a teapot by Samuel Allsopp's maltster',[4] which occurred in 1822. So it appears that the ale was in fact a combination of the nineteenth century IPA from both brewers: IC&Co. supplied the name and SA&S recipe.

When did SA&S start to produce a bottled IPA? Two labels exist from the 1880s, pre and post flotation; *c.* 1884 and *c.* 1888. The *c.* 1888 label states 'Gold Medal Paris – 1867' and 'First Class London – 1862' indicating it had been brewed for at least twenty-five years, however, an earlier label was reproduced in an article called 'Double Diamond Facets' in the 1957 issue of *The Red Hand*[5] dated *c.* 1840. The beer was an East India Pale Ale, brewed by 'Allsopp & Sons', it lacks and therefore presumably pre-dates the use of the Red Hand trademark.

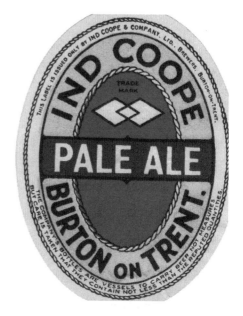

Labels showing DD trademark (Keith Osbourne).

When IC&A Ltd issued their first price list for bottled ales and stouts on 1 October 1934, it was split into two categories, Ind Coope qualities and Allsopp qualities and listed 'Ind Coope DD Pale Ale' and 'Allsopp IPA India Pale Ale'.[6] For the first two years post-amalgamation, both were produced until a resolution was approved in April 1936 'of the alteration to the Pale Ale label by the addition of the words 'Double Diamond' in red in the white space over the red hand',[7] then two months later in June 1936, it was 'decided that in the standard Bottled Beer Price List of the Company the letters 'D.D' should be substituted for "IPA" in the future'.[8] This was when the switch occurred and Allsopp India Pale Ale became Ind Coope & Allsopp Double Diamond Pale Ale. The final piece fell into place when in 1938 when it was 'decided to eliminate the word "Allsopp" from the Pale Ale Label and make it read "Ind Coope's Double Diamond"'.[9]

John Calder was interviewed in December 1959, then ninety-two years old and blind, but age and infirmity had not affected his memory. Among his reminiscences was the origin of the name DD, 'Ind Coope's had a brand name registered, but not used, for a Pale Ale called "Double Diamond" and I suggested that that would be an admirable name and that the chief brand should be called Ind Coope's Double Diamond.' Calder also commented, 'I dare say that Double Diamond is now the largest better class beer sold in Britain.'[10]

The Rise of the Diamond

Social change during the Second World War affected all aspects of life, including beer drinking habits. Until then beer had mainly been the drink of the working class, to replace sweat lost during manual labour, but post war the image began to change with the rise of bottled beer and a widening social acceptance.

Double Diamond was first brewed at an original gravity of 1052,[11] this dropped slightly to 1047 during the war years.[12] Other changes due to the pressures of war included the discontinuation of bottling in nips in 1943,[13] and the introduction of smaller labels to save paper.

Serious problems developed in 1947 with ale clarity; despite being pasteurised, it was not remaining clear in bottle. Dr Erik Helm of the Alfred Jorgenson Laboratory of Fermentology, Copenhagen, was appointed as a Technical Advisor in March 1947, working alongside Head Brewer Mr G. Younie and Head Chemist Mr H. Dryden to resolve the issue.[14] Trials were undertaken and it was discovered that using carbon dioxide during the conditioning and bottling process would greatly improve the clarity and therefore the shelf life.[15]

Presentation was a key issue for IC&A Ltd's premium beer: the words 'Brewed at Burton' were added to the label in 1947 and decorated Crown Corks came into use in late 1953.[16] Due to increased demand in the latter half of the 1950s, although still exclusively brewed at Burton, DD was being bottled by third parties. This was not always successful as the description of a 1957 bottling from Messrs Calder's in Edinburgh attests, 'It was noted that the bottle was dirty, the label badly placed, the neck label out of alignment and the Crown Cork dirty and not properly attached; in addition the beer was cloudy.' A stern letter was sent stating that either matters improved drastically or they would lose the contract.[17]

In 1948, with the new bottling stores now in operation at Curzon Street, IC&A Ltd had the scope to market and advertise DD on a national scale and within four years 110,000 barrels were being sold in about 25 per cent of the nation's retail outlets (in both tied houses and the free trade), this was to rise to about 50 per cent by 1962.[3]

As demand grew in the early 1950s, this began to put increased pressure on the facilities at the brewery. The availability of cold storage became a problem in 1951,[18] a new cold room facility with a capacity of 2,800 barrels had been commissioned in late 1950, but had yet to be built,[19] and rather than cutting corners it was decided that the ale should have a minimum of seven days in cold storage, even if this meant that orders had to be rationed.[18]

Other areas of the brewery were also struggling to cope, as of summer 1951 brewing capacity stood at 15,500 barrels over a five-day working week, extendable to 17,500 barrels with two additional brews on a Saturday. A plan was put formulated to extend plant in the brewhouse to enable 20,000 barrels per week. Capacity for fermentation stood a little higher at 22,140 barrels.[18]

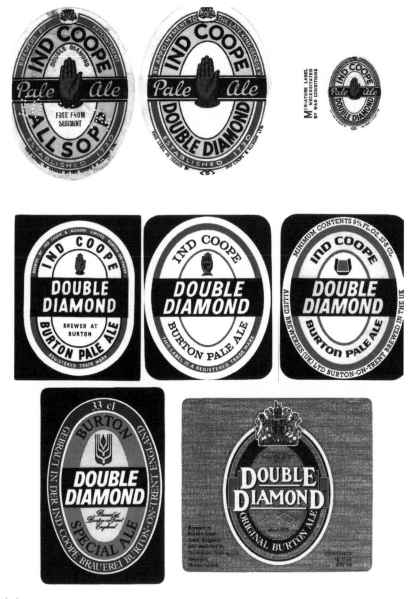

DD labels from 1936 to *c.* 1985 (Keith Osbourne).

A new cold room was constructed in 1957, housing sixteen tanks at twenty-nine feet long and weighing ten tons each. These massive structures were lifted in by crane and pulleys, with one onlooker describing the scene as 'like posting something in a giant letter-box'. The tanks were designed to store the beer at temperatures just below freezing point.[20]

By 1958, DD was being described as 'Britain's best-selling bottled beer'[21] and a can design was approved in 1959 having wording 'A brilliant pale ale of export quality brewed at Burton from the finest malt and hops by Ind Coope – Brewers of Britain's best for over 200 years.' Despite the historical inaccuracy, the company was only 160 years old at the time, this was some claim.[22]

Following the Ind Coope Tetley Ansell merger in 1961, Chairman Gerald 'Mr Joe' Thorley outlined plans for the next twelve months, to be known as 'The Double Diamond Year'. This would consist of a brand new advertising campaign (see pages 61–62 for further details) and a new sales drive for the recent advance 'draught beer under pressure' (an early name for keg beer).[23]

'With draught beers under pressure we have done in nine months what many other brewers have spent years in achieving,' Thorley explained. 'Already we have upwards of 700 of our pubs selling draught beers under pressure and by the year end we will have twice that number.'[23]

Although there had been early teething troubles with the new beer delivery system, Thorley was confident that facilities for Draught DD (DDD) along with Draught Skol would be installed in many pubs both in tied houses and the free trade. A further development, the so-called 'Super Draught' was announced in 1963, this was a new innovation for draught beers under pressure and would enable pubs to serve 'draught beers with an added sparkle and a consistent quality for the first pint to the last'. To deserve this accolade, publicans would need to be able to serve beer under full pressure from a cellar that had temperature control.[24]

'This was the main reason for the creation of national brewery companies and launching their national keg beers,' explains David Cox, Ind Coope Head Brewer and later Managing Director. 'For example DDD, Flowers Keg, Watneys Red Barrel and Whitbread Tankard, they were highly successful, especially DDD because for the first time beer drinkers were presented with ales, as opposed to lagers (which at this time in the 1960s/early 1970s were not mainstream products) that were consistent in flavour, were crystal bright and had predictable good condition and head retention. And because they were available across the nation, big marketing spends were the order of the day, justifying for instance adverts on television. "A Double Diamond Works Wonders", one of the many advertising straplines, was on everyone's lips!'

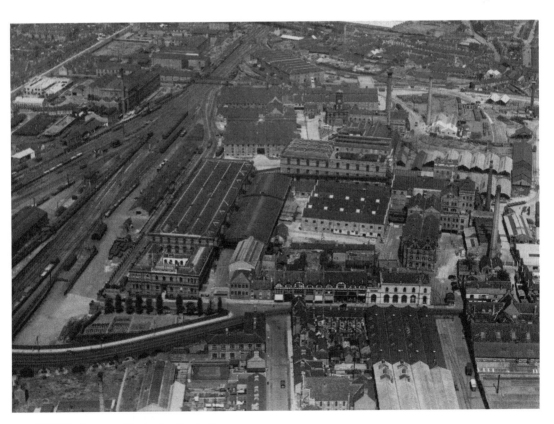

IC&A Ltd, *c.* 1947 (Author's collection).

With many parts of the brewery in regular use dating back to the nineteenth century, there was the need of either modernisation or total replacement; a commitment was made to invest in those areas that would bring a high return.[23]

Technical Director Mr Neville Thompson explained the industrial plan that would lead to greater output and increased efficiency in 1962, 'Many of you at Burton may be wondering why we have decided to move a department which has been in use since the days of Samuel Allsopp,' he asked with reference to the new Racking Room. 'It is part of an overall plan for the reconstruction of the Burton Brewery.'[25]

The department in question, at the end of A Block, already joined the existing cask washing plant, an area also due for reconstruction, this was to serve the ground floor of A Block and continue via the basement and the tunnel to B Block. The reason given was this would give more ale storage space and enable beer to be dispatched from A Block thus freeing up room at B Block loading dock. Six new 325 barrel racking tanks were installed. Steel conditioning tanks, which came from the Limehouse Brewery had also been installed, extending the conditioning rooms[25] and three additional blocks of cold room tanks were built adjoining the original store with a capacity of 15,360 barrels.[24]

A £3 million modernisation scheme was announced in 1964, which included a new barley silo next to the clock tower,[26] the previous silo had been damaged in 1944 when the force of the Fauld explosion cracked the dividing walls.[24] Conditioning and cold rooms were to be expanded, as was filtration. The cooperage was rebuilt, and the Union System, which was more than hundred years old was deemed obsolete and replaced by fifteen 400 barrel closed-type fermenters known on site as 'Mortons',[26] these were supplied by Robert Morton & Co. Ltd[27] and had a total capacity of 6,000 barrels and were so massive they had to be lowered by crane through the roof of the fermenting block.[26]

'I remember Mortons being put in, the engineers worked nights,' recalled Harold Woodward who worked as a Tunner. 'When they were completed they took the Unions out of the room above. I was the last one to Tun the Unions, I think it was number 28.'

Walkways between the office blocks and most of the brewery buildings, as well as the Silo House and small Silo Block were constructed. At Curzon Street, the original canning unit was working at full speed and a new unit was being installed enabling the production of 30,000 cans an hour. A carton-making machine, the first of its kind in the country, was also installed. Mechanisation of the floor maltings at Shobnall would enable 56,000 qrs. of malt to be produced each year.[26] There were also improvements in yeast handling and last but not least a new laboratory was built.[28]

The jewel in the crown though was a new Keg Filling Plant, in 1964 pressurised kegs were still being filled in the old racking room area, so a whole new purpose build was planned with a completion date of 1966. Sited next to the cask racking room, this was to have a Burnett & Rolfe automatic keg filling machine, which had a capacity of sixty barrels an hour but could be extended to ninety and would be fed with bright beer from six 120 barrels stainless steel tanks in an adjoining room. An Ansell type keg washer and two new Hopkins hydraulic cask washers were also planned, the latter could deal with both wooden and metal casks. The movement of cask and kegs was automated via conveyors and additional space was available for the installation of another keg racker and Ansell washer should this be necessary to cope with future demand.[28]

A further massive investment of £12 million was announced in 1967,[29] and by the early 1970s this had doubled the output of the brewery to 2.5 million barrels or 720 million pints per annum, securing the title of the biggest ale brewery in Britain[30] covering an incredible 80 acres.[29] The investment completely transformed the entire production chain; £1.6 million was spent on the new brewhouse, a 34-foot panel with 250 switches[31] controlled the twin stainless steel brewing lines capable of producing over twenty brews per day. Forty 480 barrels conditioning tanks were installed, along with forty cold room tanks of a similar size, new automatic keg filling lines with a capacity of 800 barrels per hour,[30] new malt silos, filtration units, two canning lines with capacities of 1,000 and 1,400 cans per minute,[29] thirty-nine newly designed fermenting vessels (rather than the traditional square, these were cylindrical)[31] and a new boiler house.[29]

Dr Bernard Kilkenny, the chief executive of AB (Production) Ltd commented in 1970 that there had been, 'Tremendous growth in demand for Double Diamond and DDD ... We are very proud of what has already been achieved and I know that when the new brewery is fully operational ... Burton will be the biggest brewery in Britain.'[29]

The years 1966–71 saw an average yearly rise in demand for DDD of 47½ per cent in addition to increased sales for the bottle and canned variety,[31] no wonder then that a further investment of £6 million was announced in 1971, the plan was to make the brewery the biggest in Europe capable of producing 4 million barrels per year. Robert Eades, Chief Executive of ABUK Ltd said, 'All of this has happened because of the increasing demand for Draught Double Diamond which has been the brewing success story of the century.'[32]

By 1974, it was reported in the *Morning Advertiser* that an estimated 50,000,000 pints of DDD would be sold that year[33] and the twelve months preceding September 1975 saw the brewery produce more than 2.5 million barrels. Needless to say the 2,500,000th barrel was saved for a celebratory drink![34]

The Little Man Works Wonders

The year 1937 saw the first recorded forays into the world of advertising, DD (along with No. 1 Arctic Ale, John Bull and Milk Stout) was chosen to be promoted in 'large towns and urban districts'.[35] In 1946, £3,000 was spent advertising DD mainly via posters, this increased to £20,000 the following year, with the beer being viewed as the brewery's premier quality.[36] Colour advertising was used for the first time in 1950, with a 'Walter Mitty' themed advert appearing in *Picture Post, John Bull* (the magazine, not the beer!) and *Illustrated*.[37] By the mid-1950s, DD was advertised in the press with a multitude of slogans as,

'A Double Diamond works wonders'
'Join me for a ...'

DD advert with Little Man, *c.* 1948 (National Brewery Centre).

'Thought for today: "Roll on Double Diamond time!"'
'What I wouldn't do for a ...'[38]

The face of DD 'Little Man' was born in 1950 from the mind and pen of artist Peter Probyn.[39] Originally starting life as a dejected man in a trilby hat who was enlivened by a DD with the slogan 'Double Diamond makes a new man of you'. The trilby hat quickly vanished[3] to be replaced by the more familiar 'Little Man', an immaculately turned out city gent in a bowler hat, winged collar, pin-stripe trousers, briefcase and a cane: it is hard to imagine a more English character and one more far removed from the modern concept of a superhero, but that is how he was portrayed in the media. He was designed 'to symbolise the optimistic outlook which comes from a glass of Double Diamond' according to an article in *The Red Hand* in 1952: this was beer being sold as a feel-good product, although one to be enjoyed only in moderation, at no point did Little Man's appearance slip one iota, he was not a drunk but a gentleman drinker. Little Man would feature on numerous DD advertisements, always coming out on top; catching a bottle of DD while fishing, walking away with a box of money from the tax man, performing the Indian Rope Trick, foiling a bank robbery, etc. The figure was also made into porcelain models, some of which fetch a small fortune nowadays and he was even fashioned into a six-foot-high rubber likeness for promotional purposes.[39]

The world of advertising changed dramatically in the mid-1950s, with the passing of the Television Act 1954 on 30 July 1954, the monopoly of the BBC Television Service was broken and the way paved for the first commercial channel. The prospect of advertising on television was first discussed in January 1955,[40] and a short DD advert was shot, commercial television was born as the London Station on 22 September 1955 and the advert aired the following night between 7 p.m. and 8 p.m.[41] It was a success and by 1958/59 the total advertising budget was set at an incredible £489,100, half was on television and £44,000 on neon signs, including a giant installation at Piccadilly Circus.[42]

Little Man remained the face of DD until 1962 'The Double Diamond Year' when the time was ripe for a new campaign, one that would portray their product in a more dignified light. Gone was the slogan 'works wonders' to be replaced by 'it's the beer men drink',[23] research had revealed that 98 per cent of DD drinkers were male, so a masculine image was created.[43]

The 'works wonders' campaign made a comeback in 1966 following market research: it seems that the phrase and the accompanying jingle never really left the public mind. Little Man didn't fare as well so was never reintroduced.[43]

Double Diamond found itself up in lights in 1971, all 30,000 of them as it was advertised on Europe's largest electronic newscaster at the Swiss Centre in Piccadilly Circus in London, Skol International Lager and Long Life were also featured.[32]

The Diamond Loses its Sparkle

AB Ltd's profits rose from £6 million in 1961 to an incredible £49 million in 1972,[44] but not every ale drinker was happy with his pint. Double Diamond was a victim of its own success, the very aspects that attracted the drinking public in their droves in the 1960s would lead to the backlash and change in national drinking habits in the late 1970s. The early issues of Campaign For Real Ale's (CAMRA) organ *What's Brewing* contained scathing comments about the state of keg beer or as it was touted 'The Polluted Pint'.

'Over the past ten years or so, they have managed to persuade millions of drinkers that this adulterated sludge – for that is what keg boils down to – is better than the good old-fashioned ale that we used to find decorating every bar.'[45]
'Beer is very gassy, has no life and very little taste.'[46]
'The filtered and pasteurised products of the commercial beers would be even deadlier without extraneous carbon dioxide than with it.'[33]

Campaign For Real Ale was also critical of the marketing tactics of the 'Big Six' brewers; Allied Breweries, Watney Mann Truman, Bass Charrington, Whitbread, Courage and Scottish & Newcastle,

> In the main, the big six … seem hell bent on pressuring all their beers, whether it's a good thing or bad, whether their customers want it or not. To them, it is an essential part of the drive towards whittling down choice by the introduction of a small number of beers which differ only in the amusement of their advertising campaigns.[33]
>
> During the 1950s, the reduction in the price of aluminium and particularly stainless steel made it economic to use these metals in manufacturing brewery equipment and beer containers, both kegs and casks, which for the first time allowed the production of draught products.

David Cox explains. 'Because of vastly improved hygienic standards and microbiological control, with extended shelf lives of several weeks, such products could be distributed and sold nationally and indeed internationally.' 'It was all about keg beer in the 1960s and 1970s superseding cask beer,' explains Production Director Mike Hubbard.

> There was a logic for that because cask beer was notoriously badly kept post war, there were people running licensed premises who were not trained and frankly some were doing it as a little retirement job. It was a common thing with the police force for example, if you managed to get out and take a lump sum you would go and buy a pub. So the quality of cask ales was on the way down and keg beers were the ideal thing. I remember as a student drinking Watney's Red Barrel and DDD. There was a call for it.

This is confirmed by comments such as *What's Brewing* June 1973, 'Keg – the answer to an unskilled landlord's prayer,' consumer organisation *Which?* concluded that '… it kept longer, it was easier for publicans to look after.'[46]

The general state of play was summed up by CAMRA Chairman Michael Hardman who was quoted in a report in the Sunday newspaper *News of the World*, 'Much of the blame for the pathetic state of beer today can be put on the drinkers… who have accepted the mass introduction of the adulterated sludge that is glorified under the name of keg.'[46]

David Cox takes up the story:

> Their very consistency was to cause their eventual decline: they became perceived by the drinking public as 'homogenised, pasteurised dead beers', lacking the character of cask conditioned 'real ales'. (There was a concurrent development which was also to have a large effect: the growth of lager, attributed in the beginning to holidays abroad developing a taste for them.) Thus was born The Campaign for Real Ale, CAMRA, a consumer pressure group which was to become one of the most successful ever. Their biggest target, the one which was the biggest culprit against the interests of 'real ale', was DDD Ind Coope at Burton was vilified, despite the fact that many cask conditioned beers were produced there.

Campaign For Real Ale turned its wit and poison pen towards the poisoned pints produced by Ind Coope, a badge with the slogan 'DD is K9P' (think about it) was produced in the early 1970s[47] and the £12 million investment was dismissed in *What's Brewing* as 'solely to increase the capacity to churn out Double Diamond'.[46]

'By the mid-1970s, the anti-national keg/pro real ale lobby was responsible for resurgence in demand for good cask ales. As a result, Allied decided to ask Ind Coope Burton to present a new product,' says David Cox. This would be Draught Burton Ale, which was awarded the CAMRA Supreme Champion in 1990, but that is another story.

The bottle and can version underwent a rebranding in 1979, for the first time since 1876 the name changed. 'Double Diamond Burton Pale Ale' became 'Double Diamond Burton Export Ale' and the packaging design went from the white and yellow to a more serious black, with the '◊◊' trademark and

Red Hand reinstated.[48] With a gravity of 1045–1049, 4.3 per cent alcohol, the brew was described as 'a taste without equal ... highly distinctive full bodied bitter-sweet.'[49]

Canned DD may still have been a good seller, in the top ten for England and Wales,[48] but this was a far cry from Calder's 1959 observation about DD being 'the largest better class beer sold in Britain'.[10] The 'works wonders' campaign also made a return in 1980 proclaiming 'Double Diamond Still Works Wonders'. The slogan was described as 'probably the best known of all beer advertising slogans' by Product Group manager Trevor Windle, although Carlsberg UK would have no doubt disagree![49]

Despite the rebranding by the end of 1986 DD was floundering. A marketing and sales news report in the *Burton Herald* described the situation, 'As we all know, sales are declining at the once great star of Allied reaches pensionable age.' A new campaign that centred on a new pump tap was introduced, the objective was not to completely revitalise the beer or capture the imagination of a new generation of drinker, but simply to 'to reduce the rate of sales decline by half'.[50] It was clear that DD had had its day, it was yesterday's Little Man and instead of looking after this pensioner last orders at the bar were called and DD was put in the marketing equivalent of a nursing home and allowed to fade away.

'I suspect that DD could have been rescued,' muses Mike Hubbard. 'I don't know in what form but the name was dominant. I was told of the Duke of Edinburgh going to Scottish & Newcastle and opening a packaging line and saying "I am only here for the beer" which must have gone down like a lead balloon because that was the strap line for DD! He was a great DD fan.'

The story though doesn't end there; DD was a top seller in the United States and in Canada were it beat such competition as Bass Pale Ale and Newcastle Brown.[51] Back home though it was a case of: the Burton brewed pale ale is dead, long live the Burton brewed pale ale! Sales of Draught Burton Ale began to take-off, especially after it won the CAMRA Champion Beer of Britain in 1990,[52] but did DBA kill DD?

'DD was sinking before the advent of DBA,' reflects Colin McCrorie, the last QA Manager before Carlsberg-Tetley Ltd was bought by Bass in 1998. 'Along with a decline in demand for bottled brands, as the can versions started to grow. The promotion during the early 80s of "all things lager" also wouldn't have helped the survival of DD.'

The real reason behind the demise of DD was the mismanagement of the brand, as McCrorie explains, 'What really killed DD was the same disorder that killed Skol: brand dilution.' A strong brand name, e.g. Skol and DD, is then extended from the original liquid/package combination to cover other liquids from the same stable, often in different packaged forms. The example of Skol takes the original bottled product, extends it to a can, then keg and then with the advent of premium bottled beer to Skol Special Strength Pilsner Lager, which is higher gravity Skol. 'For DD it was a similar story. The bottled version moving into can, then into keg as DDD with a much lower OG, DDD Export, DD Export ... so the customer is bewildered by what exactly is meant by the original brand name. As demand sunk, the brand lost its uniqueness.'

Shine on You Crazy Diamond

Double Diamond may have just survived the merger with Carlsberg UK, but it didn't survive the Bass takeover. The last meaningful brew in Burton was in the Experimental Brewery,[53] then renamed the Samuel Allsopp Brewery Company (SABC) under the supervision of General Manager and Brewer Kev Slater,

'The Tapsters Choice program introduced guest ales in to the estate on a two week rolling basis across the whole of the country,' explains Kev. 'In 1994 the Experimental Brewery was bought back to life as the Samuel Allsopp Brewing Company this was the ideal size to accommodate and satisfy the Tapsters Choice volumes.'

The SABC were to produce a wide range of ales, two of which are important to the story of DD.

'When I started I wanted to try and recreate some of the bygone ales which Samuel Allsopp was famous for,' says Kev. This was made possible by the discovery of old recipe books that sadly

now seem lost. 'One of the ales produced in spring/summer of 1996 was Triple Diamond, based on Double Diamond. I used Pale Malt, Torrified Wheat and Crystal Malt, the only difference in the recipe was the hops as the original recipe called for a variety that was no longer available, so I used Fuggles for bittering and for dry hopping.'

It is fitting that the story of DD has a regal end, HRH the Duke of Edinburgh was reported in 2010 by the Daily Mail as enjoying 'a glass or two of Double Diamond beer'.[54]

'"Royal Diamond (Dukes Ale)" was produced to commemorate the visit of HRH the Duke of Edinburgh on the 7 December 1995. This beer was a copy of the original Samuel Allsopp's Single "D", a brew from which the famous DD was developed,' reveals Kev. 'He toured the whole brewery, including the Allsopp's Brewhouse, where we timed it so the beer was at the boiling stage when he arrived. I can remember him being asked if he would like to add the hops to the copper. Six cases of the beer were sent to Buckingham Palace for his consumption.'

Royal Diamond – Dukes Ale (Kevin Slater).

CHAPTER 13

IDENTITY

Allied Breweries

At the dawn of the 1950s, IC&A Ltd had the following subsidiary companies: Allsopp Brewery Investments, All Saints' Brewery, Alton & Co., Archibald Arrol & Sons, Alloa Bottling Co. Colchester Brewing Co., Coopalls, B. Grant & Co., Graham's Golden Lager, Hall's Oxford Brewery, Hibbert's (Home Sales), Leeds City Brewery, Lichfield Brewery, New Victoria Brewery, Nicholl's Mineral Water Co. Strettons Derby Brewery, Taylor & Co. (Nairobi) and Wrexham Lager Beer Co.[1] This list excludes all the breweries that had been bought out and subsequently closed down since the early 1910s. Unfortunately, the histories of these companies lie outside the scope of this book.

Further breweries were acquired during the 1950s: Cowley Bros. 1955, Benskin's 1957, Hambridge Brewery 1958 and Taylor Walker 1959.[2] More companies meant a larger market for IC&A Ltd's beer that would see massive investment during the 1960s leading to the site being declared the largest in the country by 1970.[3]

Sir Edward Thompson in 1961 (National Brewery Centre).

During this time of expansion the company identity remained intact, but in 1959 the name Allsopp, which had existed in the town since 1807, was dropped. The move back to Ind Coope Ltd was justified in a letter sent to all customers, 'The present name of Ind Coope & Allsopp Limited is extremely cumbersome for advertising and publicity purposes, and the shortened form will in the long run be a great improvement.'[4]

The 1959 merger with Taylor Walker had made the company the joint biggest brewers in Britain[5] but was soon to be eclipsed by the events of two years later. Such was the need to keep these plans secret, two picnics were held on a Derbyshire hillside in January 1961, where Edward Thompson met with two other brewery heads from Ansell's and Tetley Walker. The resultant merger was worth £126 million. The new company ironically also had an extremely cumbersome name: Ind Coope Tetley Ansells Ltd (ICTA Ltd) and boasted 9,300 pubs, twelve breweries and a vast Wines and Spirits business[6] and it would remain the country's largest until the formation of Bass Charrington in 1967.[7] ICTA Ltd was renamed in 1963 to the catchier Allied Brewies Ltd.

Following the formation of ICTA Ltd, the company was run as Thompson described it, 'A Commonwealth of Brewers'. The two new breweries brought their own strong brands; Tetley Bitter (popular in Yorkshire and Lancashire) and Ansells Mild (stronghold in the Midlands especially Birmingham). ICTA Ltd controlled 10 per cent of the 70,000 nation's pubs, with assets totalling £67.3 million (IC £36.6 million, Tetley £17.0 million and Ansells £13.6 million).[8]

The Commonwealth had a very loose structure: traditions long held at Ind Coope, Ansells and Tetley Walker (itself the result of a recent 1960 merger between Joshua Tetley and Walker Cain) were so deep-rooted that this was a move born of necessity. Rationalisation of production and retail, especially where there was overlap, was required but it took until 1969 for centralisation to happen. During the 1960s the structure of AB Ltd had become ever more complex with 247 subsidiary companies listed by the end of the decade, consequently it found itself struggling to deliver the corporate strategy for the production and distribution of its national beer brands.[9] A new holding company ABUK Ltd came into existence in April 1970 and was tasked with managing Ind Coope, Tetley, Ansells, Ind Coope (Scotland) and Allied Breweries (Production). ABUK Ltd was based at Burton[10] and the Ind Coope Brewery was also renamed ABUK Ltd.[11]

Mike Hubbard joined the company in 1968 and recalls a loss of identity caused by the name changes, 'When I was employed, it was by Allied Breweries not Ind Coope, you didn't hear much about that name in the late 60s until you came into the place and you learnt what IC Gate and A Gate stood for,' this being Ind Coope Gate and Allsopp Gate respectively. 'People tended to lose sight of the old name Ind Coope although we talked about it internally. I think our internal magazines were still badged with Ind Coope, whereas with Bass: it was Bass, Bass, Bass all the time!'

David Platt sees the change from a different perspective:

> Most people felt that Allied Breweries was a "non-name". When I am asked me what I did and I say a brewer: they'll say who with and if I say Allied Breweries: they'll say who? But if I say Ind Coope they'll remember them. Allied Breweries didn't have any impact on the place, there was no antagonism.

Leaders of Men

Many of the IC Ltd directors also held positions at AB Ltd. The previously mentioned Sir Edward Thompson, the son of Neale Dudley Thompson was chairman and managing director of IC Ltd. He became the first Chairman of AB Ltd, he was knighted in 1967 and retired at his own request in 1968, although he maintained his seat on the Board. He was famously referred to as 'the world's number one brewer'[12] and drove a car with the registration plate ALE1.[13]

Sir Gerald 'Mr Joe' Thorley was the son of Clement Thorley. He became senior managing director of IC Ltd in 1963 until 1968 when he took control of AB Ltd Brewery Division.[14] He

became chairman of AB Ltd in 1970 after the resignation of Sir Derek Pritchard[15] and was knighted in 1973 and retired in 1975 after which Keith Showering took over as chairman.[16]

Group Captain Bernard Carfoot OBE was the son of Chief Transport Manager Mr Bernard Carfoot.[17] He was chairman and chief executive of IC Ltd and then in 1973 he became chairman of ABUK Ltd, retiring in 1975.[18]

Mr Neville Thompson, the brother of Sir Edward, was a trained architect. In 1944, he was appointed assistant managing director at IC&A Ltd and subsequently managing director. He took charge of designing, construction and reconstruction of the company's breweries, bottling stores and licensed properties. He was later technical director of IC Ltd and after the formation of AB Ltd he held a roving commission. By the time he retired in 1974 he had been involved with more than thirty breweries across the globe.[19]

Mr Jim Murray was interviewed by John Calder in 1936, he recalled the advice he was given, 'So you want to be a brewer Murray: it's a hard life.' As a teenager his working day started at 4 a.m. and finished at 6 p.m., all for the princely sum of £1 a week. He trained at Alloa and was appointed head brewer in 1951. After a time at Wrexham, he came to Burton in 1966 as head brewer, became brewery manager in 1969 and in 1972 a director of AB (Prod) Ltd.[20] He passed away aged ninety-two in 2012 and was described as 'the last of the gentlemen brewers'.[21]

Everything's Gone Green

By the 1977/78, with sales of DD showing a 60 per cent drop from 1971 to 1972 (particularly in Ansells and Tetley territory) a major change was brought about in which the centralised organisation became decentralised once more. The problem was that ABUK Ltd was too large to respond quickly to local requirements: the industry had changed thanks to groups like CAMRA who were demanding regional cask ales with character rather than bland fizzy keg bitters and lagers. There was the third name change in less than twenty years and thus Ind Coope Burton Brewery Ltd (ICBB Ltd) was created.[9] ICBB Ltd had control over its own destiny, 'We are now brewing under our own name' commented Managing Director Norman Crow in 1981,[22] and was tasked with producing just under half of ABUK Ltd's beer and lager, including all cans and bottles, as well as having Allied Take Home as a subsidiary company.[10]

The company underwent a major image change in 1981, gone were the brown uniforms of ABUK Ltd, replaced by a green and yellow colour scheme that adorned everything from overalls to wagons, designed to make 'the new identity of Ind Coope Burton Brewery come to life'.[22] A 20-foot-high golden hand was attached to the 170-foot-high chimney stack, which when floodlit was visible from half a mile away.[23]

Ind Coope Bitter was launched in 1982 with the strapline 'Give it the elbow'[24] and the brewery even had its own tied estate of forty pubs that stretched from the two brewery taps *The Roebuck* and *The Devonshire Arms* on Station Street, to properties as far away as Derby, Tamworth, Uttoxeter and Ashbourne.[25]

CHAPTER 14

DRAUGHT BURTON ALE

The Origin

'Marketing asked us to provide some samples to taste with the only guidelines of a premier cask beer, mid-range colour and a gravity of around 1045,' David Cox explains,

> What was to become Draught Burton Ale was one of about a dozen we put up in the sample room one sunny day in early 1976. The one chosen was not too pale, it had a good ABV of around 4.5, was full and malty and most especially had a strong dry hop produced by a good dose of Northern Brewer. My favourite which marketing accepted, was what became DBA: so I invented it!

Ind Coope Burton Ale Label, late 1930s
(Keith Osbourne).

Roger Peach, who was a Tanker Bay Operative at the time, also unknowingly played a part in the story. He'd been asked to supply two firkins for a retirement party in 1974 as was the custom, and as was common practice they got more than they bargained for!

'We used to get do's and they'd send the order down,' recalls Roger. 'They wanted two firkins for an Engineer's retirement and what we should have put in was light ale. If the gaffers were going to be there I'd put one on of light ale, which they drank from, and another one: this was a mix of bottling DD, about seven and a half to eight gallon in a firkin and a gallon to a gallon and a half of Triple A, which made it a nice blend, and that is what they were drinking that day.'

> Everyone knew what they liked to taste, but we didn't do one in a specific beer so a blend of the two gave you what most people liked: a bit of gravity and a bit of body about it. Bottling DD was a nice drink on its own, about 4.6 per cent and Triple A was 9.5 per cent, so blended it was about 5.0 per cent. The Triple A gave it that unique taste.

The story goes that Roger was spotted serving the workers from this mystery firkin, and Geoff Mumford asked him for a couple of pints for himself and boss Roy Moss.

'Roy came back to me and asked me what it was,' says Roger. 'I said it was bottling DD with a twist, I didn't tell him what the twist was.'

It seems likely that Roy Moss then ran with the idea of producing what was later to become DBA.

'They needed a flagship beer at the time to boost their image,' states Roger. 'One that'd pull the company out of the crap as they hadn't got a premium cask ale. When DBA came out it was to save the fact that DDD was going down the pan.'

When asked if it was bottling DD he was serving that day, Roger denies it, 'I only ever did one with just bottling DD in and that's because they specified it.'

DBA Myths

DBA was not a true Burton ale at all, but a pale ale. The confusion probably comes from the name and the label which harked back in design and the distinctive green colour to a Burton Ale that was produced by IC&Co. Ltd pre-1934, featuring the Britannia trademark, and was still in production with a Red Hand in place in 1938.

Draught Burton Ale was known locally as 'DBA', your author recalls ordering a pint on the Isle Of Wight, only to receive the reply that they didn't sell it, although they did serve 'Burton' instead.

The only similarity between DBA and DDD (the keg version) was that both were Burton brewed pale ales. DBA was not a descendant of DDD. The confusion most likely comes from the way DBA was brewed from the late 1980's onwards. The base for DD and DBA was one and the same. It was the same product coming from the brewhouse and only later was DBA turned into a cask beer with primings and dry hops.

In the late 80s and early 90s the production process had become so complex that it threatened both quality and costs. 'We had a big drive for two years to simplify the production process. It was essential that we did this because our product portfolio had become so complicated, especially as we had taken on so much contract brewing from smaller breweries which were closing. We reorganised our product range into what we internally called "The Beer Tree",' reveals Mike Hubbard. 'You'd start out with the smallest number of brew types and gradually work down the system, splitting them up and differentiating further and further down the line.

Colin McCrorie explains the 'The Beer Tree' further: "Analytically all beer qualities can be defined by OG, PG, ABV, bitterness and tint. So a Mother Beer plan depends on brewing a high gravity feedstock with an ABV significantly higher than its Children Beers and with proportionately higher tint and bitterness values. By adding de-aerated water, a controlled

source of colour and bitterness after fermentation, either at transfer into Cold Tank or pre-, post-filter, the Mother Beer can be diluted and adjusted to a new brand target specification.'

From Retirement to Champion!

The launch came in May 1976 at an Open Day in the IC Reception Centre and they managed to sell sixteen Kilderkins, by its first birthday it was exceeding the target of one Kilderkin a week per outlet, but most importantly customer opinion was complimentary, even CAMRA was on board.[1]

The first award came in 1979 in the *Sunday Mirror Beer Contest*, when DBA won first prize in the 'Best Southern Bitter Category (OG 1044-1054)'. By this time the ale was being sold in hundreds of Ind Coope pubs and free trade outlets in Southern England.[2]

A novel form of advertising was used, with the registration No. RFA 406J, the DBA bus became a familiar sight on the town's roads from 1979 onwards,[3] the rear-engine *Daimler Fleetline* bus[4] featured eleven oversize pints.[3] Another bus was launched in 1985, a *1981 Dennis Dominator* registration No. PRE 39W was painted to advertise DBA, Ind Coope Draught Bitter and Ind Coope Bitter.[5]

'Draught Burton Ale is the best beer on the market,' claimed David Cox in the *Burton Herald* shortly after he returned to ICBB as managing director in 1982.[6] Cox had left Burton in 1977 to take up the position of production and distribution director at Warrington[7] and no doubt was impressed how his creation had developed.

The Guild of Master Cellarmen was launched in early 1985 and served as a mark of the quality of the cellarmanship of landlords for their ability to keep cask beers, especially DBA.[8] This was a twist on the idea of Super Draught that had been used over twenty years ago for keg beers and was an indication as to how the market and drinking habits had come full circle. 420 landlords qualified for the title and a special presentation lunch hosted by Head Brewer Peter Sunderland was held for forty of them at The Southbury Hotel in Enfield.[8] By 1992 there were thousands of members, all qualified to display an individually numbered brass pump topper and a plaque that stated 'Awarded to the publican of this house four outstanding professionalism and cellar management'. Membership stretched across England and Wales, from *The Hawkins Arms* at Truro in Cornwall in the south to *The Chichester Arms* in South Shields in Tyne and Wear in the north. Local to the Brewery there was *The Roebuck* and *The Devonshire Arms*, *The Chesterfield Arms* on Ashby Road and *The Gardens Hotel* on Ferry Street in Stapenhill.[9] In 1987 Geoff Jones, the house manager at the Sports & Social Club also became a master cellarman, Geoff attributed his success to the training he had received at the Sample Cellar.[10]

£250,000 was spent on advertising in 1988; this was doubled in 1989 with a campaign that although clever and aimed at 'the knowledgeable beer drinker' it was also slightly misleading. When imprisoned in near-by Tutbury Castle, Mary Queen of Scots was said to have drunk Burton Ale, the poster claimed 'Today, Ind Coope's Burton Ale uses the very same Burton water as the drink that was Her Majesty's pleasure.' This may have been true, but the type of beers would have been totally different, Mary would have enjoyed traditional Burton Ale, stronger, darker and sweeter as brewed in the days of the Wilsons.[11]

A famous sign made its first appearance in 1989, by the Leicester Line Bridge on Branston Road, hand painted by brothers Malcolm and Ted Bower. The sign took three weeks to hand paint and proudly stated 'Ind Coope Brewery welcomes you to Burton-upon-Trent. The home of the well-bred pint.'[11]

The year1990 was a watershed year in DBA's history when it won the prestigious *CAMRA Champion Beer of Britain* award, this was a first for a beer from such a large brewery. The decision had been made at the *Great British Beer Festival* following blind tastings by the expert judging panel.[12]

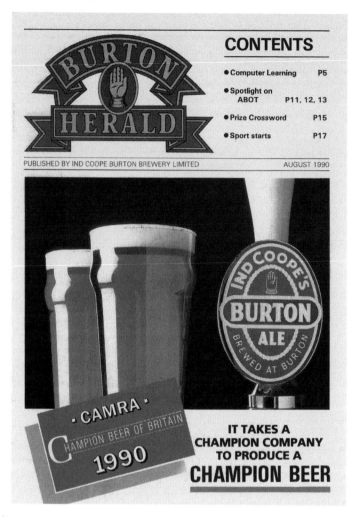

Burton Herald August 1990 (National Brewery Centre).

'I wasn't that surprised to be honest with DBA winning, what did surprised me was that CAMRA allowed us to win,' admits Mike Hubbard. 'It was tremendous for morale because CAMRA were not enthusiasts of big breweries, which was a bit insulting to our own brewers who for the most part were real ale brewers. People like Peter Sunderland, our head brewer, who had previously worked at Tetley's and our team leaders, most of them had spent their time producing real ales and were real ale enthusiasts.'

'It was an opportunity lost in some ways because I think we could have made much more of the marketing of the product than we did, but winning awards doesn't necessarily generate volume or income,' ponders Mike. 'It is more kudos.'

CAMRA was delighted when DBA won Champion Beer of Britain as it showed the national brewers were responding to drinkers and we hoped it would encourage other nationals to follow suit or, in the case of Bass, to promote Draught Bass rather than Carling,' states Roger Protz, world renowned beer writer and editor of CAMRA's Good Beer Guide. 'When I'm in Burton I always drop into the Roebuck in case DBA is on. The award was presented at *The Doggett Coat & Badge* public house on Blackfriars Bridge, London to Peter Sunderland, Barry Jones,

trade liaison brewer, David Gass, brand manager and John Haywood, public relations and commercial manager.

'We are delighted that Burton Ale has been selected as the Champion Beer of Britain,' said Barry Jones proudly. 'Reflecting the hard work and dedication of both Ind Coope Burton Brewery and the Guild of Master Cellarmen.'[13]

'DBA was a milk cow,' reveals Mike Hubbard. 'It was the sort of product that with care you could get routinely right and ship off. Getting our products "right first time" was our mantra in the late 80s. DBA could be a very profitable product.

'I have a feeling that Burton Ale went over 100,000 barrels one year, it may have reached 120,000 barrels which is big, and then gradually started to fall back,' the problem, as Mike explains, lay not with the product, but with the lack of marketing spend. 'When we merged with Carlsberg and Carlsberg got their hands on the tiller, as opposed to Allied Breweries people, they had little time for DBA. No enthusiasm. I'm sure they thought that if people stopped drinking it, they would just switch to Carlsberg. It doesn't make any sense at all really. They never understood the real ale market.'

DBA did survive after Carlsberg UK sold the Ind Coope premises to Bass in 1997, production was moved to Tetley's in Leeds, at a time when the main focus was on making keg Tetley Bitter a national brand and then finally to J. W. Lees in Manchester before Carlsberg UK finally called time on the brand in the autumn of 2014. On the back of this announcement a campaign started, calling for the re-launch of DBA as a Burton brewed beer, receiving backing by CAMRA's Roger Protz and local MP Andrew Griffiths.[14] Geoff Mumford and Bruce Wilkinson of *Burton Bridge Brewery* took up the challenge and in March 2015 there were two thirteen barrel brews[15] to be served at the *36th CAMRA Beer Festival* at Burton Town Hall and in their tied estate. The beer proved to be a great success, selling a firkin in two and a half hours.[16] Their version of DBA has now become a permanent fixture in the brewery's portfolio.

The Return

What follows is a personal account of brewing DBA at Burton Bridge Brewery.

When you start to write a book about the history of a defunct brewery, the last thing you expect is for the story to pick up again and to be involved first hand, but that is exactly what happened on 4 March 2015. When the Burton Bridge Brewery announced that they would be brewing their own version of DBA, I asked if I could go and watch, and thanks to Stephen Sinfield from the Burton Mail I managed to do that and a whole lot more besides!

I had expected to be a spectator but I was quickly put to work along with CAMRA's Regional Director Nik Antona. We were instructed to weigh out the four varieties of hop that would go in the copper. The malt, a mixture of pale with a hint of crystal, needed to be poured into the hopper for the next day's brew. The plan had been to do a single thirteen barrel run, this was quickly extended to two after the first sold out immediately. All of this was done under the watchful eye of Head Brewer Bruce Wilkinson. After Nik removed all the spent grains from the mash tun, it was my job to clean it, ready for the hops to be added. As the wort cooled through the paraflow, the air became filled with a gorgeous aroma taking me back to being a small child walking to town with my Mum down Station Street. To non-Burtonians this was often a stink, but to me it is one of the finest smells around. As the wort cooled, it was pumped to the vessel FV5 in the fermentation room where it was pitched with yeast. The water was from the town's supply that had been Burtonised, the malt and hops as close as memory and current availability would allow, only the yeast differed.

I had a fantastic day, which made the couple of pints I managed to drink on the opening night of the beer festival taste even better!

CHAPTER 15

SKOL

The Legacy of Percy Allsopp

The following statement appeared at the SA&S Ltd Executive minutes from 6 March 1900, 'That the thanks of the Board be given to Mr Allsopp for his assistance to the Company in the past'.[1] This rather polite comment was in response to the resignation of Percy Allsopp a few days before. The damage he inflicted has already been detailed, but ironically Percy left a legacy to the company albeit it one that would take 60 years to bear fruit.

Graham's Golden Lager/Graham's Skol labels, *c.* 1940–59 (Keith Osbourne).

Without Percy, there would have been no Allsopp's Lager: when the drink was discontinued in 1921, the whole plant was moved to Achibald Arrol's brewery in Alloa. Allsopp's Managing Director John Calder was also a director at Arrols, and the plant was put to use brewing lager for Scotland. In 1927, Calder developed a lighter lager that went under the cumbersome name of Graham's Golden Lager, and it was this drink that underwent a rebranding in 1959, first as Graham's Skol and then simply Skol.[2]

Calder recounted the early history, 'In order to satisfy the prejudices of Allsopp's old shareholders against the words "Allsopp's Lager" which had cost them so much loss, I formed a new company called Graham's Golden Lager, and this with all the power of the company at its back developed into a gigantic business too.'[3]

The Growth of Lager

The growing importance of lager was first noted back in 1955, when the new Chairman Edward Thompson prophesised in a meeting 'that the day of the lighter beer was approaching',[4] and he also noted that Alloa was producing such a beer. Lager quickly became a priority, and they became convinced that with the right approach and advertising, a home market could be found.[5] By the middle of 1956, Neville Thompson was asked to report on the capacity of Alloa and whether there was a possibility of Wrexham Brewery taking on some of the production.[6] The feasibility of opening a new brewery dedicated to lager was considered, as this may be cheaper than developing Alloa and Wrexham,[7] but following consultation with Gerald 'Mr Joe' Thorley this idea was dismissed.[8]

In April 1957, an approach was made by Heinekens with a view to IC&A Ltd and a third party, possibly Barclay-Perkins/Courage, forming a new company and opening a new lager brewery near London, with the objective of developing Heinekens lager in this country.[9] Compared to Tuborg and Carlsberg, the brand Heinekens was not well known, so approaches were made to both Turborg and Carlsberg about a possible association in which they had technical control over the production of a continental lager.[10] Two distinct markets had been identified: a bottom fermented non-lager beer (IC&A Ltd was already the market leader with Long Life) and the second a traditional lager. Although the partnership was described as 'highly desirable', the plan was to 'delay the building of a "partnership brewery" for as long as possible' until the Long Life market had developed sufficiently to take up the capacity at Alloa and Wrexham.[11]

Negotiations soon broke down, and a decision had to be made in the light of 'the assumption that lager will be one of our best sellers'.[12] In the end, it came down to one simple consideration, 'Are we going to make more money on our own or through an association?'[13] The answer lay closer to home: Graham's Golden Lager.[14]

Graham Says 'Skol'

For advertising reasons, the name changed to Graham's Skol[13] and then simply Skol.[15] The word 'skol' derived from Swedish or Norwegian 'skal' and means 'good health' or 'cheers'.[16]

Production ramped up at Alloa[17] followed by a £1.35m investment at Alloa and Wrexham.[18] The advertising campaign was aggressive, the budget rose from £80,000 in 1959/60 to £325,000 in 1960/61[19], and it was very successful: by mid-1960, Skol had 'established itself as the best-selling British-brewed lager'.[18] In 1961, Director Mr J. L. Le Fanu was given the title 'Mr Skol' as the Chairman of Skol Lager Ltd,[20] under his direction sales continued to rise, and in a 1962 article he commented that lager consumption in Great Britain had increased tenfold in twenty years. In 1960, lager was two per cent of all beer sales: this had risen to about 3.5 per cent, which in his words 'means a lot of lager'. The market had changed, previously

Skol labels, *c.* 1960 onwards (Keith Osbourne).

Danish brewers Carlsberg and Tuborg were dominant, but now Carling from Canada, Harp from Ireland and Heineken from Holland were all serious competitors.[21]

The new Wrexham Brewery, costing £2.5 million, opened in July 1963 and was capable of producing 100 million bottles of Skol per year.[22] By 1965, Skol underwent rebranding to Skol International, which bore a resemblance to Skol, but they had 'introduced certain refinements in the process'. The new product was available in two strengths, Skol International and the stronger Skol International 2000.[23] The new company was in fact a partnership with three overseas brewers: John Labatt Ltd of Canada, Pripp-Bryggerierna AB of Scandinavia and Unibra SA of Belguim.[24] As suggested by the name, this was the start of the Skol franchise spreading across the world, Cervezas de Santander had opened a brewery in Spain, New Zealand Breweries had been in production since Autumn 1964,[25] then by 1966 Oranjeboom in Holland, Lisbon and

Portugal.[24] 1967 saw Skol in Italy, Algeria and the Democratic Republic of Congo, and the list got longer and longer.[23]

Skol Liqueur Lager was launched in 1967, a special high gravity version of Skol International, it had previously been brewed and given out as Christmas presents. Available only in nips, it was described as having 'an exciting flavour and is smooth, strong and dry, and is brewed "for the connoisseur"'.[25]

Skol Comes to Burton

Throughout the 1960s, the brewery at Burton played an important, but minor role in the Skol story. All keg Draught Skol brewed at Wrexham and Alloa was packaged on site, while the canning and bottling was performed at Curzon Street in Burton, as David Platt recalls, 'Draught Skol was done at Wrexham and Alloa, bottle Skol was done at Burton, as was canned Skol.'

As the sales of Skol increased, further expansion was needed which was not possible at the existing Alloa and Wrexham breweries, enter Burton and one David Platt:

> Skol was moved to Burton because of the volume required. I came back in November 1971 with the major objective of putting Skol into Burton, so it was launched in 1972. We built a new Cold Room, No. 7, and we moved from double-strain yeast AB36 and AB94 to single-strain yeast, and then, it was perfectly straightforward. It was a lager yeast, lager malt, low-coloured, with crystal if necessary. It was fermented in No. 7, Cold Room, centrifuged and pumped back. There were always problems with getting the yeast off due to the shallow bottoms, and as the tanks were so big and exposed to the outside air, we had problems in keeping them cold.

The worldwide future of Skol was discussed at length by the AB Ltd directors in 1984. The brand was selling 5.24 million barrels per annum, generating a profit of £22.5 million, but since the 1970s, the number of countries brewing had fallen. Skol International was 95 per cent owned by AB Ltd and had assets of $1.4 million. The options were to close Skol International (this was dismissed outright), to invest and build it up to be a 'Category A' brand or to treat it as 'B+ Category' by committing limited resources. It was decided to give 'a modest increase in effort'.[26] The market had developed so that 'the sale of lager was now approaching that of ale'[27] so this decision may appeared short-sighted had there not been another factor at play: Castlemaine XXXX that had just been launched.[28] Initially brewed at Wrexham, this would eventually be rolled out to Alloa and Romford in 1986[29] and finally Burton.[30] By March 1986, Castlemaine XXXX 'had succeeded beyond expectations', and the brand was to go national by the summer. A further attack was on Skol Special Strength Pilsner Lager, which 'was to be replaced as far as possible by draught Löwenbräu', another beer contract brewed at ICBB Ltd.[31]

Skolars

The most highbrow of all the Skol advertising campaigns was launched in 1979. Brand Manager Julian Bond explained, 'Our Skol commercials are not about Teddy Bears or the Sahara Desert, they are all about drinking good lager in your local pub.'[32] The 'Seat of Learning' advert showed a typical pub scene, with a game of darts in play 'Skolars of aerodynamics' and late actor Kenny Ireland adding up the scores 'Skolars of mathematics'. The message was simple 'When you know lager, you're a Skolar'.[33]

The campaign was so successful; it ran for a number of years and even jumped on *The Hitchhikers Guide To The Galaxy* bandwagon in 1983 featuring Trevor 'a hyper intelligent mega being from a distant galaxy' who could score 180 at darts with his eyes closed, 'beat Space

Invaders at their own game'[34], and most importantly after travelling light years to Earth, he knew what the best lager in the world was: Skol.

Eventually, the yellow-colour scheme was phased out, replaced by red, gold and black, 'a new and up to date look which gives the brand a high degree of awareness and more accurately reflects its high quality.'[35]

Horribly Good

In May 1986, the story of Skol took a 'horrible' turn with the announcement of a new advertising campaign: *The Sun/News of the World* character Hagar the Horrible was to be the new face of the brand. It was claimed that Hagar was 'the most widely syndicated cartoon character in the world' with an awareness as high as 75 per cent among Skol's own target audience[36], the character, along with supporting cast first appeared in 1973[37] and featured in newspapers all around the world.

The campaign was an assault on all fronts, first there was the strapline 'Skol. Horribly good lager' followed by TV adverts, national door-to-door leafleting, plus promotional items like novelty dripmats and T-shirts,[36] but the arrival of the cartoon Viking was not welcomed by everyone, especially those at the top who could see the bigger picture.

'I went to a presentation and after we came out people were saying to me "That's it then, Skol's done for!". Hagar the Horrible: horrible beer for horrible Hagar, because Hagar was a horrible character. You couldn't do any better than that to trash your product,' explains Mike Hubbard, although this was just another nail in the coffin as far as he was concerned.

> We failed on Skol, it could have been a great brand and it was in the late 60's and 70's but then we started mistreating it, we failed to grasp it. At that time Carlsberg still had that beautiful strap line 'Probably the best lager in the world' that is so effective at the bottom of all your adverts. You couldn't compare the two.

Initial reports showed that the Hagar campaign had not achieved the hoped results. At board level, it was debated if Skol was a true competitive brand, or just a 'cash generator'.[38] In 1988, it was certainly a seller, rated the country's fourth most popular lager.[39]

Super?

Skol entered the extra strength market in 1986 with the launch of Skol Extra Strength 1080 in half-pint bottles and 440-ml cans. It was the first major brand ever to declare the Original Gravity in its name, promising 8.5 per cent alcohol and a 'very strong lager'.[40] It was rebranded as 'Not your average beverage' in 1991 with a classy gold design,[41] but ICBB Ltd would even outdo this monster in the mid-1990s with Skol Super at a whopping 9.2 per cent! The beer is now brewed by Carlsberg UK and is still in the news. Recent campaigns have led the brewer to promise to either reduce the size of the 500-ml can or water the beer down slightly.[42]

Skol's Out!

Advertising agency Leagas Shafron Davis Chick was given the unenviable taste of promoting Skol in 1991. Skol, now graded as a 'downmarket lager', needed its brand image 'to be restored to being acceptable, without going too far' as the lager was in trouble. Without some intervention, Skol would 'continue its slide towards being yesterday's brand'. The Skol

drinker 'felt disappointed that their brand had been neglected', echoing the comments of Mike Hubbard.[43]

With Castlemaine XXXX advertising heavily on TV, it was decided to opt for a poster-only format, and the resultant advertising campaign 'Faces'[44] was as clever as it was crass, coupling unfashionable talking heads and phrases to what had been allowed to become an unfashionable lager. The letter O in Skol was replaced by various heads; Alan 'Fluff' Freeman 'Have a pint. Not 'arf', TV presenter Jim Bowen had the strapline 'Great, Smashing, Super', a garden gnome, 'It's got more taste than the bloke who bought me'. The poster campaign targeted thirty-one towns in the autumn and winter of 1991[45] at a cost of £2 million[46] and succeeded in slowing down the decline in sales, but the final word goes to the rather ironic poster featuring a member of 1970s pop group, the Bay City Rollers 'Buy me one and we'll cancel our comeback'.[44]

Skol may have rallied, but it never recovered, having played second fiddle to Castlemaine XXXX in the 1980s, post-Carlsberg merger it then found itself up against the unassailable might of Carlsberg Lager. During the early 1992 negotiations with Carlsberg, the current brands were split into two categories, those that the new company 'should use its best endeavours' and those that 'should use its reasonable endeavours'; Skol fell into the latter, along with DD.[45]

Surprisingly, the brand Skol still exists in the UK, brewed by InBev at a paltry 2.8 per cent ABV and available in most supermarkets, so somebody must still be drinking it! However, the real legacy of the brand is in Brazil, where it has been brewed since 1968[47] and where it remains the country's best-selling lager.

CHAPTER 16

MISCHIEF

Drinking Was a Way of Life

'It was more like a holiday camp'.

'It was such a laugh, it wasn't like going to work'.

'Sometimes you'd stay late, stop in the locker room drinking'.

'The drinking when I started there in 1968 was bad. It was mad'.

'It was dead easy to get a drink, that's why all the brewery workers had such big teapots, they used to fill them with beer'.

If there was one common thread among the interviews given for this book, it was the drinking culture in the brewery. The quotes that make up this section were given anonymously and come from about a dozen different individuals, but when put together, they give a shocking insight into brewery life. To call it, a 'drinking culture' is to downplay the fact that it was chronic alcohol abuse on a massive scale. This was not unique to Ind Coope; it was endemic in the brewing industry as a whole so the following scenarios would have been repeated in breweries up and down the country and across the globe.

Men originally received a daily allowance: there were two pubs on site, The Brewers Arms at the main brewery and The Bottlers Arms at Curzon Street, in an effort to curb on site drinking this was latterly replaced by beer tokens that could be redeemed at The Roebuck on Mosley Street and the club on Belvedere Road. The amount of ale you were given depended on your job, ranging from a couple of bottles upwards. If you had a heavy manual job, like a maltster for instance, the allowance was vast.

> They'd give you twelve pints of beer and six of them were for sweat beer if you were in the kiln. I was given six Double Diamonds and six Light Ales, I wasn't a drinker and I saw chaps fighting for my beer. At Robinson's it was that old fashioned in the yard, the coal used to come in by wagon and you'd get extra money and beer if you unloaded it. When you got the Malt off the kilns you'd catch it in hessian sacks and put it on the railway wagons. You'd get another six bottles of beer for that so on some days you'd be allowed twenty pints of beer.

In principle at least, excessive drinking on the job was frowned upon by the company and could lead to disciplinary action; it ate into the profits, made the workforce less effective and led to accidents and sickness, but the reality was somewhat different.

'They used to say if you were caught drinking it was instant dismissal but I can't remember anyone getting sacked'.

'I can remember some chaps getting sacked but not for drinking, thieving mainly, tools, materials ...'

'There was cubbyhole under some stairs in the blending room and they caught about six blokes in there drinking. They got suspension'.

'There was only one who would chase you up for drinking, he'd shop you and you'd get a suspension. I got caught by him, five days suspension. He was keen and good at it'.

Aside from a few keen Watchmen, there seemed very little way of enforcing the rules, and even then, they often fell foul.

'One of the Keg Plant lads got followed back to the hut, he was carrying a teapot full of ale. The Watchman burst in saying "Got you!" but before he could grab the proof all the other lads surrounded him and by the time he got through all the beer had been drunk. He tried again a few nights later and this time he got hold of the teapot: it was full of tea'.

Drinking was endemic, and there appeared to be little they could do to control it; the supervisors either tolerated it or joined in.

'All the Gaffers knew what was going on but they turned a blind eye to it, there were one or two Security men who were a bit keen and would try to catch you out but most had worked there all their lives and they knew what the game was'.

'A couple of the supervisors used to shout "Watch what you're doing" or rattle their keys before they'd walk in, but most never bothered at all'.

'They knew drinking was happening but they didn't want to see it'.

'The supervisors were all as bad. There was one who would drink a crate, maybe two, of Double Diamond a shift and he'd got the bloody shakes, he'd put his hand on your shoulder "When you've got time lad, fill the crate up and take it upstairs for sampling." He'd be shaking like a leaf all the time'.

'You'd know a supervisor had been drinking even if you didn't see him'.

'One of the supervisors used to fill up for us!'

With many promotions coming from within, it seems that some supervisors were reluctant to make the switch from poacher to gamekeeper. Drinking was the elephant in the room: it happened, everyone either did it or worked with someone who did, but no one was prepared to face the problem head-on. To make a play on a well-known phrase, these men could organise a piss-up in a brewery.

'Burton is a brewery town and the youngsters are weaned on beer'.

'Drinking was a way of life'.

'On nights you'd get the most. I'd remember coming home sometimes! I used to drive home. You should have seen the state some people went home in'.

'There was no breathalysers in those days ...'

One employee recalled his initiation into the culture.

'First morning I started I was introduced to the lads I would be working with, they were having a tea break. "Do you want a cuppa?" asked one, I did so I got a mug and he poured me a beer from the big teapot. I couldn't believe my eyes'.

The amount some men could consume in a shift was frightening and would inevitably lead to long-term health conditions and in certain cases early death. Men would drink anything with little or no regard to the consequences. One Tunner recalled men drinking beer that was still fermenting.

'They'd wait till you'd gone for your meals, they'd say "What's the best you've got?" meaning what was the closest to being finished'.

'Some of them were not too bothered what quality the beer was, they'd push the yeast on one side, dip a mug in and drink it'.

'Dog Ale, that's beer that's come back from a pub, so say there's three gallon in the bottom of the barrel and it's all mixed up with hops, they'd get it out the cask as best they could, they had a plastic beaker painted black so you couldn't see inside it and when they drank they'd drink through clenched teeth and when they took the mug down they'd have hop seeds all round their mouth'.

'I'd drink the 'green beer' which hadn't been filtered yet, I didn't drink this through choice: it was the only stuff I could get my hands on'.

If you worked in the keg plant, it was keg beer; if you were in the bottle and can, it was packaged beer; etc. You drank what was to hand. If the brewery teapot has passed into legend, this was nothing in comparison with the lengths some went to.

'If you got the keg on its side you'd push the extractor with your thumb and it'd fill your teapot: that was known as "thumbing it." "Whistles" were made especially for the job, it was like an extractor with a bent pipe on the top, you'd put that in the extractor, push it on and the beer would come out and fill the teapot. The Fitters would make you one up if you got in with them'.

'It wasn't simple to get a drink but all the blokes had a way round it, they knew all the tricks'.

'There was a keg hidden down the inspection pit at the Garage, it even had a gas canister. The Watchman discovered it and it was put on display for all the directors to see!'

'Under the Pasteuriser at Curzon Street, they'd carefully chiselled around one blue brick out of thousands, slid the brick out and took out all the soil behind. The gap was filled with beer, usually Triple A. They then replaced the brick so you couldn't tell which one it was'.

One universal trait of the drinker was the lack of guilt and responsibility for their actions: some even going as far as to blame the company for making it so easy and offering no help for the alcoholics.

'I think the breweries had a lot to be responsible for. When I first started the access to beer was ridiculous, you could go and get a bucket full'.

'There was no help for people. There were some bad cases, but you didn't realise it, you just called them piss heads'.

The final word goes to one of the biggest drinkers interviewed, who when asked to think about the fact that all the beer he'd drunk had in fact been stolen, simply replied, 'I didn't think I was thieving by drinking, I never gave it a thought: I just carried on ...'

Ale Tales

The following anonymous stories all come from brewery employees:

'One chap would drink four or five Gold Labels in his break-time and they come back to work and carry on. Never saw him drunk at all, ever. They reckon he could drink a firkin, 72 pints, on a shift. He had burst ulcer, then came to work and drank about ten pints, then we went to the pub after work and I left him there. Next time I saw the landlord he told me he'd drunk 14 pints before he went home! He said you can bring him in again! He was so thin, he wouldn't eat except for Mars Bars'.

'We went for a day out to Lichfield. We met at the brewery at half seven, had breakfast, set off and we had a beer stop on the A38 by the boat yard. It was rush hour and there was traffic bombing past as we had a bottle of beer and some crisps'.

'I used to have three Gold Labels every morning at half six. I'd go into the Bottling Stores to load up and the bloke who'd have to check my line would say "Do you want one?" so I'd take the top off and knock it straight back. When were halfway through he ask if I wanted another and then we'd check off and have another. If my wife hadn't talked me into taking redundancy I wouldn't have been here, in two years I'd have been dead. I was drinking twenty Gold Labels a day, then I'd come home, have me dinner and go out and have some more'.

'My wife said she wished I'd got the sack sometimes, I was never sober'.

'One guy had a special seat made in the joiners' shop that had a flap on the front. It was big enough to hide a crate of nips. When he was on 6-2 he'd pick up a crate of Triple A while walking through the warehouse and open all the bottles. He had perfected the art of opening the flap, grabbing a bottle and necking it all in one motion so if you were watching him all you thought he was doing was ducking down. He'd drink twenty-four Triple A's before breakfast'.

'I went to a turnover in Nantwich, if a lorry had gone over we'd get sent out with a bit of kit that we'd pump the beer out into another road tanker. This tanker was in a ditch, underwater, we started pumping it out. Come the evening word had got round and a few locals came up asking for free samples, I said yeah, go and get something to put it in. They came with saucepans, kettles … this bloke came with a pedal bin. I filled it up to the top and he went waddling off and it was all over him, he was covered in it! About twenty minutes later this bloke came with a baby's bath!'

'There were two chaps ran with the tankers from Ansells and if you wanted anything for your car they could get it, they were in touch with the car factory at Birmingham'.

'If people got too drunk you'd just put them to sleep somewhere. You'd carry them for a night'.

'When you saw timber you get a piece of wood about three inches by one inch on the floor and there was this one fellow going home, got his coat on and his bag and was coming through the coopers' shop and he couldn't get past the wood, he hadn't the strength to get round it and when he picked his foot up to step over it he lost his balance, and we thought it was bloody hilarious! He was there for ages trying to get past this bit of wood'.

'Another time a lorry full of Skol had jack-knifed and the coppers came up looking for any spare, bigger bloody rogues than we were'.

'Triple A was a favourite tipple, it was a beautiful drink. You had to go to the cold room to get hold of it. We just to have to fetch stuff for cleaning from the ale stores in five gallon plastic cans, so we'd cut a flap in the side and across the bottom and up the top and you could get two gallon containers inside it. You'd go to the ale stores, fill the judys with Triple A and you could walk back with the Supervisor and no one knew what you were doing'.

'When the contractors repaired the roof at Ind Coope, they'd got a hoist outside that they used to take the wheel barrow up with all the material and that, they took a cask up there and stillaged it so they'd got 36 gallons on the roof'.

'I remember Tank 13 in the tank room, it was all crumpled up, someone put caustic in it and it flattened to a pancake'.

'One tank got topped up with water: it was St Christopher the non-alcoholic beer so it didn't make any difference. The samples were took off first. It was about four or five barrels short, so they stuck a water main on it'.

'I had this new boss who said "We'll sort you lot out." I said you are boss number thirty-one and they've all said exactly the same thing and I'm still here!'

'One character had an office at the top of the brewhouse and would sit facing an open window, waiting for any careless pigeon to show itself in said window. Whenever this happened, he would terminate the pigeon with a very large calibre handgun. Eventually, after complaints that the workers below were getting fed up of being splattered with bits of disintegrated pigeon and the odd bunch of bloody feathers, he was persuaded to stop his target practice'.

'A lot of the bosses hadn't a clue: one asked why I wasn't filling a tanker. I'd got no mains, he said you've plenty of mains down there, these were CIP mains, so I said I couldn't use them. They're mains, use them he said. So I did. We sampled it and it was all cloudy due to the caustic. We all knew that but he didn't'.

'We used to blend Löwenbräu and Skol Super and take it on the Blackpool trip'.

'Triple A was always in Tank 68 in No. 2 Cold Room'.

'Two blokes had been having a game of "Riley" reputedly for the past thirty years of their tenure together in the Cost Office. "Riley" was a dangerous game, which consisted of catching your opponent bending, and "rattling" his testicles with the long, hooked window pole. By 1965, one was well in front in scoring and on this particular day, a fine opportunity presented itself when the other bent down to recover his sandwiches from his briefcase. The over enthusiastic "Riley" put his mate into A&E and from thenceforth it was declared that the game would end as a draw'.

'They used to have a big black dustbin full of homemade tea wine, it was bloody good'.

'We were on strike outside the gates in Hawkins Lane and someone had undone a couple of bolts out the railings and firkins were coming through and we had a nice party outside the Watchman's Box in the elderberry trees'.

'They sent us some space heaters down, big things with infrared, so I got a bread tray and bent the heater down and we were grilling steaks on them at the weekend'.

'We've had curries with daffodils in them, everything. One lad said "this rabbits got little legs" when it was squirrel he was eating. We've shoved everything in curries'.

'I said can you give me a pass-out for some scrap plywood? There was an old shed around the back and I was told I could have that as well, so I went out with that on my bike and gave them the pass-out. I got found out and was told not to ask for anymore pass-outs, I'd been seen leaving with a bloody shed on my bike'.

'One chap got sacked for pinching out of beer recovery when he was on nights and a few broke into the engineers' stores on nights, pinching boots and things'.

'A five tonner was due to go to Rugby with Light Ale in it, we came in at six o'clock, brewed up, came out and it had gone unfilled. We rang the Weighbridge and told them it had gone empty, so the joke was it was Light Ale. Transport sent someone to Rugby in a car, no sign of them. Got halfway there and turned back. Been back ten minutes and the lorry turned up, they'd been to the café on Derby Road for their breakfast first! The bloke on the Weighbridge took some ribbing for that'.

'People would drink the fermenting beer. They kept one Union row on to do Triple A, they didn't think they could do strong beer in the new vessels. When they knew you were dropping strong beer they'd be there with their cups. It came out so fast it took it out of one chaps hand and it ended up down the pipe'.

'A bunch of Old Age Pensioners pulled up inside the brewery grounds one evening, a big coach. The driver was walking around, he said "I know where I am but how did I get here? We were on the main road by the police station and turned left into here." I rung the Watchman and he didn't believe me at first. "You're joking, I only went for a piss, I thought I heard a wagon come in!"'

'One of the ale loaders would have eight or nine pints as soon as he started work, he'd put the three pint measure we'd use for the finings, fill it with beer and knock it straight back'.

'There was a woman in the canteen who was a little bit deaf so we'd talk quietly to her. There was no feeling sorry for people. You were always looking for devilment'.

'You'd always leave the tanks nearest the control room in Nos 2 & 6 Cold Rooms for the best quality beer, that way you hadn't that far to walk'.

'One of the cleaners used to take his ale into the toilet, that was his pub, he used to say, "I'm off to the Mop and Bucket for one."'

'If you wanted something off a contractor, they'd let you have it as long as you gave them a drink'.

'Some lorry drivers drinking all day long, cause if you went delivering inevitably the Landlord would ask if you wanted a pint. This fellow who was tee-total was told "don't tell him you don't want it, I'll have it" so his mate was getting two a time!'

'They were going mad in 1976, seven days a week, twelve hours a day and night, the stress sent some loopy. That and all the boozing as well'.

'Some would sling their sandwiches in the bin, they'd drink but they wouldn't eat'.

'There were some good blokes there, good times with them, absolutely fantastic. Some idiots, some arseholes, but there you go. Some real good 'uns. Some bastards as well'.

CHAPTER 17

IND COOPE: THE EMPLOYER

'1962 was probably a halcyon year for the breweries in Burton,' recalls Chris Eaton, then a mere slip of a lad fresh from Technical College. 'It was the year when keg ale in the form of Draught Double Diamond, and the lager taste really started to take off. While the perception of the school leaver at that time was that Bass's was the prestige company to join, given its heritage, Ind Coope was seen to be the more progressive and better paying firm. In all cases, a job at any of the Burton major brewers was seen as a job for life'.

After a successful interview, Chris Eaton landed a job as a Traffic Clerk on £204 per annum. 'On 20 August 1962, I presented myself as requested in the appointment letter, "in dark suit and white shirt, with sober necktie" taking my place I the most junior corner desk of the Traffic Accounts office, to start a career spanning forty-three years'.

'It was still like being in a large family, working at Ind Coope, the facilities for sports etc. up at the Belvedere Road Sports Club were amazing. I was introduced to the game of bowls there, not that I followed it up much but it was a good excused to get a couple of pints of Ind Coope D down yer neck!'

Phil Croft, who was working at Marley Tiles in 1960, agrees with Chris, 'My brother in law told me that Ind Coope were recruiting for a second shift at the Bottling Stores so I applied. At that time Ind Coope was the place to work with good pay and conditions. All new starters in the Bottling Stores started by stacking the finished product in the Full Stores then moved into the Bottling Hall on the packaging machines. I went from stacking onto the Can Line Packer, Pasteurisers, Bottle Washers, Bottle Line Packers, Labellers (probably the cushiest job in the place) then finally on to the bottle and can fillers'.

'Out of the three main brewers in Burton at that time, if they had all been advertising then probably Ind Coope would have been my last choice purely based on the public opinion and rating,' says Jim Waters. 'However, I am glad it turned out the way it did as they were an extremely good company to work for, despite the Ind Coope and "Allslops" tag, I believe they brewed an excellent glass of bitter. Also, thanks to their forward thinking on pension schemes, I now enjoy a comfortable retirement'.

'When I left school in 1948,' recalls Alan Burbidge. 'I wanted to be a bricklayer and believe it or not, despite all the houses that had been bombed during the war, nobody in Burton was setting on bricklayers as apprenticeships. I went to the employment bureau and said I wanted an apprenticeship, and they said the only ones going are Slating and Tiling or Coopering, so I said which is the hardest and they said Coopering and that's the reason I chose to be a Cooper, cause someone had told me I was frightened of hard work. I always thought they were a good company, they found you clogs and overalls. They wouldn't pay anymore to the Coopers as that was governed by the price list'.

Bernard Lawes: 'I started in 1946 aged fourteen and worked in the laboratory which was over at Grants. My first job in the morning was to light the coal fires. You'd be fetching samples from

all over the brewery, checking the water levels in the wells at the bottling stores. Unless you'd got a relation who worked there you couldn't get on at the brewery, my Dad was in the Ale Stores, my Uncle was in charge of the engineers, so I got in'.

Harold Woodward: 'You had to honour the job, whatever that entailed. I worked eighteen Christmas Days out of about twenty. You never left your job until you'd been taken off: sometimes I'd have to stay late if they couldn't get someone in. They'd pick you up on a Sunday when there were no buses'.

Maltster Bill Bancroft: 'It was hard heavy work, seven days a week, Christmas day, Boxing day whatever, you only had a day off when you were ill'.

'I started in 1971 as a post boy,' says Stuart Gates. 'The main role was delivering to all offices throughout the brewery which was spread over a large area. All deliveries were collected by hand. The managers had secretaries in those days'.

'At 10 a.m. and 3 p.m., wearing a white jacket with shirt and tie, we had to take tea and coffee on trays to the directors & middle management. The directors all had silver teapots and trays, all tea was served with two biscuits from the Rover biscuit tin. On my first day I thought I was going to get the sack as when walking through the large oak door to the Directors office I dropped both trays, spilling hot coffee all over the plush green carpet. I tried to mop it up unsuccessfully with my white handkerchief!'

'At 11 am each day I collected glasses filled with Double Diamond from the Sample Cellar. These were taken to the directors offices served on a tray. Every lunch time we cleaned the brass plates on the large entrance doors to the A Offices'.

Thomas Otho-Briggs: 'The lads were just as happy living in a small house and coming to work on a bicycle as my father was in a bigger house and driving a Jag. There was a big difference between the working lads and management. The difference didn't cause any friction, it was just accepted. They'd refer to him as Sir or Mr Otho-Briggs, but never his Christian name'.

'The whole ethos of Ind Coope was a good one and the lads all worked very hard and never complained to my Pa about anything, they were a good lot, worked conscientiously and were fond of my Pa, he was good to them and they worked hard for him-things were different in those days. They would do anything for you'.

CHAPTER 18

BREWERY LIFE

Of Hands and Heralds

The first company magazine appeared in January 1947 entitled *The Red Hand* at a price of 3*d*. with a print run of 2,000 copies[1] so began a tradition that would run for nearly fifty years until 1996. *The Red Hand*, *Ind Coope News*, *The Argosy* and *Burton Herald* would all serve a similar purpose in reporting the social side of brewery life.

The initial run of *The Red Hand* was from 1947 to 1951 as a small monthly booklet. This was revamped between 1952 and 1957 when it was replaced by a bimonthly publication that had a greater emphasis on photographs. The 1957 March/April issue stated that '*The Red Hand* ceases publication in its present style',[2] in its place would be a newspaper-sized publication, *Ind Coope News*. There must have been an outcry from subscribers as *The Red Hand* returned the following year and would run concurrently with *Ind Coope News*, which began its run in June 1957. *The Red Hand* bowed out again in 1962, before returning in 1970 coinciding with the formation of ABUK Ltd. Another publication *The Argosy* emerged at the same time and shared a lot of content with *The Red Hand*.

The first edition of *Burton Herald* appeared in 1975 and would see out the 1970s, before a rebrand in 1981 to coincide with the new green and yellow colour brewery colour scheme. As the decade advanced, so did the quality of the magazine: colour photographs became more commonplace, although the publication dates became somewhat sporadic. The spring 1996 edition opened with a foreboding editorial from Jim McLay entitled 'The Final Edition'. In it, McLay explained, 'It is the policy of the Carlsberg-Tetley Executive not to have local magazines, although the reason for this is not made clear, however, it would seem to stem from the lack of development of a clear Carlsberg Tetley identity since the formation of the company.'[3]

Ind Coope Sports and Social Club

The origins of the club date back to 1865, when the land between Belvedere Road and Mona Road was home to the brewery cricket pitch and pavilion. 1930 saw a number of buildings erected,[4] which would remain until the club was demolished in 2011.[5] A dancehall was added in 1970, followed by squash courts, a lounge extension, snooker room, bowling greens and a floodlit court for tennis and netball.[4]

There were 3,700 members in 1980, and any employee of ABUK Ltd was eligible to join. Brewery workers could spend their beer tokens and be entertained by well-known acts such as Slade and The Hollies, who cost over £3,000 to book! The club was the centre of brewery social life, hosting Galas, Derbyshire County cricket matches, the Christmas party for the kids, etc.[4] It underwent privatisation in 1988 and opened its doors to other local companies.[6]

Below are some memories from people who enjoyed the facilities over the years:

Judy Pacey: 'It was great! Lots of acts played there; when Ken Dodd performed, we were still there at 1.30 a.m.!'

David Tomlinson: 'In the mid 60s trying to watch the cricket: Derbyshire against Middlesex over the screened fences along Mona Road'.

Rebecca Dunn: 'I practically grew up here in the 80s and 90s. My dad Jock Skinner was in the Bowls team and also on the committee for a little while. I went to all the Christmas parties and family discos. Also remember watching the wrestling with Big Daddy fighting'.

John Harper: 'Using my beer tokens'.

Mark Frost: 'I got sunburnt watching Staffordshire v Surrey cup game. Dickie Bird was umpiring, then the same evening played for Pirelli v Lullington'.

Janet Williams: 'My Grandad Gould was a Cooper and played cricket for them. He later became the Green Keeper. Grandma and my mum did afternoon teas, I was in my pram'.

Ian Arkesden: 'Slade burst a few ear drums at their gig, my mates Mum & Dad could hear them in Bosworth Drive'.

Mike Shelton: 'I always went to Derbyshire cricket matches in the mid-/late 60s. Particularly remember visit of Kent I got autographs of Colin Cowdrey and Derek Underwood!'

Come on you Brewers!

It was only fitting that Burton Albion FC also known as the Brewers landed a sponsorship deal from Ind Coope. The announcement came in August 1980, with the figure in the region of £3,000. Chairman Ben Robinson said, 'This is a marvellous gesture on the part of Ind Coope Burton Brewery'. The money was to be put towards a much stronger challenge of 'their ultimate goal of promotion to the Alliance Premier League'.[7] ICBB Ltd was sponsors when the team went to Wembley on 9 May 1987 for the Football Association Challenge Trophy final against

The Red Hand, Vol. 1, No. 1 (National Brewery Centre).

Kidderminster Harriers. After a nil–nil draw, the Brewers were narrowly defeated 2-1 at a thrilling Hawthorns replay.[8] The deal was still in place in 1993.[9]

Fundraising

ICBB Ltd was a great corporate citizen, founding its own charity committee as David Platt explains, 'The Charity Committee was given money by the company to disperse within twelve miles of the brewery to needy causes on the understanding that the committee tried to raise a similar amount. We were always fundraising! We supported St Giles, of which I am still a Director, the two schools on Bitham Lane, Queens School at Lichfield, old peoples' home and local people too'.

A quick glance through copies of the *Burton Herald* shows £1,050 raised by the Keg Plant by a 25-mile walk[10], an incredible 126-mile slog in driving rain to deliver Ind Coope Silver Jubilee Ale to Buckingham Palace raising £3,400,[11] a guide dog was funded by a tandem ride from Burton to Romford in 1983[12] and a minibus being presented to Bitham School in 1990.[13] These are only a few examples of the tireless work of the kind-hearted employees.

In 1990, two thirty-eight-tonne lorries and a Swan Light jeep left Burton bound for the Romanian orphanages in Hemerod, Dacia and Cazini, with a cargo of baby clothes, toys, toiletries, sheets and blankets that had been donated by the Burton public. The Chairman of East Staffordshire District Council Peter Haynes had launched the appeal. The 3,960-mile round trip took six days.[13]

The brewery hosted an Open Day on 8 May 1983, and the public flooded in to see how beer was brewed and canned. There were Model T cars sporting Long Life and Skol liveries to sit in, talks to, listen to, the ICBB Ltd brass band and state-of-the-art computers to play with.[14]

Ind Coope Sports & Social Club, *c.* 1960 (author's collection).

Who Wants to be a Millionaire?

Pallet Stacking Machine operative Dave Preston scooped nearly a million pounds on the Littlewoods and Vernons pools in 1980. Dave, who had previously won £10,000 five years before, before leaving for Las Vegas with wife Jean, popped in to pick up his wages from the cash office, and he left a message for his mates on 'C' shift: 'Tell the lads I will be back to give them a big party in the next few weeks'. Workmate Gordon Carter: 'There had a big artificial cheque and he was presented with it. It was a marvellous do at the club'.[15]

A Haunting

There were ghostly goings-on in 1975 in the corridors of the engineers' offices and workshops, which had previously served as the old Ind Coope brewery. Various strange happenings had been reported, from footsteps outside the Instrument Shop, to banging doors and rattling windows; however, early one morning in late 1975 things got even stranger. Electrical Storekeeper Ray Middleton was having his meal break at 2 a.m., and while he was making toast, he noticed the toilet door had opened, so he shut it and went back to the stove. He then heard a noise and saw the door opening and closing on its own. As this was a closed room, there was no explanation, and Ray 'shot out of the room like a scalded cat'. He recounted this to the security officer who decided to investigate. Unsurprisingly, he found nothing untoward until he turned the lights off when he swears he saw a grey-haired man standing at the end of the room, who promptly vanished when the lights went back on.[16]

CHAPTER 19
EVERYBODY OUT!

Grants of St James Strike 1979

Three thousand brewery workers walked out in support of staff at Grants of St. James, ABUK Ltd's wines and spirits business, over proposals that would take 300 jobs from Burton to Derby.[1] Grants staff picketed the brewery, which very quickly came to a standstill,[2] leaving 600 pubs without supplies.[3] The unions accused the management of not consulting prior to making the decision and not exploring all the available options.[2] A meeting took place at Curzon Street where more than 100 men voted not to support the strike; however, the number who crossed the picket line was eleven. One source said that many 'were too afraid to go to work'. They feared losing not only their jobs but also their union cards as ICBB Ltd was a closed shop.[4]

David Cox summed up the general attitude in the company, 'Confrontational, with strong unions. Management made decisions with no employee involvement, the workers retaliated to those decisions. All Management decisions were taken knowing that the unions, Transport & General particularly as they had the strength in numbers, would resist, then lots of smoke-filled-room discussions took place before a compromise was reached or a strike was called'.

Compulsory Notices 1980

The year 1980 was a watershed year for the brewing industry, 'During the 60s and 70s the beer market grew with almost monotonous regularity … in 1980 a phenomenon completely new to the then captains of the industry occurred – the market actually declined,' writes David Cox in his book Major physical, cultural and organsisational change acheived by GABB & GIBB..[5]

ICBB Ltd reacted in August 1980 with a bombshell: 120 redundancies. Although the losses were to be voluntary, they had to be in place within three months, and protected pay was also to be scrapped. The *Burton Daily Mail* led with the headline 'Brewery set to axe jobs as sales fall'. Ironically in the same edition, an article appeared about the recent Brewery gala![6]

Talks between the company and the union quickly broke down[7], and a strike was called. By 10 p.m. on 15 August 1980, brewing had stopped,[8] overtime had been banned, as had outside contractors, contactors vehicles and temporary labour, and pubs were not allowed to make their own collections. Some employees did try to come to work but were unable to clock in.[9]

The company retaliated with warnings that this could bankrupt the company[9] so a meeting was held at the sports and social club that more than 1,500 workers attended.[10]

Work may had stopped, but drinking certainly hadn't, as one anonymous worker recalled, 'Before we went on strike the forklift drivers got two stacks of firkins, all full of beer and put them by the fence at Brook Street to keep us going when you were on strike. We'd got thirty-six firkins to go at!'

Workers leaving a union meeting, August 1980 (Burton Mail).

Talks resumed, and the strike was called off, with the workforce returning for the night shift on 25 August 1980, but the damage had been done: it was too late to supply the pubs with beer for the imminent August Bank Holiday.

'They paid us sixty quid for a speedy return to work, we had a meeting at the dinner time and I had to go back on nights. That covered what we'd lost on strike,' Shop Steward Mick Billings recollected.

'The problem was that beer production was so profitable in those days: every barrel brewed was easily sold,' remembers Colin McCrorie. 'Management bent over backwards to keep the members sweet: this included reimbursing all monies lost by the workers when they eventually came back to work, always with all concessions they went on strike over were given totally, so there was no financial hardship whatever brought about by withdrawing one's labour'.

Talks were in deadlock, so by mid-September, the company decided to scrap the original plan[11] and issued 175 compulsory redundancy notices on a last-in first-out basis.[12] Mick Billings: 'When they mentioned the first redundancies we kept buggering about: we didn't take them serious. They were after volunteers, so they issued compulsory notices'.

This ruthless move by the company finally forced an agreement: voluntary losses were agreed to,[13] but the figure had risen from 120 to 175 jobs. This whole episode soured industrial relations even further and would come back to haunt the company when further job losses were sought in 1983.

Ansells Sympathy Strike 1981

'Allied Breweries told all sites in 1979 after a twelve week strike in Warrington, that the next site to go on strike would be closed: Ansells was the one!' states McCrorie. He experienced the Ansells strike first hand, involving 1,000 workers in opposition to a proposed four-day week,

turn into a twenty-week stoppage that eventually led to the closure of the brewery.[14] McCrorie would move to Ind Coope mid-1981.

No sooner was the closure of Ansells announced on 9 February 1981 that speculation began in the *Burton Mail* that some of the production was to move to Ind Coope. 'The closure of the brewery is irrevocable. We have reached the point of no return' was the official line from Allied Breweries. Support was pledged by Mr Cliff Small, the district secretary of the Transport & General Workers Union (TGWU).[15] After fourteen weeks of dispute, 100 Ansells workers formed a picket at Ind Coope. Pickets also went to the Romford site.[16]

'To some extent we all felt sorry for the Burton Brewery people,' remembers David Platt. 'They were losing money through no fault or say of their own, and they were going to be in bother nationally if they didn't go into sympathy with their colleagues from Birmingham'.

Although no attempts were made to stop workers coming on site, deliveries of raw materials were urged to turn back. A spokesman for the pickets claimed, 'We are not here to close a brewery, we are here to open one, the brewery at Aston.'[17]

Ind Coope continued to brew despite the picketing, David Platt recalled how one obstacle was overcome, 'You had no problem getting malt into the Mash Tun but you had to be able to get rid of the spent grains, they normally go out in wagons. So we dropped them on the back yard and blocked off the drains. By the weekend they were not brilliant and they were going to get worse. The local company that shifted the grains had TGWU drivers, the same branch, so they didn't want to know, but as they had a commitment to us they got their fleet from Manchester to come down. They arrived with a low loader and a convoy of lorries. I was in the gate house and the pickets were across the zebra crossing. The low loader door opened and the driver got out, to say he was big was a massive understatement, he was enormous! He picked up his shovel, I doubt I could have lifted it empty, and he said "Right which of you lot wants it first?" The pickets, who had been shouting abuse, split a bit and the whole lot went through.'

David Platt was also involved in a rather humorous and unexpected tailoring incident, 'I was out meeting a CO_2 wagon and I came back in and they were over the zebra crossing. I told them we were going to go through and I could get a police escort if I had to, this was 11 p.m. and one or two of the pickets had been in one of the local establishments for the evening. One of them was a Shop Steward from Birmingham who I knew: I'd worked there in the middle 1970s.'

'Instead of opening the window and talking to him I opened the door. He grabbed hold of my jacket and pulled. I was darn lucky I didn't end up with my head on the floor, but as I reported it the next day to one of the directors, it was a good job I'd had my jacket made in Hong Kong because the sleeve came off! He did the honourable thing and threw it back into me. It caused quite a bit of amusement around the brewery, it was good for morale because people could laugh at a senior manager which is always good in stress circumstances like that'.

CHAPTER 20

CHANGES

Background

In 1982, a new managing director, David Cox, arrived in post. Having previously worked at Ind Coope as Head Brewer from 1972–77, Cox later commented, 'They knew me as (I hope) a straight guy.'

In the previous two years, the beer market had started to decline, this was to cause a problem for many breweries, including ICBB Ltd who had made investments in the 1970s to meet projected future growth.[1]

One of the biggest problems was overmanning. McCrorie: '1846 people, most on protective earnings plus overtime, restrictive practices … An example was my Bright Beer Tank group that went from eight to three per shift, with no obvious hardship; one filter group on three-shifts with two men per shift, as opposed to three separate filter rooms totalling five per shift, the Finished Beer Team eventually numbered thirty-six, compared to a starting total (including Curzon St equivalents) being eighty-nine!'

A diverse range of beers and lagers, c. 1985 (National Brewery Centre).

Planning

The concepts of GABB (Greenfield Appraisal Burton Brewery) and GIBB (Greenfield Implementation Burton Brewery) that were implemented from 1983 to 1988 became synonymous with the greatest period of change in the history of the company.[2]

Cox had already tried something similar as production and distribution director at Warrington, 'I had to make massive cost savings, I couldn't come up with any real ideas myself, so sent my four senior managers off site to a hotel for three days and told them to come up with a plan and they did! So I arrived at ICBB wanting to try the same trick for a full ICBB change plan which I did with some fifteen managers given six months to do so, they invented GABB, not me! And it was brilliant – both the plan and the process of getting there, fifteen people owning the plan for starters as opposed to the usual one or two people.'

The ICBB Ltd executive team consisted of David Cox (MD), Harry Pendleton (Production), Bob Robbie (Personnel), Ivor Chester (Management Services/Customer Services), John Knowles (Distribution), Alan Smith (Marketing), Malcolm Wright (Finance until 1984, Marketing 1984–85), John McKeown (Marketing), John Holmes (Finance from 1985), Irwin Elkin (Deputy Production from 1986) and Doug Alexander (Deputy Production 1982–86, Deputy Distribution 1987-xx).[3]

A top secret report was presented to Cox and the senior managers in September 1982 detailing ideas of cost savings and streamlining, but after a few hours debate, it became obvious that change was needed on a much grander scale, and so the concept of GABB was born. Although ICBB Ltd had developed over the years, this had been piecemeal and had resulted in a company concerned with getting the beer out at almost any cost.[4]

'Greenfield thinking – a comprehensive reappraisal of every facet of the business without constraint,' summarised Cox.[4] This was a controversial move that flew in the face of the training and experience of the senior management team, Cox himself told them, 'Don't involve me in what you are doing; you will get no guidance from me; you tell me how the company should be developed.'[5]

Committees were formed and an outside Consultant Mike Connolly appointed, when they reported back to Cox five months later it was with a general outline, and this was then fleshed out with the realities of the limitations of the brewery site when they met again in May 1983. All of these were still very hush-hush between the fifteen managers who then set about convincing first the ABUK Ltd Board and then the hardest part: the employees.[5]

Presentations

Fifteen presentations were made in the week of 17 October 1983, as the brewery worked three shifts, everyone had to be told. Questions were taken, ninety-three in total, and the answers were collated into a book that every employee received the following week.

The presentation set out the current position, 'the beer market is declining and becoming more competitive', and 'a fundamental and comprehensive review' had been undertaken of 'the physical and human resources' needed to match the current and future demands. This review imagined the brewery starting from scratch: this was the 'greenfield'. The main proposed physical changes were the following:

1. Streamlining of fermentation, cold storage and filtration;
2. All packaging centralised on the main site, that is, closing Curzon Street Bottling Stores;
3. A single warehouse for all packaged goods; and
4. The centralisation of all by-product handling.

The cost was revealed to be £15 million over the next five years, over and above the normal capital expenditure, which would have to be borrowed from ABUK Ltd. The benefits of the scheme were 'that the savings and additional flexibility achieved will increase our

competitiveness considerably'. The increase in efficiency meant a reduction in manpower, initially of 400 (this would increase to over 500 in 1984); this could be brought about by voluntary redundancy, retirement or people leaving the company of their own volition. The key was flexibility and retraining, and there was no plan for compulsory redundancies. There were also to be fundamental changes to pay.[6]

Questions

The biggest question was: why?

'We will not survive in the long term,' was the blunt prediction at the presentation. 'Unless we can produce our products as cheaply as possible and have the flexibility to respond quickly to the demands of the market place'. 'GABB was not an option but a must …'[4]

The current position was summarised, 'we have adapted to date reasonably well from a Brewery producing a small number of high volume products to the larger number of smaller volume products'; however, 'this has been very much on a make- do and mend basis which inevitably has a cost penalty and means that we react slowly to the changing demands of the market place.' Not undertaking GABB 'would threaten our long term survival', change had to come.[4]

To the question of reducing numbers and the ability to run with less manpower, 'we are confident that given the new plant layout and more efficient methods of working, we can not only get the job done but will be able to respond to future changes'. The cost savings were from seventy per cent in reduction in man power and the rest from process improvements. Those that did not wish to be involved in GABB were given a simple option: voluntary redundancy. All levels of staff were affected, from the shop-floor upwards, 'the jobs required at all levels will be determined solely by the requirements of GABB'.[4]

Initial Reaction

Within a few days of the presentations, the fifty-seven Industrial Employee Representatives came back with about seventy questions, the response was simple, the answers did not exist, and there was no such document locked away in David Cox's desk. Answers could only be got by management and unions working together.[6] Unhappy with this, the union carried three mandates by Christmas 1983:

1. No supervisor/tradesman/operative was to do another job that fell outside their grading;
2. No cooperation in task analysis; and
3. Talks for manning to take place only within the historically based departments.

'We didn't take it seriously at first, we thought they were pissing about,' one Shop Steward said. 'We thought it was a joke, they sent people all over the world looking at things. We went away for a few nights, they had Tommy Doherty as a guest speaker emphasising team work, to us it was a piss up, free beer, beautiful meal, shorts, cigars … unbelievable'.

As the project began to gather momentum, the union had to change their point of view: 'When they started threatening things, you had to look at it seriously. We didn't like the changes. People had worked at the Bottling Stores for years and didn't want to come over to the main place. Curzon Street was very old-fashioned, you could see why they wanted to shut it. We were kegging for Allied and we used to send beer out to Holden's at Dudley for bottling. Marston's used to bottle for us, we hadn't got the capacity'.

The management/unions showdown came quickly in January 1984 at what was known by the management as the 'Brick Walls Meeting' after the stance from the union had taken.

Open discussion was needed, but the wounds of the 1980 redundancies were still festering. The meeting was described by Cox as 'stormy to say the least', but the outcome was that 'there appeared to be a change in the weather' although there was still a long way to go.[7]

By mid-1984, there had been over 300 applications for voluntary redundancy, falling short of the 500 required: this meant that compulsory redundancies on a 'last-in first-out' basis, as had nearly happened in 1980, was considered. The required number was eventually obtained by making the redundancy package more attractive.[8]

Managing Change

Production needed to continue as normal, and the job of ensuring the brewery was 'getting the beer out' fell to Doug Alexander.[9] The GIBB Centre, which acted as the hub for the project, was sited in front of the brewhouse and housed those employed full-time by the project and a scale model of the GIBB brewery.[10] Twenty-six team leaders were appointed in 1985 covering every aspect of the brewery.[11]

Cultural Change

In March 1984, there was a week-long stoppage in the Keg Plant, oddly not GABB/GIBB related but over Palletless Handling, leading to fifty per cent of the brewery at a standstill. The management held their nerve, and the union's demands were not conceded. Cox reported that when the Fork Lift Truck Drivers' representative came to tell him, his members would be returning to work, that he told him 'You've won. Not only that, GIBB will go through now without further stoppages. Everyone was watching you on this one'.[7]

By the middle of 1984, the union decided to take a full role in the Remuneration Joint Group. Operatives over sixty-two years old wanted to take voluntary redundancy in the Keg Plant, but the union at first refused to let them go, as they insisted that manning levels be maintained. In the end, it was agreed that the levels be dictated by seasonal requirements and that the shortfall could be made up by taking on temporary staff. Sixty staff had taken redundancy by January 1985.

The three mandates put in place by Christmas 1983 were still causing problems, in fact it had reached crisis point. Employees were balloted with the following two questions:

1. Are you committed to the GIBB principles? and
2. Do you agree that a GIBB pay structure covering all employees should be negotiated immediately?

Eighty-five per cent of employees responded, sixty per cent saying yes. The union response was 'You've won' to which the management replied, 'No one has won.'[12]

Physical Change

The Moor Mill Dam ran under site of the new Cask and Keg department, this had to be rerouted at a cost of £157,000,[11] but the first real physical change was when the Brook Street Bridge opened in late 1985.[13] May 1986 saw the chairman of Allied-Lyons PLC Sir Derrick Holden-Brown open the new warehouse or 'The Shed'.[11] Built by Norwest Holst, it was the largest contract in the GIBB project and had a floor space of 16,500 square metres, the size of five football pitches. Beer in all forms of packaging was to be stored there[14] with a capacity of over 50,000 barrels.[15]

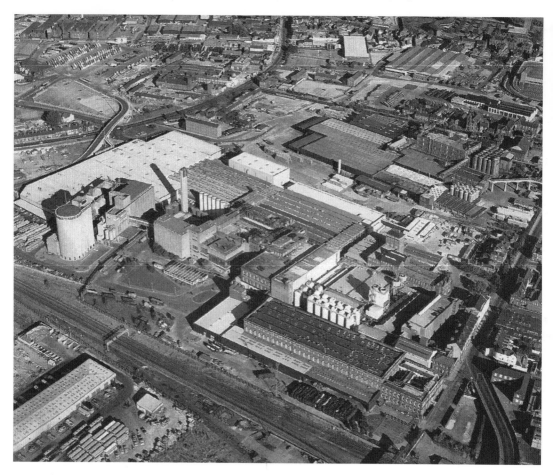

Ind Coope Burton Brewery, *c.* 1987 (National Brewery Centre).

The old Cask & Keg area closed in December 1986, when the final cask was racked on the B1 Racking Line, a ceremony was held. Dennis Barkes loaded the last cask, it was capped by Ben Bowles, and then the operatives stopped for a well-deserved pint. Minister of Agriculture Michael Jopling officially opened the new Cask & Keg Racking Hall on 4 February 1987, described as 'the most modern and certainly one of the biggest packaging operations in the world'; it contained five separate packing lines, three keg and two cask, capable of an output of 6,000 pints a minute.[15]

One telling physical and cultural change was the New Restaurant, which opened in 1986, sited on the ground floor of B Block, converted from the old Ale Stores.[16] This signalled the end of segregated eating, for the first time operatives and the managing director could sit side by side.[17] The new open plan office was also completed at the same time.[18]

A sixty-tonne bottle washer arrived with a police escort in July 1987, literally stopping the traffic as it made its way into Burton all the way from the Ortmann Herbst factory in Germany. The washer took twenty-four hours to travel 100 miles from Grimsby. Two bottle fillers arrived from Simonazzi in Italy, the first capable of 60,000 bottles per hour, and the second arrived near Christmas 1987 for polyethylene terephthalate bottles.[19]

Number One Canning Line opened in the new Bottling Hall bang on time on 27 August 1987, having an output of 1,500 cans per minute, 600 more than the old line. 'One down

and three to go,' commented Harry Pendleton in reference to three more lines: one more for cans, one for bottles and another for two and three litre plastic bottles that would soon be commissioned.[20] Curzon Street Bottling Stores finally closed in December 1987 just short of its fortieth anniversary.[21]

The Cost

When GABB was originally put before the ABUK Ltd board, it was agreed to make £19 million available, with a reduction in the workforce of 358. This was reappraised in July 1984 to £21 million and a reduction of 527.[22] It was anticipated that the project would start on 1 September 1984 and be completed some thirty-nine months later on 1 December 1987. The cost gradually increased, first to £26 million, then £30 million and finally £35 million.[15]

Changes at the top

David Cox resigned in March 1988[23] and was followed a month later by two other members of the Executive Team Bob Robbie and Harry Pendleton.[24] Cox's replacement was Mr Alan Davis who had previously been managing director at Ind Coope's Romford Brewery, he had also worked at Joshua Tetley & Sons, Tetley Walker, Ind Coope Scotland, and between 1979 and 1981 Burton. Under Davis, the GIBB process continued, profits rose while manpower continued to reduce[25] falling from 1,430 to 1,130 in one year alone.[26]

A report was commissioned from PwC in early 1988 that concluded that 'although ICBB still has some way to go before achieving world-best standards of equipment, the great strides already made as part of GIBB have strengthened, considerably, its competitive position'. Praise was also given to the workforce, 'it has people who are all pulling in the same direction, aiming to exploit the opportunities now open to them'.[27]

The Legacy

In reflection, David Platt thinks, 'Most say "You know the best thing that ever happened was when you lot got rid of me and gave me my barrow load of pound notes and sent me home!" As far as I know we only got abuse from one man, which I thought was brilliant. I accept that one man was a failure and that was very sad. It is good that people didn't see it as the one disaster in their life'.

Although Mike Hubbard and David Cox have never met, Hubbard has a lot of respect for Cox's achievements, 'I always thought that he did a good job. Maybe people above him thought he was taking too long but some of the changes he made transformed the way the business was run. I can't criticise. The most important thing was that attitudes began to change, on both sides, maybe management got better, sensible, pragmatic, more careful in the way we listened but the Trade Unions also changed their attitudes dramatically. They saw at the heart of things was the need to keep jobs for the long term. They knew that that was the key point and as long as they could meet our need to become more efficient by slimming down our labour force and we ensured there were good redundancy packages, then change could happen'.

'Without GABB/GIBB the brewery would have perished', says Colin McCrorie.

'We were trying to ensure the brewery survived. It didn't, well not in its existing form', reflected David Platt.

'Where's Ind Coope now? Gone," said one Shop Steward. "Whether it was a good thing or not … I don't really think so'.

CHAPTER 21

MERGERS

'Probably ...'

The Supply of Beer (Tied Estate) Order 1989 and The Supply of Beer (Loan Ties, Licensed Premises and Wholesale Prices) Order 1989, more commonly known as the Beer Orders, were made by the Secretary of State for Trade and Industry in December 1989, aimed at breaking the monopoly of the six largest national brewers. AB Ltd alone owned about 6,000 outlets and were given two choices, selling either approximately 2,000 on-licence premises or their breweries.[1] They chose the former.

Burton Herald, Autumn 1995 (National Brewery Centre).

'There were real doom-mongers at that time, at all levels, saying where is this all going to end? How are we going to survive as a brewery separated from pubs?' says Mike Hubbard. 'Carlsberg-Tetley came as a bit of a relief to be honest. There was a real keenness to be associated with a major brand and generally employees bought into the merger'.

Billed in the press as 'probably the best merger in the world'[2] the £510-million joint venture with Danish brewers Carlsberg was announced in October 1991 and would see the formation of a new company Carlsberg-Tetley Ltd (CT Ltd) that would encompass the six breweries at Burton, Leeds, Romford, Warrington, Alloa and Wrexham and Carlsberg's brewery at Northampton. It was originally hoped to be up and running by March 1992;[3] however, the deal had to be agreed by the Office of Fair Trading on monopoly grounds.

The proposal was a popular move in the city with share prices rising,[3] but not everyone was happy. There were warnings of redundancies within the group, especially at Romford and Warrington, this was proved correct, and they closed in 1992[4] and 1996[5], respectively. The merger was also opposed by CAMRA.[2] It took thirteen months to gain approval, and in November 1992, the President of the Board of Trade Mr Michael Heseltine finally agreed, and CT Ltd. became Britain's third largest brewer with a seventeen per cent market share, behind Bass and Courage.[6]

'The end of Ind Coope in 1992 was really "Ind Coope is dead, long live Carlsberg-Tetley!"' reflects Hubbard. 'It was the feeling of hope: people could begin to see a new and positive future. It didn't turn out quite like that but at least it meant that the Brewery remained and prospered'.

The brewery underwent yet another name change, by autumn 1995 it was known as 'Carlsberg-Tetley Burton Brewery' as depicted on the cover of the *Burton Herald*.[7] The name Ind Coope was slowly phased out.

Bass

CT Ltd turned out to be a relatively short-lived concern. Secret talks with neighbours and long-standing rivals Bass had begun in 1994[8] with CT Ltd later described as 'not a happy marriage'.[8] Sales volumes and profits had not been as high as planned, and future projections were not healthy: the deal for CT Ltd to supply Allied Domecq PLC's pubs was to run out in 1997.[8]

By August 1996, the Bass merger story hit the press.[9] The proposed deal would see Bass pay £200 million for Allied Domecq PLC's 50 per cent share in CT Ltd and would make the combined Burton brewery 'the biggest, best and most efficient brewery in Europe'.[8] The situation was neatly summed up by the *Burton Mail*: 'Bass has today won a battle for supremacy in Burton stretching back hundreds of years'.[8] The backlash was immediate 'Merger's a disaster' read the following day's headline, CAMRA decried what it called a 'duopoly' where Bass and Scottish Courage would own 70 per cent of the market.[10]

As with CT Ltd, the merger came under the scrutiny of the Office of Fair Trading; however, this time President of the Board of Trade Mrs Margaret Beckett decided not to give the go-ahead in June 1997.[11]

'There was actually some delight to be honest because a lot of employees really didn't want to be merged with Bass, they had been competing with them for years!' observed Mike Hubbard.

In the light of Beckett's decision, a shocking announcement appeared in July 1997: 'Brewery May Close',[12] and in September 1997, it was revealed that the brewery was to shut in April 1999 with the loss of 550 jobs,[13] and it was dubbed as 'Probably the worst closure in the world' by the *Burton Mail*.[14] Bass responded by offering to buy the premises but not the brands. At the Labour Conference in October, local MP Mrs Janet Dean asked Mrs Beckett not to intervene in the deal. Budweiser considered buying the brewery in October 1997 as did another unnamed company, but finally on 2 December 1997, Beckett announced that the sale could go ahead.[15]

Mike Hubbard remained at Bass until he retired two years later, 'I elected to go at the end of 1999, I was the last person left from the Ind Coope Executive team, although I had been working in a corporate role for a few years. I finished on 30 December 1999 at about 3 o'clock. It was a lonely experience. I remember thinking should I phone the *Burton Mail* so they could take just one last picture of me locking the door on the last bit of production in Burton? To me, that was truly the end of Ind Coope, it wasn't when Carlsberg-Tetley took over'.

CHAPTER 22

THE END

... *And Fall*

'When the site was finally offered for sale in 1996, although volumetrically it was probably still the largest brewery in the UK, it had little if any identity,' observes Colin McCrorie. 'By then its so-called drive brands, i.e. cask DBA, keg DDD and draught/bottle Skol, were in steep decline. It had moved so far away from the two stream operation of Skol and DDD in the late 70s to twenty-one worts, fifty plus Bright beers and literally 100s of pack variants!'

'The company's decline was in no small part due to taking on so much contract brewing work,' he criticises. 'Each brand had its own instruction manual, many of the instructions which often conflicting from brand to brand, so the brewery lost authority and identity to these organisations.'

'Its owners were demanding,' agrees David Cox before making a very valid point. 'They had to be to protect the integrity of their brands.'

In the 1970s, Ind Coope was in charge of their own destiny with two strong brands, but with the appearance of Castlemaine XXXX, Löwenbräu, Labatts, Greenalls, Sainsbury's own label products ... By the 1990s, Ind Coope was serving a number of masters.

'How they lost sight of the value of their own drive brands completely escapes me,' says a bemused McCrorie. 'Ironically the company had a very healthy experimental brewery which developed some novel products that were not handled professionally by marketing e.g. beer in box, mini-kegs, fruit-flavoured beers etc.'

'My view is that in the 80s, with beer demand starting to fall, the company became obsessed with volume rather than profit, so filled the brewery up with any liquid to keep plant and manpower busy,' says McCrorie. 'This was company strategy emanating from the main Allied Breweries board and endorsed by the shareholders. In hindsight it was an easier marketing ploy for the company than developing new in-house brands. The company should have seen through the overtures of the various international brand management groups, as the first one, XXXX, cost the brewery a £6 per barrel license fee, plus extra investment that cut into company funds'.

'UK beer drinking declined inexorably from around 1980 onwards,' explains David Cox.

Given that Allied's breweries collectively had not been rationalised quickly enough in the face of that decline, it's competitiveness began to suffer so investment in brewing new brands would not have made commercial sense. Contract brewing of brands that were growing and were fashionable was a good alternative. The demise of Skol was in the circumstances inevitable; and DD itself was by this time seen as a brand of the past, along with all the other keg ales which grew up in the '60s'.

Where are the New Brands?

With the lead time for the development of a new brand impossible to predict, as Cox states, 'There is no straight answer', and there is of course no guarantee of success. A case in point would be Arctic Lite which was developed and launched in the late 1970s and shelved a few years later.

'Arctic Lite was created as a competitor to Hemmeling,' remembers McCrorie. 'It was brewed in Burton, kegged at Ansells and bottled at Curzon Street. The marketing initiative was aimed, mistakenly as it turned out, at beer-drinking weight-watchers, but obviously scant account was paid to the calorific value of alcohol as opposed to sugar!'

'The organisation was keen to promote the brand for other reasons, in those days excise duty was paid on the specific gravity of collected Wort, so if the beer could be fermented more fully, no more duty was payable and the ensuing alcohol duty was proportionately less. I recall an 1033 OG and a final PG of less than zero, equating to 4.55 per cent ABV'.

The promotion of Arctic Lite was completely over the top, McCrorie lists some of the branded merchandise, 'Mohair sweaters, metal-backed note books, S/S Cross pens … The launch was one of the biggest I'd encountered'.

A novel advertising board appeared on the side of the Station Hotel in Burton, spelling out the logo in tiny foil circles. The noise of the wind blowing through it could be heard as you walked into town up the Station Bridge, then one day half of it was taken down, rumours are that correct planning permission was never applied for!

Ind Coope brewery buildings in 2013. Note the name Ind Coope & Co. Ltd has been bricked over.

'Eventually after a few years the product was phased out. It was felt that at the time there was little consumer demand for very dry beers. As you will gather, another example of a very poorly thought-out concept and marketing campaign,' concludes McCrorie.

The End

What caused the eventual downfall of the brewery? There appears to a multitude of factors at play; a declining beer market from 1980 onwards, lack of support for the core brands, loss of identity with contract brewing, a lack of successful new brands, the Beer Orders in 1989 ... no one aspect can be singled out and blamed or seen as the turning point.

Dropping the ball with Skol and DDD was a major mistake: after all what is a brewery without its core brands? To answer this, take a walk down Station Street and stand by the Guild Hall and peek through the railings at the original Ind Coope premises. What you will see is a once world renowned brewing institution that has been sold on and then sold on again until all that remains is the bricks and mortar now owned by a foreign brewer. Can you imagine how inconceivable this would have been to the great men who built the great companies of Wilson, Allsopp and Ind Coope?

Now pop over the road to *The Devonshire Arms* (or the Devi as it is known locally), order a pint and toast over 250 years of brewing history. Oh and if you're buying, mine's a DBA.

CHAPTER 23
THE FLAME STILL BURNS

The following details those with connections to Ind Coope and Samuel Allsopp who are still involved with brewing.

Burton Bridge Brewery: Burton upon Trent (1982–to date)

Pints being pulled at the Burton Bridge Brewery, 2015.

The owners of the longest running independent brewery in the town The Burton Bridge Brewery'had both worked at Ind Coope Burton: Bruce Wilkinson 1971–74 and Geoff Mumford 1972–75. Both moved to Ind Coope Romford before returning to Burton in 1981.'In about 1973,' reminisce Geoff on a particularly wet December Thursday evening.

I could take you back to the very spot where I thought 'There must be a lot of money in this game, the way these fools operate!' I wondered then if it would be possible to brew on a smaller scale, we would have been very much pioneers if we'd done it, but I needed to get a Brewer involved, and most were big company orientated. Beer sales had started to decline in 1977 and by 1981 the writing was on the wall, especially Romford that had 25 acres of prime site in the middle of the town. If you wanted to remain in brewing, you could get another job or as some other brave souls had done, do it yourself. Banks were happy to lend us money because of our expertise.

'Bruce and I discovered we were thinking along the same lines, we did a long term feasibility study; too expensive in London: Glasgow and Edinburgh would have been a culture shock. If you want to set up a Pottery you go to Stoke-on-Trent, that's where the raw materials and expertise is, so it was back to Burton'.

'I discovered these premises by accident: I came to a meeting in Burton, drove over the bridge and saw a "For Sale" sign on the front,' the pub had been the old Bass house 'The Fox and Goose'.

'I excused myself from lunch, came and climbed over the back wall. We'd been advised by a main board allied director that we'd need a pub because it's a good shop window and it is cash flow. There were buildings at the back that could convert into a brewery. It was just a two room pub and it came at a good price'.

The brewing equipment has not changed very much over time.

'As we have grown we've added more fermenting vessels and more casks, we were thought to be too optimistic having a fifteen barrel brew length, but we've grown in to it and we brew usually five days a week, averaging just under sixty barrels a week, 25 per cent goes into our own pubs, the rest to free trade'.

'We've been effectively brewing to capacity for fifteen to eighteen years, it's a profitable business. We've invested the profits in other pubs; the Alfred, the Devi, the Great Northern (which we've sold to the landlord this year), the Plough at Stapenhill and three years ago the Brickmakers Arms at Newton Solney'.

The number of beers has grown over the years to the established and varied range it is today.

'We started off with one beer, Bridge Bitter, we looked at the strengths of other bitters being brewed in the town so we pitched it in the middle at 4.2 per cent. That was followed by a rare beast in Burton, a Porter, then Festival Ale that we launched at a Burton Beer Festival, XL, Top Dog stout, then Golden Delicious, a summer ale, Stairway To Heaven and Sovereign Gold. We do our Christmas beer Hearty Ale and Old Expensive, Thomas Sykes Old Ale at 10 per cent, it doesn't sell at our pubs, just beer festivals. We brew and bottle an IPA called Empire Pale Ale, we called it that before Marston's did theirs, it's 7.5 per cent and we do an English Old Ale also at 7.5 per cent called Tickle Brain that is only in bottle. We do a different beer every month, have done for the last fifteen years, at 4.5 per cent and we try and match the beer to an event, a little known but interesting fact, we vary the ingredients to reflect that'.

'We used to be only able to buy hops by the pocket, there was deterioration over the time it took you to use them, now you can buy them in 50kgs vacuum packed boxes and that's done a lot for quality. Now there is a whole range of hops you can chose from with different characteristics. If we'd have tried to do these monthly beers thirty years ago, we couldn't have done it'.

The brewery has won more than its fair share of awards over the years.

'We won the Bitter Class at the Great British Beer Festival in 1982, our first year,' Geoff reveals rather humbly. 'We've won numerous awards, Best Bottled Beer with Empire Pale Ale, most of them are screwed to the wall in the skittle alley'.

Geoff is also very complimentary about those working for him.

'We have absolutely superb staff. Including Bruce and I there are eleven, all very committed. Everybody depends on everybody else'.

The Old Cottage Brewery: Burton upon Trent (1999–to date)

Kev Slater had been happily brewing for the SABC until it closed in April 1998, after the then owner Bass decided that it was no longer needed. Kev was not ready to hang up his brewing boots just yet and began to put feelers out to secure his own equipment.

'Six months or so prior to leaving Bass and after a tip off from a colleague, I bought the then defunct Old Cottage Brewery from the Kendal in the Lake District,' a sum of £3,000 secured the deal. 'For anything that was un-screwable, including malt and firkins'.

The brewery was set up in a building on the old Heritage Brewery site in Anglesey Road. It is now a residential apartment.

'The first trial went through in December 1999 which was followed by a couple more before I put the first brew out to trade. On the 11 January 2000 the first beer which I named Windrift was brewed. A week later it was for sale. The first cask was sold to the Thomas Sykes which utilised another part of the Heritage site buildings'.

Windrift proved to be an instant success, 'It sold in one day,' exclaims Kev. 'The remainder of the brew all went through the Sykes, which sold out some three days later. With a brew length of five barrel producing around twelve firkins I thought we're onto a winner here!'

This led Kev to take the brave step and collect his redundancy from Bass at the end of September 2000.

'The Sykes became my unofficial Quality Control and Research Departments. Every new beer would begin its life by being served over the bar in the pub before being distributed further afield'. In late 2001, Kev was forced to move to new premises at Eccleshall's Business Park situated in Hawkins Lane. As sales and demand continued to increase, the next move was to buy a tied house.

'I looked at couple including the Station Hotel as I thought this would be ideal to put the brewery at the back. It was close to the station with plenty of parking and room for functions,' said Kev; however, there were problems with the site. 'The cost to bring it up to scratch was too much for the projected returns, so that was put to bed'.

Another potential site came up for sale, the British Oak behind the Town Hall on Byrkley Street/Rangemoor Street corner. This time, it was perfect, and Kev bought it for £160,000 and promptly renamed it the Old Cottage Tavern. Kev then started brewing something new every couple of weeks.

'I produced more than 100 differing ales during the time I had the brewery by changing the recipe,' he reveals. 'I ended up with three mainstay ales; Oak Ale at 4 per cent (named after the pub name before it changed), Old Cottage Stout at 4.7 per cent and the famous Halcyon Daze at 5.3 per cent'.

'Although Halcyon is the most talked about ale, it was the Stout which claimed all the awards, from local pub festivals to the larger regional festivals. The highlight though was the Stout being judged the West Midlands Beer of the Year by CAMRA in October 2002. It also came second in the "Beer to Die For" in the same year'.

A further highlight was being asked to brew a beer specifically for the Wetherspoons pub the Lord Burton, 'I called it 161 as it was the 161st pub that Wetherspoon's opened,' 161 was a light pale ale with an ABV of 4.7 per cent, and it was limited to a mere 650 pints!

By 2004, Kev was beginning to feel the strain, 'Running the brewery and the pub simultaneously was getting hard work, and I wasn't getting any younger and I couldn't really build the pub up any more. This forced me to a decision to sell one or the other. As I enjoy brewing, selling the pub seemed to be the obvious way to go. In November 2004 a deal was done with Tadcaster Pub Co. which bought it off me. I then concentrated on brewing until I sold the brewery in 2008.'

The Old Cottage Brewery still produces under the current owner Mick Machin.

Gates Burton Brewery: Burton upon Trent (2011–to date)

'I have been brewing cask beer as a hobby for about twenty-five years, I have a very understanding wife,' confesses Stuart Gates. 'Cask beer has always been my love and passion. I still have some excellent recipes going back all those years'.

'At my retirement party in the Roebuck I put on a pin of ale (which is now called Reservoir) and Julie the landlady sampled it and said if I ever followed my dream of brewing commercially she wanted to be the first to have some! I eventually started in 2011 with a one-barrel plant, the beer sold itself as word of mouth soon got round and demand was soon outstripping production, even brewing twice a week. I am lucky to have a lot of local support throughout the town of Burton for which I am very appreciative of. I deliver within a ten mile radius, supplying to around twenty-six pubs, of which about eight are regulars'.

Stuart has since expanded to a three-barrel plant and produces three qualities:

Reservoir (4.6 per cent): Full-bodied, amber in colour with a finely balanced malt and hop character giving a wonderfully smooth finish.

Damn (5 per cent): Smooth drinking Ruby ale with chocolate malt tones and delicately hopped with a subtle sweet finish.

Reservoir Gold (8 per cent): Full-bodied, amber in colour, finely balanced with roast barley and subtly hopped, sweet finish and wonderfully smooth.

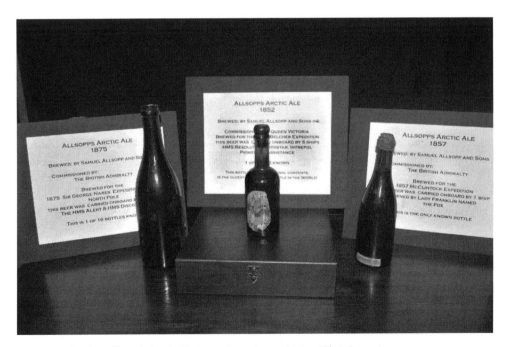

A unique collection Allsopp's Arctic Ale from 1852, 1857 and 1875 (Chris Bowen).

Arctic Alchemy: Bethlehem, Pennsylvania (2007–to date)

In June 2007, an eBay auction ended for $304 on a bottle of 'allsop's arctic ale.full and corked with a wax seal brewed in 1852 for an arctic expedition' [sic]. The seller was based in Lynn, Massachusetts, and the buyer 'collectordan' from Tulsa, Oklahoma. One of the watchers for the auction was Chris Bowen, a dedicated and award-winning home brewer from Bethlehem, Pennsylvania, and so began an obsession that would take him places such as the dusty basement of an old brewery in Burton upon Trent, Hudson Bay in the Canadian Arctic Circle and Brighton for an appearance on British television!

'I came across the Arctic Ale, I can't remember at what price it was listed, but it was way over my budget at the time, but the bottle was interesting looking and clean for being so old, I saved it to my watch list,' Chris then continues, 'Take a closer look at the listing, the seller had neglected to add the second "p" in Allsopp's, I missed it too, but search engines on eBay hadn't yet developed for misspellings or suggested corrections, so if someone was looking for this beer by the correct spelling it wouldn't come up in a simple search result list'.

Two months later, the bottle had been relisted by the buyer, this time with the correct spelling 'Museum Quality ALLSOPP's ARCTIC ALE 1852 SEALED/FULL!!! RAREST Historic Beer in the World! AMAZING HISTORY!!!'

'The seller had done some limited research, as I read through the newly listed bottle and the story of Queen Victoria commissioning the brewing and the search for John Franklin's lost expedition, I thought wow this is amazing, being a history lover and more importantly a beer lover, this was the coolest thing I had ever heard,' enthuses Chris. The auction then went crazy. 'As I watched the bidding war ensue, I was checking in on this auction daily, seeing $80,000 go to $120,000, then to $240,000, then to $430,000, it was also starting to become talked about extensively , it had gone viral. In the end the final bid was $ 503,000 for this crazy bottle of beer!'

The winner this time was known as 'voodoo4score', and although the final bid turned out to be hoax, the auction had passed into eBay legend, and what's more it had captivated Chris.

'What happened next for me was a complete and utter fascination with the bottle: its story and most importantly its history. For the next couple of years I started researching all about this beer and its brewer Samuel Allsopp and Sons'.

This led Chris to buy a full and sealed bottle of the 1852 in 2009, the 1857 shortly afterwards and to also produce his own version of Arctic Ale, he poetically compares the original brew to his own.

'Like sitting with a family elder, a grandmother or grandfather and having them show you pictures of themselves when they were young. The newer version has all the fancy upfront flavours in higher resolution whereas the older version has all the complexities and subtle reminders of time and age. Each are to be appreciated and cherished for their role in who they are and where they came from'.

In September 2010, Chris made a trip to Burton upon Trent to give a talk to the local branch of CAMRA; the following day a tour of the former Allsopp's New Brewery was arranged. While in the cellar, Chris found a crate containing some very dusty unlabelled champagne bottles.

'When I first saw the bottles I suspected they may be special, but certainly couldn't assume them to be Arctic Ale, however my gut and intuition said they were. I sent a sample to a laboratory in Chicago, Illinois for testing, the results were returned to me on the unknown sample, along with a sample of the ale that I produced, they were nearly the same, the differences could be attributed to age, especially levels of oxidization and cell level yeast structure. It was from these samples, along with other supporting research, a similar study that was conducted in a 1961, determined that the ale was indeed the fabled Arctic Ale of 1875!'

Chris dreamt of brewing Arctic Ale in the Arctic Circle, and on 25 July 2010, he set off to do just that. With a mobile brewery and a film crew, 'Arctic Alchemy' was born. They stopped along the Rivere Ruppert to collect the brewing water, and after ten days on the road, they arrived

at Longue Point, where Hudson Bay and James Bay meet, here they brewed. The process was arduous and hampered by bad weather but was a success, and the film was released in 2015.

In 2014, Fresh Ones Productions were filming the new Jamie Oliver food show *Jamie & Jimmy's Friday Night Feast*, appearing on one episode was Kirstie Allsopp, the daughter of Charles Henry Allsopp (6th Lord Hindlip) and therefore a direct descendent of Samuel Allsopp. Chris was invited to appear briefly on the show and opened one of his last remaining bottles of the 1875.

'Kirstie was completely stunned, we planned it this way! This was the first time in her entire life, that she had actually tasted her family's beer. The nature of Arctic Ale being 12 per cent ABV meant it could, survive the test of time to be an enjoyable experience. Many of Allsopp's brewings had been of a much lower ABV and would not have endured and would have been undrinkable,' explains Chris. 'Kirstie had sent me a note on my return to the States, expressing overwhelming disbelief at what actually happened that day. I also gave her a few other bottles from my ale that I brewed in the Arctic. Kirstie was exceptionally nice to both me and my wife, whom accompanied me on the show'.

NOTES

Chapter 1: Benjamin Wilson (Snr)

1. Owen, C. C., *The Development of Industry in Burton upon Trent* (Phillimore & Co. Ltd, 1978), p. 36.
2. Peaty, Ian, *Brewery Railways* (David & Charles, 1985), p. 23.
3. Bushnan, J. Stevenson, *Burton and its Bitter Beer* (1853), p. 79.
4. Ibid., p. 89.
5. Ibid., p. 88.
6. *The Red Hand*, Vol. 1, No. 1.
7. Ibid., Vol. 7, No. 4.
8. Ibid., Vol. 8, No. 4.
9. Bushnan, *Burton*, pp. 74–75.
10. Shaw, Dr, *History and Antiquities of Staffordshire* (1798) quoted in Bushnan, *Burton*, pp. 74–75.
11. Owen, *The Development*, p. 33.
12. Allsopp Deeds, 12 October 1742.
13. Owen, *The Development*, p. 37.
14. Wyatt, William, *Plan of Burton-on-Trent and surrounding districts* (1757–1760), Allsopp Deeds, 21 December 1756.
15. Bushnan, *Burton*, p. 80.
16. Fowler, George, *Lives of the Sovereigns of Russia* quoted in Bushnan, *Burton*, p. 80.
17. Ibid., p. 81.
18. Barnard, Alfred, *Noted Breweries of Great Britain and Ireland*, Vol. 1 (Sir Joseph Causton & Sons, 1889), p. 123. (The original source is no longer in existence.)
19. Owen, *The Development*, Appendix 49.

Chapter 2: Benjamin Wilson (Jnr)

1. Allsopp Deeds, 12 and 13 February 1773.
2. Ibid., 23 June 1774.
3. Ibid., 24 June 1774 and 09 October 1774.
4. Bushnan, *Burton* p. 90.
5. Allsopp Deeds, 01 April 1778 and 02 April 1778.
6. Owen, *The Development*, p. 38.
7. Barnard, *Noted Breweries*, p. 123 (The original source is no longer in existence.)
8. Bushnan, *Burton*, p. 82.
9. Ibid., p. 83.
10. Ibid., p. 86.

11. Ibid., p. 88.
12. Owen, *The Development*, p. 39.
13. Ibid., p. 41.
14. Ibid., p. 42.
15. Ibid., p. 43.
16. Benjamin Wilson Letter Book, 31 August 1791.
17. Owen, *The Development*, Appendix 19.
18. Ibid., p. 44.
19. Ibid., p. 45.
20. Bushnan, *Burton*, p. 91.
21. Owen, *The Development*, p. 46.
22. Ibid., p. 47.
23. Ibid., p. 51.
24. Ibid., Appendix 49.
25. Allsopp Deeds, 25 and 26 September 1807.

Chapter 3: Samuel Allsopp

1. Allsopp Deeds 25 and 26 September 1807.
2. Bushnan, *Burton*, p. 92.
3. Ibid., p. 90.
4. Ibid., p. 93.
5. Owen, *The Development*, p. 72.
6. Ibid., p. 74.
7. Ibid., p. 73.
8. Ibid., p. 75.
9. Bushnan, *Burton*, p. 96.
10. Ibid., pp. 96–97.
11. Ibid., p. 97.
12. Ibid., pp. 100–102.
13. Mathias, P., *Wartime Trade 1806-1815 (The Red Hand*, Vol. 10 No. 6).
14. Owen, *The Development*, p. 76.
15. Bushnan, *Burton*, p. 102.
16. Ibid., p. 104.
17. Owen, *The Development*, p. 77.
18. Bushnan, *The Development*, p. 107.
19. Ibid., p. 108.
20. Ibid., p. 109.
21. Ibid., p. 110.

Chapter 4: Samuel Allsopp & Sons

1. Bushnan, *Burton*, p. 99.
2. Shepherd, Cliff, *Brewery Railways of Burton on Trent*. (Industrial Railway Society, 1996) p. 208.
3. Owen, *The Development*, Appendix 49.
4. Bushnan , *Burton*, pp. 123–4.
5. Shepherd, *Burton*, pp. 10–25.
6. Bushnan, *Burton*, p. 125.
7. Messrs Allsopp, Townshend & Leigh, *Brewery Burton upon Trent*, 1846.
8. *The Red Hand*, Vol. 5, No. 5.
9. Owen *The Development*, pp. 85–101.

10. *Burton Weekly News*, 19 June 1957.
11. Cooksey, Julian, *Brewery Buildings in Burton on Trent* (Victorian Society, 1984).
12. Barnard, Alfred, *Noted Breweries of Great Britain and Ireland* Vol. 3 (Sir Joseph Causton & Sons, 1889) p. 133.
13. Ward, Ben, *Notes on Buildings Burton-on-Trent* (Unpublished document held at National Brewery Centre Archive).
14. Shepherd, *Brewery*, pp. 196–206.
15. *The Red Hand*, Vol. 5, No. 11.
16. 'Fabled Franklin Arctic Ship Found', BBC Online, 9 September 2014.
17. Bushnan , *Burton*, p. 126.
18. *The Strand*, No. 59, November 1895.
19. Barnard , *Noted*, pp. 126–161.
20. Rudin, A. D. & Watts, M. J., *Analysis of an Ale Brewed in 1875* (Journal of the Institute of Brewing, Vol. 67, 1961, Issue 5) p. 511–513.
21. December 1896 letter 'Allsopp's Arctic Ale'.
22. *Whitbread Gravity book*. London Metropolitan Archives LMA/4453/D/02/001.
23. *The Red Hand*, Vol. 4, No. 11.
24. *The Argosy*, No. 2, October 1970.
25. *The Red Hand*, Vol. 4, No. 9.
26. Newton, David, *Trademarked: A History of Well-Known Brands, from Airtex to Wright's Coal Tar* (The History Press, 2013).
27. Memorandum as to Division of Purchase Money, 31 December 1886.

Chapter 5: Samuel Allsopp & Sons Ltd

1. *The Standard*, 13 February 1890.
2. Ibid., 20 February 1890.
3. *Lloyd's Weekly Newspaper*, 13, February 1887.
4. *Leeds Mercury*, 03 March 1887.
5. *Pall Mall Gazette* 07 February 1887.
6. *SA&S Ltd Prospectus*, 02 February 1887.
7. *Birmingham Post* 14 February 1890.
8. *The Times* 10 May 1887.
9. Owen , *The Development*, p. 73.
10. *Birmingham Post*, 09 August 1888.
11. *The Standard*, 12 July 1889.
12. Ibid., 09 August 1889.
13. Ibid., 22 February 1890.
14. Ibid., 08 March 1890.
15. Ibid., 13 June 1890.
16. Ibid., 13 February 1890.
17. *York Herald*, 27 June 1890.
18. *Huddersfield Chronicle*, 18 October 1890.
19. *Pall Mall Gazette*, 24 October 1890.
20. *Nottingham Evening Post*, 08 August 1891.
21. *Worcester Journal*, 08 August 1891.
22. *Western Times*, 09 August 1892.
23. *Taunton Courier and Western Advertiser*, 12 July 1893.
24. *Liverpool Mercury*, 10 August 1895.
25. *Derby Daily Telegraph*, 10 August 1894.
26. *Biggleswade Chronicle*, 15 July 1898.
27. *SA&S Ltd Executive Minutes*, 04 September 1896
28. *London Standard*, 29 March 1898.
29. Ibid., 12 August 1898.

30. *Western Daily Press*, 21 October 1899.
31. Shepherd, *Brewery*, p. 205.
32. *Aberdeen Journal*, 23 April 1900.
33. *SA&S Ltd Executive Minutes*, 06 March 1900.
34. *Morning Post*, 18 August 1900.
35. *Derby Mercury*, 22 August 1900.
36. *Yorkshire Evening Post*, 09 July 1901.
37. *Dundee Evening Telegraph*, 10 July 1901.
38. *Sheffield Independent*, 23 August 1901.
39. *Dundee Evening Post*, 31 December 1901.
40. *Lancashire Evening Post*, 13 August 1902.
41. Dundee Courier, 17 August 1904.
42. *Derby Daily Telegraph*, 28 December 1904.
43. *Manchester Courier and Lancashire General Advertiser*, 31 August 1906.
44. *Chelmsford Chronicle*, 06 April 1906.
45. *Portsmouth Evening News*, 15 September 1906.
46. *Exeter and Plymouth Gazette*, 07 March 1907.
47. Ibid., 14 September 1907.
48. *West Briton and Cornwall Advertiser*, 16 December 1907.
49. *Manchester Courier and Lancashire General Advertiser*, 14 December 1907.
50. *Gloucester Citizen*, 16 June 1911.
51. *Aberdeen Journal*, 706/1911
52. *Manchester Courier and Lancashire General Advertiser*, 17 June 1911.
53. *Dundee Evening Telegraph*, 12 January 1912.
54. *Yorkshire Post and Leeds Intelligencer*, 24 May 1912.
55. *Staffordshire Sentinel*, 05 June 1912.
56. *Manchester Courier and Lancashire General Advertiser*, 14 September 1912.
57. *Dundee Evening Telegraph*, 02 June 1909.
58. *Dundee Courier*, 25 December 1909.
59. *Cambridge Independent Press*, 24 December 1909.
60. *Manchester Courier and Lancashire General Advertiser*, 18 August 1905.
61. Yorkshire Post and Leeds Intelligencer, 08 July 1904.
62. *Birmingham Daily Post*, 23 December 1914.
63. Shepherd, *Brewery*, p. 208.
64. *Daily Gazette for Middlesbrough*, 18 July 1916.
65. *Western Times*, 19 July 1916.
66. *Yorkshire Post*, 30 December 1921.
67. Ibid., 24 December 1926.
68. Barber, N., Brown, M. Smith, K. *Century of British Brewers Plus 1890-2004* (Brewery History Society, 2005), p. 122.
69. *SA&S Ltd Executive Minutes*, 07 July 1913.
70. J. J. Calder interview, 1 December 1959 (unpublished).
71. *Manchester Courier and Lancashire General Advertiser*, 31 September 1913.
72. *Nottingham Evening Post*, 11 March 1913.
73. *Derby Daily Telegraph*, 07 June 1913.
74. *Birmingham Daily Post*, 01 January 1914.
75. *Yorkshire Post and Leeds Intelligencer*, 29 December 1917.
76. *Gloucester Citizen*, 24 December 1918.
77. *Western Morning News*, 29 December 1923.
78. *The Daily Mail*, 30 December 1922.
79. *Yorkshire Evening Post*, 30 December 1921.
80. *Nottingham Evening Post*, 22 December 1928.

Chapter 6: Delivering the Goods

1. Shepherd, *Brewery*, pp. 10–25.
2. James, Malcolm, *Brewery Buildings of Burton-upon-Trent: Reflection and Opportunities* (RICS Post-Graduate Diploma in Conservation of the Historic Environment, 2006), p. 294.
3. Peaty, *Brewery*, p. 24.
4. *The Red Hand*, Vol. 10, No. 3.
5. Ibid., Vol. 7, No. 1.
6. Ibid., Vol. 6, No. 5.
7. Ibid., September 1960.
8. Ibid., No. 13, 1972.
9. *Burton Herald Spring*, 1981.
10. Ibid., October 1987.
11. Ibid., December 1991.
12. *The Red Hand Autumn*, 1961.
13. Ibid., Vol. 7, No. 6.

Chapter 7: Ind Coope

1. *The Red Hand*, Vol. 1, No. 2.
2. Debretts House of Commons and the Judicial Bench, 1886.
3. *The Red Hand*, Vol. 8, No. 4.
4. Ibid., Vol. 3, No. 7.
5. *The Chelmsford Chronicle*, 30 September 1846.
6. Owen, *The Development*, p. 80.
7. 1851 Census.
8. *Brief early history from the deeds of the Burton Brewery of Ind Coope & Co. RCP 11/11/1991* (unpublished).
9. Barnard, *Noted*, Vol. 2, p. 53.
10. *Derby Daily Telegraph*, 08 September 1906.
11. Barnard, *Noted*, p. 65.
12. Map dated 1861.
13. Map dated 1888.
14. Shepherd, *Brewery*, p. 209.
15. James, *Brewery*, p. 333.
16. Shepherd, *Brewery*, p. 211.
17. Ibid., pp. 214–215.
18. *Essex Standard*, 27 November 1886.
19. *Tamworth Herald*, 04 December 1886.
20. *Northampton Mercury*, 23 November 1889.
21. *Nottingham Evening Post*, 20 November 1895.
22. *Lincolnshire Chronicle*, 26 April 1895.
23. *Yorkshire Evening Post*, 01 January 1892.
24. *The Red Hand*, Vol. 2, No. 7.
25. Barnard, *Noted*, p. 54.
26. Ibid., p. 55.
27. Ibid., p. 56.
28. Ibid., p. 57.
29. Ibid., p. 58.
30. Ibid., p. 60.
31. Ibid., p. 61.
32. Ibid., pp. 62–63.
33. Ibid., p. 64.

34. *Chelmsford Chronicle*, 22 May 1896.
35. *Western Daily Press*, 03 July 1899.
36. *Calder interview.*
37. *Burton Evening Gazette*, 24 June 1899.
38. *Yorkshire Evening Post*, 19 December 1902.
39. *Sheffield Daily Telegraph*, 19 April 1902.
40. *Tamworth Herald*, 26 March 1904.
41. *Derby Daily Telegraph*, 31 March 1906.
42. Ibid., 20 March 1906.
43. *Chelmsford Chronicle*, 06 April 1906.
44. *Nottingham Evening Post*, 12 June 1906.
45. *Manchester Courier and Lancashire General Advertiser*, 15 August 1906.
46. *Chelmsford Chronicle*, 08 March 1907.
47. Ibid., 27 December 1907.
48. *The Devon and Exeter Gazette*, 07 January 1909.
49. *Derby Daily Telegraph*, 22 November 1909.
50. Ibid., 19 December 1910.
51. *The Citizen*, 05 June 1912.
52. *Nottingham Evening Post*, 23 July 1912.
53. *The Red Hand*, Vol. 1, No. 1.
54. Calder interview.
55. Ind Coope Committee Of Management Minutes, 10 February 1913.
56. Ibid., 09 March 1914.
57. Ibid., 18 May 1914.
58. Ibid., 15 March 1920.
59. Ibid., 11 June 1923.
60. Ibid., 24 September 1923.
61. Ibid., 17 September 1924.
62. Ibid., 09 May 1927.
63. Anderson, R. & Brown, M. 'Saving the Past: The rescue of the Allied Breweries Archive'. *Brew. Hist.*, 112, pp. 49–60.
64. Faulkner, N.O. 'A Long Life'. *Allied Breweries: A Directory Of Ancestor Breweries* (Staples Printers).

Chapter 8: Amalgamation

1. *Yorkshire Post*, 16 March 1934.
2. *The Red Hand*, Vol. 1, No. 1.
3. Calder op. cit.
4. Shepherd, *Brewery*, p. 216.
5. *Derby Evening Telegraph*, 16 March 1934.
6. *IC&A COMM*, 26 June 1934.
7. Ibid., 19 July 1934.
8. Ibid., 30 January 1935.

Chapter 9: The New Bottling Stores

1. *The Red Hand*, Vol. 2, No. 11.
2. Gourvish, T. R. & Wilson, R .G. *The British Brewing Industry 1830–1980* (Cambridge University Press, 1994) p. 299.
3. Report to the Board: Extension of Bottled Beer Department by John J Calder, 15 March 1934.
4. Undated map, probably late 1930s.

5. *IC&A COMM*, 09 January 1935.
6. Ibid., 11 July 1935.
7. Ibid., 23 January 1936.
8. Ibid., 15 March 1936.
9. Ibid., 06 January 1937.
10. Ibid., 03 February 1938.
11. Ibid., 05 January 1939.
12. Ibid., 21 February 1940.
13. Ibid., 04 March 1939.
14. Ibid., 10 January 1940.
15. Ibid., 05 February 1941.
16. Ibid., 25 June 1941.
17. Ibid., 19 February 1941.
18. Ibid., 12 November 1941.
19. Application for reconstruction of Bottling Stores, August 1945.
20. 'Britain's Greatest Bottling Stores' booklet, *c.* 1948.
21. *IC&A COMM*, 04 April 1945.
22. Ibid., 19 May 1946.
23. *The Red Hand*, Vol. 1, No. 1.
24. *IC&A COMM*, 08 August 1945.
25. Ibid., 28 August 1945.
26. Ibid., 19 September 1945.
27. Ibid., 31 October 1945.
29. The Red Hand, Vol. 1, No. 2.
30. Bottling & Canning – Burton (Unpublished document), *c.* 1976.
31. *IC&A Ltd. COMM*, 01 June 1949.
32. *The Red Hand*, Vol. 2, No. 3.
33. *IC&A Ltd. COMM*, 14 June 1954.
36. Ibid., 26 April 1955.
35. Ibid., 14 February 1955.
36. Ibid., 13 May 1957.
37. Ibid., 15 April 1957.
38. Ibid., 22 May 1957.
39. Ibid., 24 June 1957.

Chapter 10: Barley & Malting

1. *The Red Hand Spring*, 1958.
2. Undated map, probably late 1930s.
3. *Ind Coope News*, No. 65, 1965.
4. Geary, R., *The County Borough of Burton upon Trent Fire Brigade. My service 1948 to 1973* (Reprint).
5. James, *Brewery*, p. 294.
6. *Burton Daily Mail*, 16 June 1981.
7. *Albrew Maltsters Burton Maltings* booklet, 1984.
8. *Burton Mail*, 07 January 2012.

Chapter 11: Fire!

1. Geary, *The County*.
2. *The Red Hand*, Vol. 8, No. 2.
3. *Fire Protection Review*, April 1954.

4. *IC&A Ltd. COMM*, 21 July 1954.
　5. Ibid., 08 November 1954.
6. *Fire Protection Bulletin*, December 1954.
7. *Burton Daily Mail*, 25 February 1954.
8. Cox, R., *We all and each of us: The story of the Burton upon Trent Fire Brigade* (2002).
9. *Burton Daily Mail*, 26/02/1954
10. *IC&A Ltd. COMM*, 28 April 1954.
11. *Burton Daily Mail*, 08 February 1971.
12. *The Argosy*, No. 5, 1971.

Chapter 12: Double Diamond

1. *The Red Hand*, Vol. 1, No. 1.
2. *The Chelmsford Chronicle*, 30 September 1846.
3. *The Red Hand Autumn*, 1962.
4. Ibid., Summer 1960.
5. Ibid., January–February 1957.
6. Price list of Burton bottled ales & stouts, 01 September 1934.
7. *IC&A Ltd. COMM*, 29 April 1936.
8. Ibid., 10 June 1936.
9. Ibid., 30 March 1938.
10. Calder interview.
11. *IC&A Ltd. COMM*, 08 March 1939.
12. Ibid., 05 February 1941.
13. Ibid., 01 September 1943.
14. Ibid., 01 March 1949.
15. Ibid., 27 July 1949.
16. Ibid., 12 February 1953.
17. Ibid., 27 November 1957.
18. Ibid., 25 July 1951.
19. Ibid., 19 September 1950.
20. *Ind Coope News*, No. 1, 1957.
21. Mine Host No. 2.
22. *IC&A Ltd. COMM*, 27 November 1958.
23. *Ind Coope News*, No. 61, 1962.
24. Ibid., No. 69, 1963.
25. Ibid., No. 62, 1962.
26. Ibid., No. 82, 1965.
27. Plaque commemorating the installation of Morton's fermenters, 1965.
28. *Ind Coope News*, No. 72, 1964.
29. *The Argosy*, No. 1, 1970.
30. Your Guide to the Double Diamond Brewery. Booklet undated *c.* early 1970s.
31. *The Argosy*, No. 6, 1971.
32. Ibid., April 1971.
33. *What's Brewing*, June 1974.
34. *Burton Herald*, No. 2, 1975.
35. *IC&A Ltd. COMM*, 02 September 1937.
36. Ibid., 2 September 1947.
37. Ibid., 27 July 1950.
38. Ibid., 14 February 1955.
39. *The Red Hand*, Vol. 6, No. 5.
40. *IC&A Ltd. COMM*, 26 January 1955.

41. Ibid., 12 September 1955.

42. Ibid., 26 August 1958.

43. *Ind Coope News*, No. 86, 1966.

44. *What's Brewing*, September 1973.

45. Ibid., August 1972.

46. Ibid., June 1973.

47. Cornell, M., Zythophile blog, 02 August 2011.

48. *Burton Herald*, No. 18, 1979.

49. Ibid., No. 1, 1981.

50. Ibid., December 1986.

51. Ibid., December 1990.

52. Ibid., August 1990.

53. *The Red Hand Autumn* 1958.

54. The Daily Mail Online, 06 September 2010.

Chapter 13: Identity

1. *The Red Hand*, Vol. 4, No. 1.

2. Gourvish and Wilson, *The British*, pp. 623–626

3. *The Argosy*, No. 1, 1970.

4. Letter from R. Bristow, 29 December 1958.

5. *Ind Coope Extra*, 1959.

6. *Ind Coope News*, No. 44, 1961.

7. Gourvish and Wilson, *The British*, p. 525.

8. *The Red Hand Summer*, 1961.

9. Gourvish and Wilson, *The British*, pp. 525–527.

10. Cox, D., Major Physical, Cultural & Organisational Change achieved by GABB & GIBB' (1988) p. 3–5.

11. Faulkner, *A Long Life.*

12. *Ind Coope News*, No. 99, 1968.

13. *Burton Mail*, 27 May 1994.

14. *Ind Coope News*, No. 100, 1969.

15. *The Red Hand*, No. 2, 1970.

16. Ibid., No. 33, 1975.

17. Ibid., Vol. 3, No. 9.

18. Ibid., No. 42, 1977.

19. *The Argosy*, No. 24, 1974.

20. *Burton Herald*, No. 17, 1979.

21. *Burton Mail*, 26 May 2012.

22. *Burton Herald*, Special Edition Spring, 1981.

23. Ibid., March 1982.

24. Ibid., September 1982.

25. Ind Coope Burton Brewery v. The Lord's Taverners programme, 02 June 1985.

Chapter 14: Draught Burton Ale

1. *Burton Herald*, No. 7, 1977.

2. Ibid., No. 16, 1979.

3. Ibid., No. 17, 1979.

4. Ibid., March 1982.

5. Ibid., February 1985.

6. Ibid., December 1982.

7. Ibid., No. 9, 1977.
8. Ibid., February 1986.
9. *The Burton Ale Guild of Master Cellarmen* (Pub Guide, 1992).
10. *Burton Herald*, October 1987.
11. Ibid., August 1989.
12. *What's Brewing.* November 1990.
13. Ibid., December 1990.
14. *Burton Mail*, 08 January 2015.
15. Ibid., 15 March 2015.
16. Ibid., 28 March 2015.

Chapter 15: Skol

1. SA&S Ltd. EM, 06 March 1900.
2. The Red Hand, No. 1, July 1970.
3. Calder interview.
4. IC&A Ltd. COMM, 27 October 1955.
5. Ibid., 24 November 1955.
6. Ibid., 25 July 1956.
7. Ibid., 30 October 1956.
8. Ibid., 29 November 1956.
9. Ibid., 25 April 1957.
10. Ibid., 29 August 1957.
11. Ibid., 31 October 1957.
12. Ibid., 24 July 1958.
13. Ibid., 29 December 1958.
14. Ibid., 22 May 1958.
15. Ibid., 02 April 1959.
16. *The Red Hand*, Autumn 1960.
17. Ibid., 04 January 1960.
18. Ind Coope News, No. 33, 1960.
19. IC&A Ltd. Chairman's Committee of Executive Directors Minutes 02/05/1960.
20. Ind Coope News, No. 43, 1961.
21. Ibid., No. 62, 1962.
22. Ibid., No. 68, 1963.
23. Ibid., No. 89, 1967.
24. Ibid., No. 85, 1966.
25. Ibid., No. 91, 1967.
26. ABUK Ltd. Directors Minutes, 23 February 1984.
27. Ibid., 21 March 1985.
28. Ibid., 14 June 1985.
29. Ibid., 24 July 1986.
30. Ibid., 12 April 1988.
31. Ibid., 06 March 1986.
32. *Burton Herald*, No. 17, July 1979.
33. 'You're a Skolar' Skol advert, 1979.
34. 'Trevor' Skol advert, 1983.
35. *Burton Herald*, July 1983.
36. 'Vikings invade Britain for the second time' information sheet inserted in BH, May 1986.
37. http://en.wikipedia.org/wiki/Hagar_the_Horrible.
38. ABUK Ltd. DM, 16 October 1986.
39. Ibid., 18 February 1988.

40. Corporate Services News, December 1986.
41. *Burton Herald*, December 1991.
42. Mirror, 13 January 2015.
43. 'Advertising's broken dreams', The Independent, 07 February 1993.
44. *Burton Herald*, December 1991.
45. ABUK Ltd. DM, 12 March 1992.
46. *Burton Herald*, December 1991.
47. *The Red Hand*, No. 2, October 1970.

Chapter 18: Brewery Life

1. *The Red Hand*, Vol. 4, No. 9.
2. Ibid., Vol. 11, No. 2.
3. *Burton Herald Spring Edition*, 1996.
4. Ibid., No. 24, December 1980.
5. Burton Mail, 23 June 2011.
6. *Burton Herald*, December 1988.
7. Burton Daily Mail, 29 July 1980.
8. *Burton Herald*, October 1987.
9. Ibid., August 1993.
10. Ibid., No. 14, 1978.
11. Ibid., No. 8, 1977.
12. Ibid., October 1983.
13. Ibid., December 1990.
14. Ibid., July 1983.
15. Ibid., May 1980.
16. Ibid., No. 2, 1975.

Chapter 19: Everybody Out!

1. Burton Daily Mail, 15 October 1979.
2. Ibid., 16 October 1979.
3. Ibid., 18 October 1979.
4. Ibid., 17 October 1979.
5. Cox, Major Physical, pp. 3–5.
6. Burton Daily Mail, 11 August 1980.
7. Ibid., 14 August 1980.
8. Ibid., 15 August 1980.
9. Ibid., 19 August 1980.
10. Ibid., 20 August 1980.
11. Ibid., 22 September 1980.
12. Ibid., 29 September 1980.
13. Ibid., 30 September 1980.
14. Waddington, D. P., *A Social Psychological Analysis of Strikes* (PhD Thesis, The University of Aston in Birmingham, 1985).
15. Burton Daily Mail, 10 February 1981.
16. Ibid., 23 April 1981.
17. Ibid., 23 April 1981.

Chapter 20: Changes

1. Cox, Major Physical, p. 3.
2. Ibid., p. 5.
3. Ibid., pp. iv–v.
4. Ibid., pp. 21–35.
5. Ibid., p. 9–14.
6. Ibid., p. 18–19.
7. Ibid., p. 77.
8. Ibid., p. 85–87.
9. Ibid., p. 45.
10. Ibid., p. 52.
11. GIBB News, May 1985.
12. Cox, Major Physical, pp. 75–80.
13. *Burton Herald*, November 1985.
14. Ibid., August 1986.
15. Ibid., May 1987.
16. Ibid., December 1986.
17. Cox, Major Physical, pp. 75–80.
18. Ibid., p. 79.
19. *Burton Herald*, October 1987.
20. Burton Mail, 29 August 1987.
21. ABUK Ltd. DM, 17 December 1987.
22. The GABB Q&A Booklet.
23. Burton Mail, 04 March 1988.
24. Ibid., 18 April 1988.
25. ABUK Ltd. DM, 01 September 1988.
26. Ibid., 27 October 1988.
27. Cox, Major Physical, p. 117.

Chapter 21: Mergers

1. *The Supply of Beer: A report on the supply of beer for retail sale in the United Kingdom* (1989) Chapter 6.
2. Burton Mail, 23 October 1991.
3. Ibid., 22 October 1991.
4. Barber et al., Century of British Brewers Plus 1890-2004, p. 34.
5. Ibid., p. 12.
6. Burton Mail, 28 November 1992.
7. *Burton Herald*, Autumn 1995.
8. Ibid., 26 August 1996.
9. Burton Mail, 24 August 1996.
10. Ibid., 27 August 1996.
11. Ibid., 12 March 1997.
12. Ibid., 04 July 1997.
13. Ibid., 25 September 1997.
14. Ibid., 26 September 1997.
15. Ibid., 03 December 1997.

ABOUT THE AUTHOR

Ian Webster was born and raised in Burton upon Trent, Staffordshire. He obtained BSc (Hons) in Applied Biology at Coventry University, and post-graduation was employed at Ind Coope Burton Brewery for five years in the Process and Bottle & Can Laboratories.

For the last fifteen years, he has worked in the Pathology Department at Burton Hospitals Foundation Trust, latterly as a Senior Biomedical Scientist, and was awarded an MSc in Biomedical Science at Nottingham Trent University.

Although this is Ian's first book, he has been writing for around twenty years and has been published in a number of music magazines. He is married to Netty and has one daughter, two sons and a stepson.

His idea of bliss is attending a rock festival, listening to loud music with a beer in his hand!

INDEX